POCKET
Visual Encyclopedia

Art Nouveau
Jugendstil

SCALA

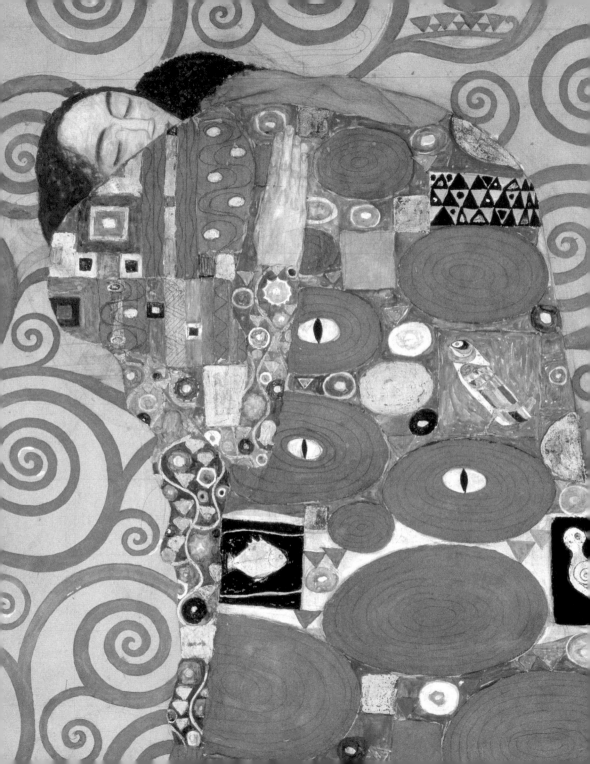

Contents

Inhalt

Index

Inhoudsopgave

Introduction

Between the end of the nineteenth and beginning
of the twentieth century the Art Nouveau
movement introduced a vital spirit of artistic
and cultural renewal into Europe and the United
States. It assumed a variety of different names
and interpretations throughout Europe: Austria
(Sezessionsstil), Germany (Jugendstil), Netherlands
(Nieuwe Kunst), Spain (Modernismo), England
and Scotland (Modern Style), France and Belgium
(Art Nouveau), Italy (Liberty or stile floreale). This
far-reaching international vogue filtered through
every aspect of artistic production, from paintings
and graphics to advertising posters, finding its
most remarkable expression in architecture, interior
design and the decorative arts. It developed
in reaction to academic art, eclecticism and to
industrial production. Many interpreters of Art
Nouveau – including Van de Velde, Tiffany, Klimt,
Horta, Beardsley, Guimard, Mackintosh – were
inspired by the sinuous, elegant and dynamic
shapes and lines in flowers, plants and the
female form, introducing these natural forms
into their art. At the same time they explored the
possibilities of industrial design through material
such as iron, glass and cement to create an organic
harmony of building, decoration and furnishings.
The innovatory approach of Art Nouveau was
disseminated through magazines, exhibitions, and
conferences. Craftsmen's workshops, including
those in Dresden, Munich and Vienna, were also
influential in consolidating modern design.

Einleitung

Vom Ende des 19. bis zum Beginn des 20.
Jahrhunderts wurden Europa und die Vereinigten
Staaten von einer Welle der künstlerischen und
der kulturellen Erneuerung erfasst, die von der
Art Nouveau Bewegung ausging. Mit ihren
unterschiedlichen Bezeichnungen und Richtungen
in Österreich (Sezessionsstil), Deutschland
(Jugendstil), den Niederlanden (Nieuwe Kunst),
Spanien (Modernismus), England und Schottland
(Modern Style), Frankreich und Belgien (Art
Nouveau) und Italien (Liberty oder Stile floreale),
erneuerte diese umfassende internationale Tendenz
die verschiedensten Bereiche der Kunst: von der
Malerei über die Grafik bis hin zum Werbedruck.
Ihre stärksten und wichtigsten Ausdrucksformen
fand sie dabei in der Architektur, der angewandten
Kunst und in der Innendekoration. Sie entstand als
Reaktion auf den Akademismus, den Eklektizismus
und die zunehmende industrielle Produktion.
Zahlreiche Meister des Jugendstils – darunter Van
de Velde, Tiffany, Klimt, Horta, Beardsley, Guimard
und Mackintosh – erneuerten den Zusammenhang
zwischen Kunst und Natur und wurden dabei vom
Linearismus und von den kurvenreichen, eleganten
und dynamischen Formen von Blumen, Pflanzen
und weiblichen Figuren inspiriert.
Der Jugendstil entdeckte die Möglichkeit,
Industriedesign mit Materialien wie Eisen, Glas und
Zement zu einer organischen Harmonie zu führen,
für Gebäude, Dekoration und Einrichtung.
Der innovative Ansatz des Jugendstils zeigte sich
in Magazinen, Ausstellungen und Konferenzen.
Kunsthandwerksstätten wie die in Dresden,
München und Wien, beeinflussten das Design des
20. Jahrhunderts.

Introduction

À la fin du xixe et au début du xxe siècle, l'Art nouveau est à l'origine d'un mouvement artistique et culturel qui gagne toute l'Europe et les États-Unis, et prend différentes dénominations : le *Sezessionsstil* en Autriche, le *Jugendstil* en Allemagne, le *Modern style* en Grande-Bretagne, l'Art nouveau en Belgique et en France, le *Nieuwe Kunst* aux Pays-Bas, le *Modernismo* en Espagne, le style *Liberty* ou *Stile floreale* en Italie. Ce vaste mouvement international contribue à renouveler tous les domaines de l'art, de la peinture à l'affiche publicitaire, mais trouve ses expressions les plus accomplies dans le domaine de l'architecture, des arts appliqués et de la décoration intérieure. En réaction contre l'académisme, l'éclectisme et l'appauvrissement de la production industrielle, les maîtres de l'Art nouveau – Van de Velde, Tiffany, Klimt, Horta, Beardsley, Guimard, Mackintosh – redécouvrent le lien entre l'art et la nature et s'inspirent des formes sinueuses, élégantes et dynamiques du monde végétal. En même temps, ils définissent un nouveau rapport entre l'art et l'industrie à travers des créations tantôt dépouillées, tantôt complexes, qui utilisent des matériaux modernes comme le fer, le verre et le béton, et qui constituent un tout organique, intégrant la structure, la décoration et le mobilier. Dans ce climat d'innovation, l'Art nouveau impose et diffuse son style à travers les revues, les expositions, les conférences et les ateliers d'artisanat, dont ceux de Dresde, de Munich et de Vienne, qui jettent les bases du design moderne.

Introductie

Tussen eind negentiende eeuw en begin twintigste eeuw werden Europa en de Verenigde Staten geraakt door een vlaag van artistieke en culturele vernieuwing, door de Art Nouveau. Onder verschillende benamingen en declinaties in Oostenrijk (Sezessionsstil), Duitsland (Jugendstil), Nederland (Nieuwe Kunst), Spanje (Modernismo), Engeland en Schotland (Modern Style), Frankrijk en België (Art Nouveau) en Italië (Liberty of Stile Floreale), vernieuwde deze enorme internationale tendens de meest uiteenlopende sectoren van de kunst, van de schilderkunst tot aan de grafische kunst en de reclameprenten, door zich vooral en veelbetekenend uit te drukken in de architectuur, de toegepaste kunst en binnenhuisdecoraties. In reactie op het academisme, het eclecticisme en op het verval van het industriële product, herontdekte veel Art Nouveau meesters – waaronder Van de Velde, Tiffany, Klimt, Horta, Beardsley, Guimard en Mackintosh – het verband tussen kunst en natuur, geïnspireerd op het linearisme en op de kronkelende, elegante en dynamische vormen van bloemen, planten en vrouwelijke figuren. Tegelijkertijd werd de tweeterm kunst-industrie door middel van uitdrukkingsmiddelen gemoderniseerd, zowel lineair, als gedetailleerd, door gebruik te maken van moderne materialen als ijzer, glas en cement, zo een organisch geheel tussen structuur, decoratie en meubilair creërend. In het licht van de innovatie, vestigde en verspreidde de Art Nouveau haar eigen stijl door middel van tijdschriften, tentoonstellingen en ambachtswerkplaatsen, waaronder die van Dresden, München en Wenen, die worden beschouwd als de wortels van het moderne design.

The places of Art Nouveau
Schauplätze der Art Nouveau
Les lieux de l'Art Nouveau
De plaatsen van de Art Nouveau

MODERN STYLE

Victor Horta
Hôtel Tassel
1892-1893
Bruxelles

ART NOUVEAU

ART NOUVEAU

Hector Guimard
Métro entrance
Metroeingang
Entrée de la station de métro
Ingang van het metrostation
1899
Paris

MODERNISMO

Antoni Gaudí
Parc Güell
1900-1914
Barcelona

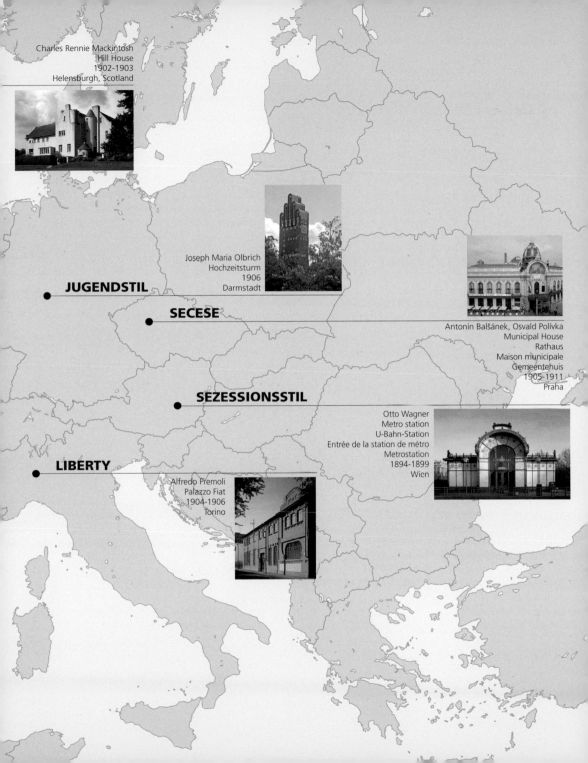

Charles Rennie Mackintosh
Hill House
1902-1903
Helensburgh, Scotland

Joseph Maria Olbrich
Hochzeitsturm
1906
Darmstadt

JUGENDSTIL

SECESE

Antonín Balšánek, Osvald Polívka
Municipal House
Rathaus
Maison municipale
Gemeentehuis
1905-1911
Praha

SEZESSIONSSTIL

Otto Wagner
Metro station
U-Bahn-Station
Entrée de la station de métro
Metrostation
1894-1899
Wien

LIBERTY

Alfredo Premoli
Palazzo Fiat
1904-1906
Torino

The great masters of Art Nouveau
Vertreter der Art Nouveau
Les protagonistes de l'Art Nouveau
De protagonisten van de Art Nouveau

1840	1850	1860	1870	1880	1890

Emile Gallé
1846

Oakleaf vase / Vaas
c. 1895
Victoria and Albert Museum, London

Louis Comfort Tiffany
1848

1852

Sagrada Familia
1883-1926
Barcelona

1860

1861

Hotel van Eetvelde
1895-1898
Bruxelles

Gustav Klimt
1862

Henri de Toulouse-Lautrec
1864

Loïe Fuller aux Folies-Bergère
1893
Musée Toulouse-Lautrec, Albi

1868 **Charles Rennie Mackintosh**

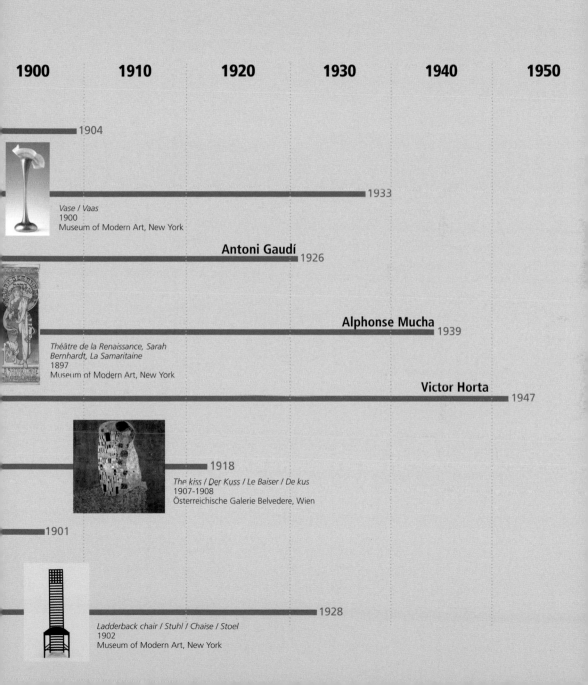

1900 **1910** **1920** **1930** **1940** **1950**

1904

Vase / Vaas
1900
Museum of Modern Art, New York

Antoni Gaudí 1926

Alphonse Mucha 1939

*Théâtre de la Renaissance, Sarah
Bernhardt, La Samaritaine*
1897
Museum of Modern Art, New York

Victor Horta 1947

1933

1918

The kiss / Der Kuss / Le Baiser / De kus
1907-1908
Österreichische Galerie Belvedere, Wien

1901

1928

Ladderback chair / Stuhl / Chaise / Stoel
1902
Museum of Modern Art, New York

DER · ZEIT · IHRE · KVNST ·
DER · KVNST · IHRE · FREIHEIT·

Architecture

In the field of architecture artists such as Gaudí, Wagner, Van De Velde, were among those who introduced modern elements into building, using iron, glass and cement in the creation of sinuous and floral decorative and structural motifs or linear form.

Architektur

Auf dem Gebiet der Architektur haben Künstler wie Gaudí, Wagner, Van De Velde, um nur einige der wichtigen Protagonisten zu nennen, dieser Kunstrichtung eine moderne Wende gegeben. Sie führten Materialien wie Eisen, Glas, Beton ein und warfen dekorative und strukturelle Stilrichtungen auf, die sowohl von geschwungenen und floralen Formen geprägt waren, als auch von der Geradlinigkeit der Oberflächen.

Architecture

Dans le domande de l'architecture, des artistes comme Gaudí, Wagner, Van de Velde – pour ne citer que quelques-unes des plus grandes figures du mouvement – ont fait prendre à cet art le tournant de la modernité, en introduisant des matériaux comme le fer, le verre et le ciment, et en proposant des éléments décoratifs et structuraux marqués par des formes végétales flexueuses autant que par la linéarité des surfaces.

Architectuur

Op het gebied van architectuur hebben kunstenaars als Gaudí, Wagner, Van De Velde, om zo maar een paar van de belangrijkste protagonisten te noemen, hebben een moderne draai gegeven aan deze kunst, door materialen als ijzer, glas en cement te introduceren en door decoratieve en structurele elementen naar voren te brengen, de nadruk leggend op zowel de kronkelige en bloemachtige vormen als op de rechtlijnigheid van de oppervlaktes.

1

The Art Nouveau architecture
Art Nouveau Architektur
L'architecture Art Nouveau
De Art Nouveau Architectuur

Wien

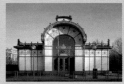

Otto Wagner
Metro station
U-Bahn-Station
Entrée de la station de métro
Metrostation
1894-1899

Barcelona

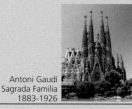

Antoni Gaudí
Sagrada Familia
1883-1926

Antoni Gaudí
Palacio Güell
1885-1889

Budapest

Otto Wagner
Rumbach Synagogue
1868

Bruxelles

Victor Horta
Hôtel Tassel
1892-1893

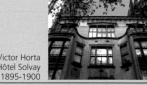
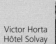

Victor Horta
Hôtel Solvay
1895-1900

Paris

Hector Guimard
Castel Béranger
1897-1898

Otto Wagner
Österreichische Postsparkasse
1903-1912

Otto Wagner
Steinhof church
Kirche am Steinhof
Église St-Léopold,
hospice du Steinhof
Kirche am Steinhof
1903-1907

Adolph Loos
Steiner House
1910

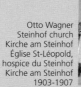

Adolph Loos
Looshaus
1910

Antoni Gaudí
Parc Güell
1900-1914

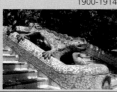

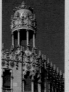

Lluís
Domènech
y Montaner
Casa Lleo
Morera
1902

Antoni
Gaudí
Casa Batlló
1904-1906

Lluís Domènech y Montaner
Casa Fuster
1908-1910

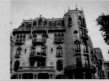

Antoni Gaudí
Casa Milà (La Pedrera)
1906-1912

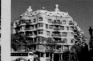

Zsigmond Quittner,
Jozsef and Laszlo Vago
Gresham Palace
Gresham Palast
Palais Gresham
Gresham Paleis
c. 1906

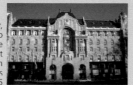

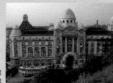

Hotel Gellért
1918

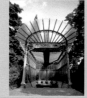

Victor Horta
Hôtel van Eetvelde
1895-1898

Victor Horta
Maison & Atelier Horta
1898

Adolph Loos
Tzara House
1926

Hector Guimard
Métro entrance
Metroeingang
Entrée de la
station de métro
Ingang van het
metrostation
1899

Hector Guimard
Rue Pavée-au-Marais
Synagogue
1913

Hector Guimard
Villa Flore
1924-1925

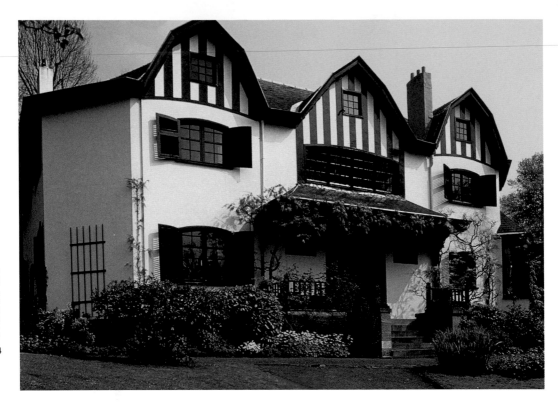

Henri Van de Velde
(Antwerpen 1863 - Zürich 1957)
Bloemenwerf House
Haus Bloemenwerf
Maison Bloemenwerf
Huize Bloemenwerf
1896
Uccle, Bruxelles

▶ **Josef Hoffmann**
(Pirnitz 1870 - Wien 1956)
Palais Stoclet
Sculpture on tower
Turm mit Skulpturen
Tourelle ornée de sculptures
Torentje met sculptuur
1905-1911
Bruxelles

▌ *"The line is as active as all elementary forces."*
▌ *"Wie jede Elementargewalt, ist die Linie eine aktive Kraft."*
▌ *"La ligne est une force active comme toutes les forces élémentaires."*
▌ *"De lijn is een kracht, die zoals alle elementaire krachten bezig is."*
Henri Van de Velde

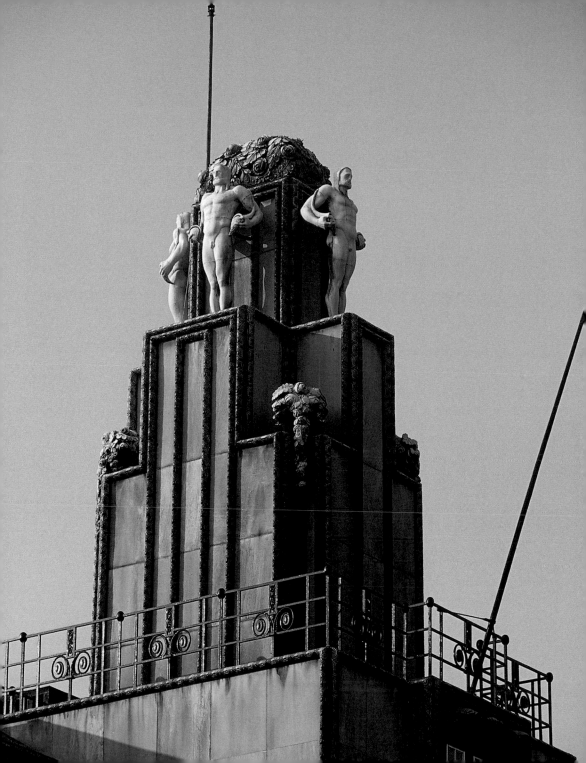

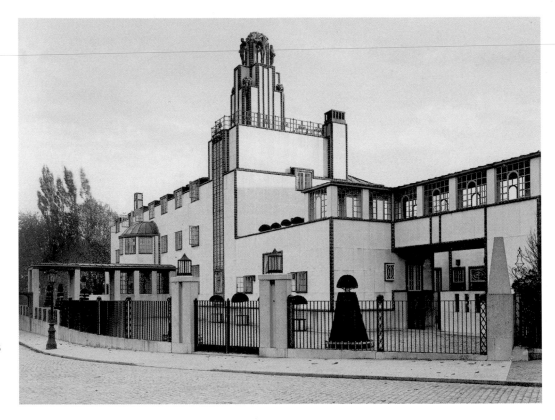

Josef Hoffmann
(Pirnitz 1870 - Wien 1956)
Palais Stoclet
1905-1911
Bruxelles

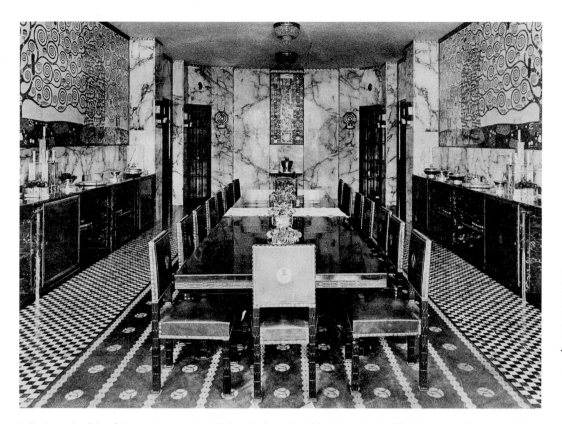

▌ The linear simplicity of the exterior contrasts with the rich decoration of the interior. Gustav Klimt designed a frieze, executed in mosaic by craftsmen from the Wiener Werkstätte, for the marble lined walls of the dining room.

▌ Linearität und Schlichtheit der Fassade stehen im Gegensatz zur reichen Innendekoration. Für die Wände des Speisesaals, die vollständig mit Marmor ausgekleidet sind, entwirft Gustav Klimt ein Mosaik-Fries, das von den Künstlern der Wiener Werkstätte umgesetzt wird.

▌ La simplicité linéaire de l'extérieur de l'édifice contraste avec la richesse de la décoration intérieure. Pour les murs de la salle à manger entièrement revêtue de marbre, Gustav Klimt a conçu une frise réalisée en mosaïque par les artisans de la Wiener Werkstätte.

▌ De lineariteit en eenvoud van de buitenkant van het gebouw, zijn tegengesteld aan de rijke decoraties van de binnenkant. Voor de wanden van de eetzaal, geheel bekleed met marmer, ontwerpt Gustav Klimt een fries, door de ambachtsmannen van de Wiener Werkstätte uitgevoerd in mozaïek.

Palais Stoclet
Dining room
Speisesaal
Salle à manger
Eetkamer

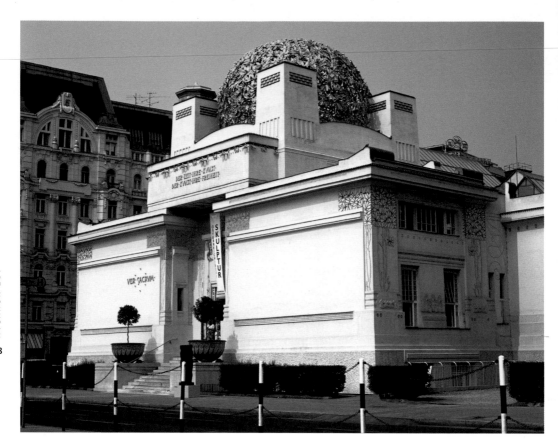

Joseph Maria Olbrich
(Troppau 1867 - Düsseldorf 1908)
Secession Building
Sezession
Palais de la Sécession
Secessionsgebouw
1897-1898
Wien

▶ Secession Building, detail: façade and dome
Sezession, Detail der Fassade und der Kuppel
Palais de la Sécession, détail de la façade et de la coupole
Secessionsgebouw, detail van de voorgevel en van de koepel

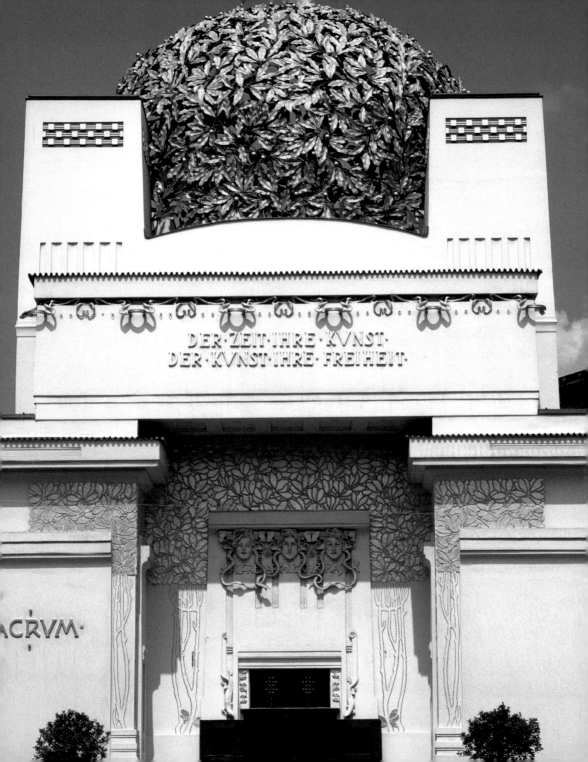

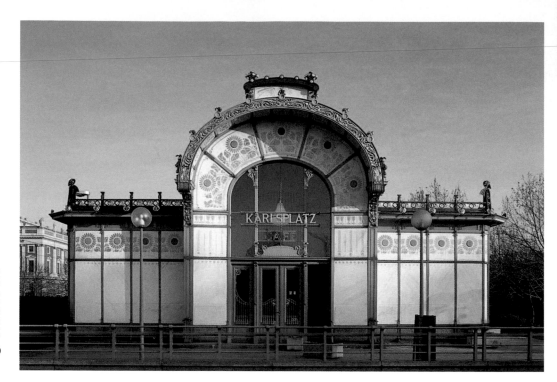

Otto Wagner
(Penzing, Wien 1841 - Wien 1918)
Metro station
U-Bahn-Station
Entrée de la station de métro
Metrostation
1894-1899
Karlsplatz, Wien

▶ **Otto Wagner**
(Penzing, Wien 1841 - Wien 1918)
Jugendstil house
Ansicht eines Hauses im Jugendstil
Maison Jugendstil
Aanzicht van een huis in Art Nouveau stijl
1898
38 Linke Wienzeile, Wien

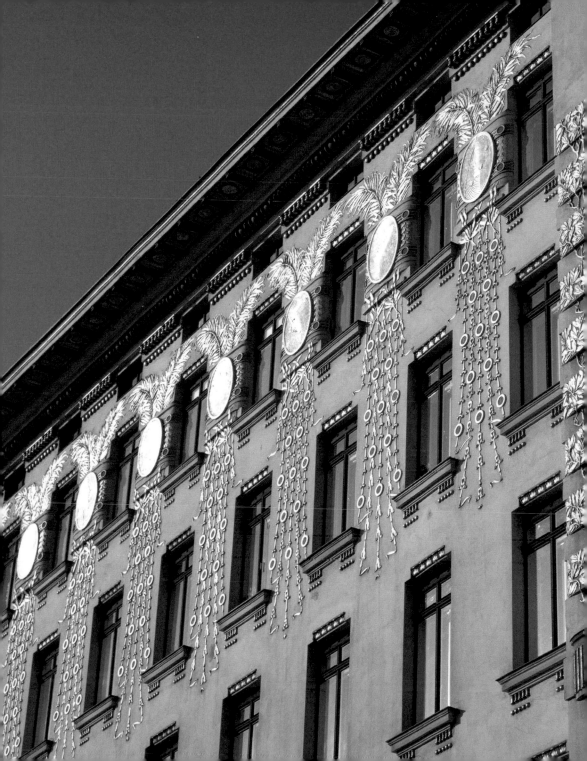

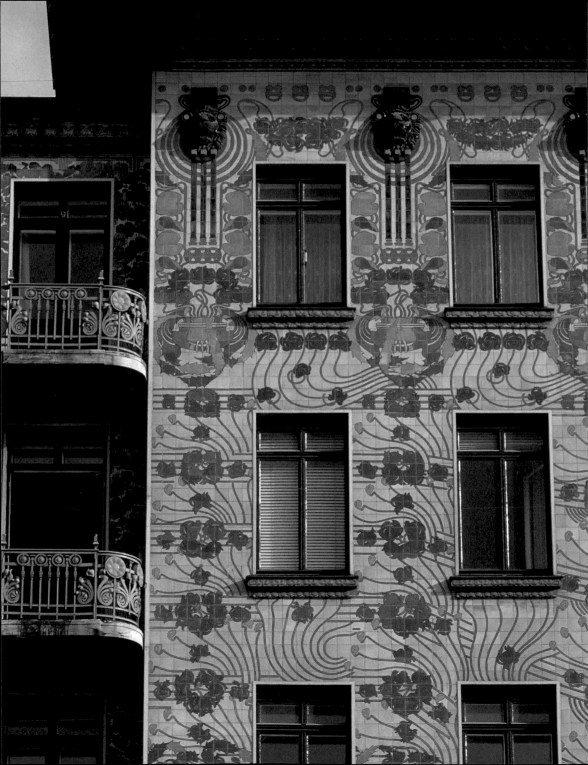

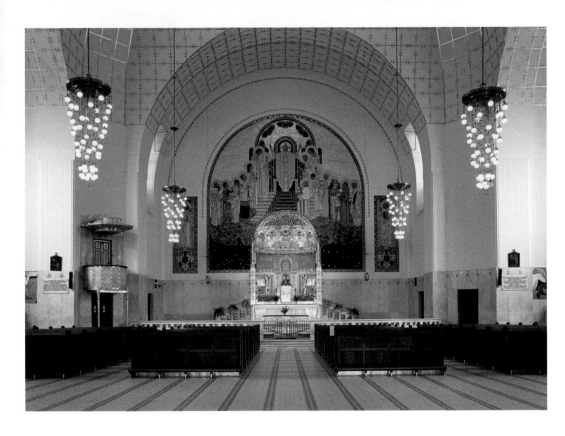

Otto Wagner
(Penzing, Wien 1841 - Wien 1918)
Steinhof church
Kirche am Steinhof
Église St-Léopold, hospice du Steinhof
Kirche am Steinhof
1903-1907
Wien

◀ **Otto Wagner**
(Penzing, Wien 1841 - Wien 1918)
Majolikahaus
Polychrome façade decoration
Polychrome Dekoration der Fassade
Maison aux majoliques, décoration polychrome de la façade
Polychrome decoratie van de voorgevel
1898-1900
40 Linke Wienzeile, Wien

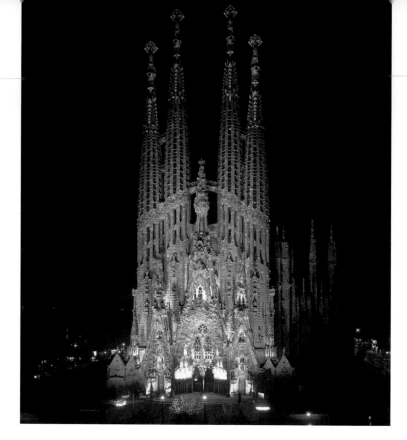

▌ Work on the building, based on drawings left by the artist, continued after Gaudí's death. It still remains only a little more than half finished as the project entails the construction of eighteen towers and three facades, the whole to be surmounted by a large central cupola.

▌ Die Errichtung des Gebäudes wurde nach dem Tod von Gaudí auf der Basis der vom Künstler hinterlassenen Pläne fortgesetzt und bis heute ist es nur zu 55% fertiggestellt. Das Projekt sieht den Bau von 18 Türmen und 3 Fassaden vor, die von einer großen zentralen Kuppel überragt werden.

▌ La construction de l'édifice se poursuit après la mort de Gaudí, à partir des dessins laissés par l'artiste. Elle n'est actuellement achevée qu'à 55%. Le projet prévoit la réalisation de dix-huit tours et de trois façades, l'édifice devant être par ailleurs surmonté d'une grande coupole centrale.

▌ De bouw van het gebouw ging verder na de dood van Gaudí, op basis van de door de kunstenaar achtergelaten ontwerpen en is vandaag de dag voor slecht 55% voltooid. Het ontwerp omvat 18 torens en 3 voorgevels, met daarboven een grote centrale koepel.

Antoni Gaudí
(Reus 1852 - Barcelona 1926)
Sagrada Familia
1883-1926
Barcelona

▶ Sagrada Familia
Façade, spires and rose window
Fassade mit Turmspitzen und Rosette
Façade avec clochers et rosace
Voorgevel met pinakels en roosvensters

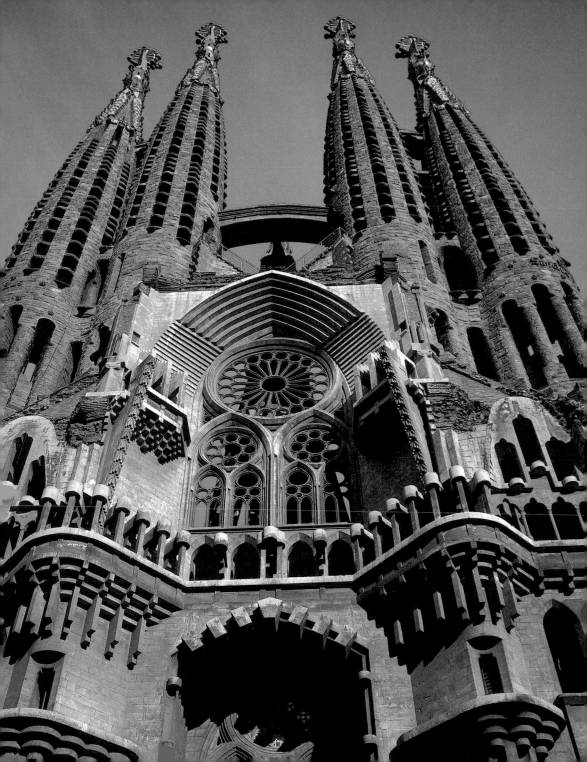

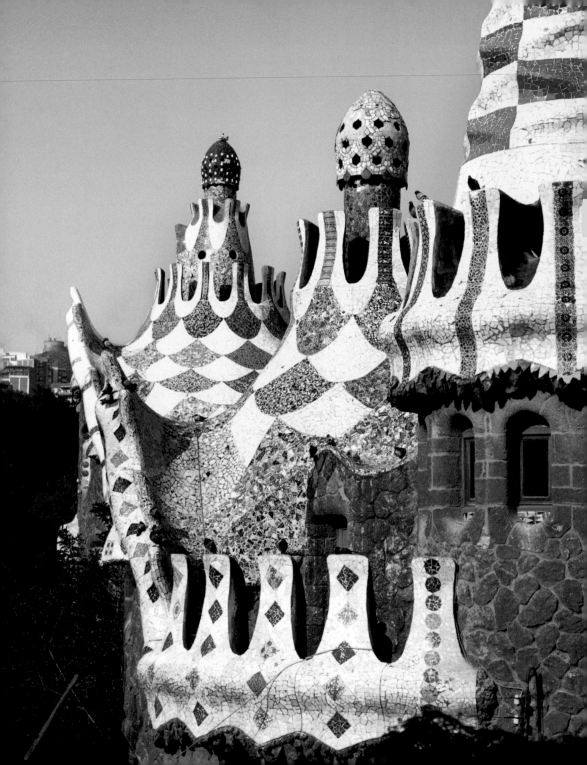

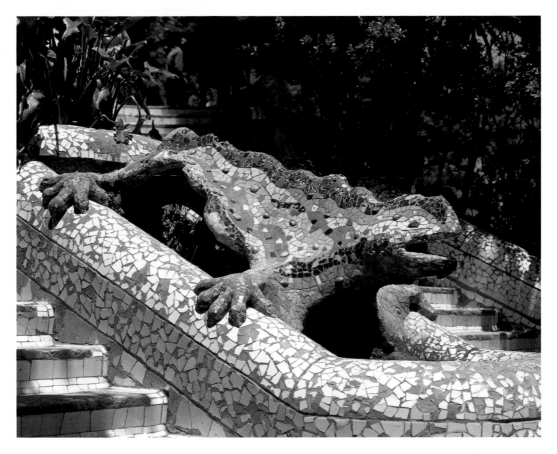

Antoni Gaudí
(Reus 1852 - Barcelona 1926)
Parc Güell
Detail: salamander
Detail des Salamanders
Détail de la salamandre
Detail van de Salamander
1900-1914
Barcelona

◄ Parc Güell
Museo Gaudí

▌ *"The terrifying and edible beauty of Art Nouveau architecture."*
▌ *"Die schauerliche und bekömmliche Schönheit der Art Nouveau Architektur ."*
▌ *"La beauté terrifiante et comestible de l'architecture de l'Art Nouveau."*
▌ *"De vreselijke en eetbare schoonheid van de Jugendstilarchitectuur."*
Salvador Dalí

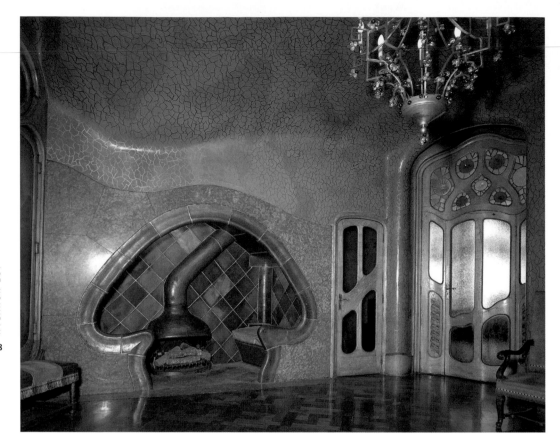

Antoni Gaudí
(Reus 1852 - Barcelona 1926)
Casa Batlló
Fireplace with tiles
Kamin mit Keramikverkleidung
Cheminée avec revêtement de céramique
Schoorsteen met keramische bekleding
1904-1906
Barcelona

▶ Casa Batlló
Façade, detail
Fassade, Detail
Façade, détail
Voorgevel, detail

❚ *"The straight line is human, but the curve is Divine ."*
❚ *"Die gerade ist die Linie des Menschen, die gekurvte die Linie Gottes. "*
❚ *"La ligne droite est la ligne des hommes, la ligne courbe est celle de Dieu."*
❚ *"De rechte lijn is eigendom de mensheid, de gebogen lijn is eigendom van God."*
Antoni Gaudí

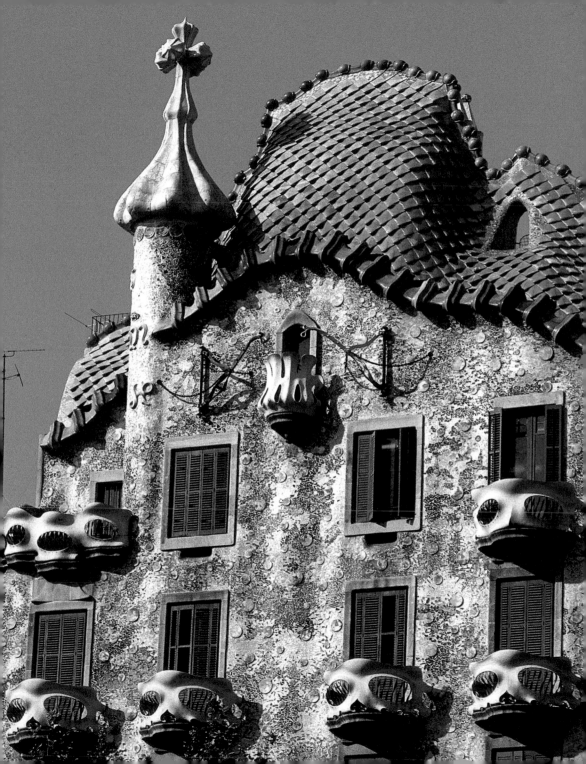

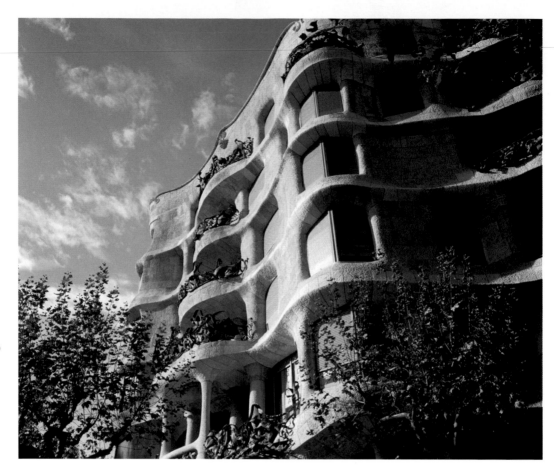

Antoni Gaudí
(Reus 1852 - Barcelona 1926)
Casa Milà (La Pedrera)
Residential palace
Residenzpalast
Palais Résidentiel
Woonpaleis
1905-1907
Barcelona

▶ **José Grases Riera**
(Barcelona 1850 - Madrid 1919)
Palacio Longoria
Detail: tower
Detail des Turms
Détail de la tourelle
Detail van het torentje
1903
Madrid

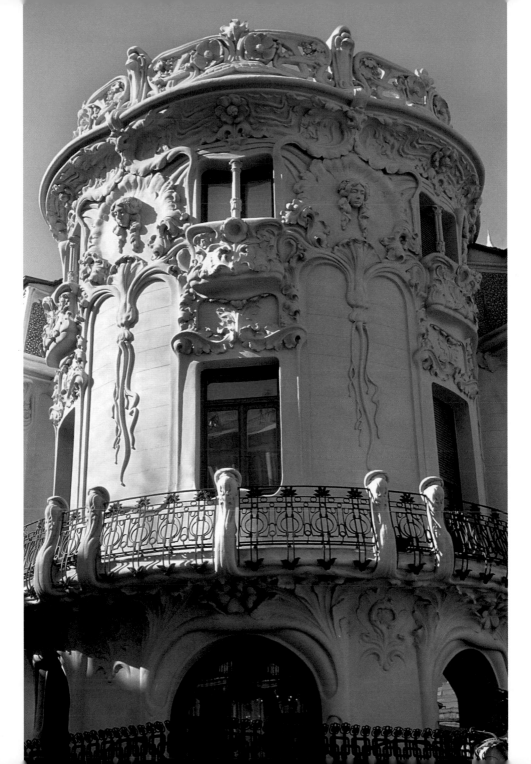

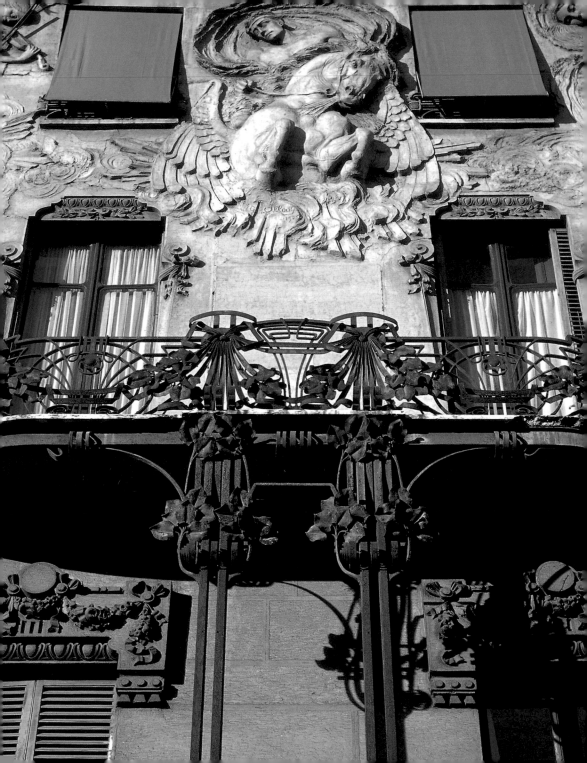

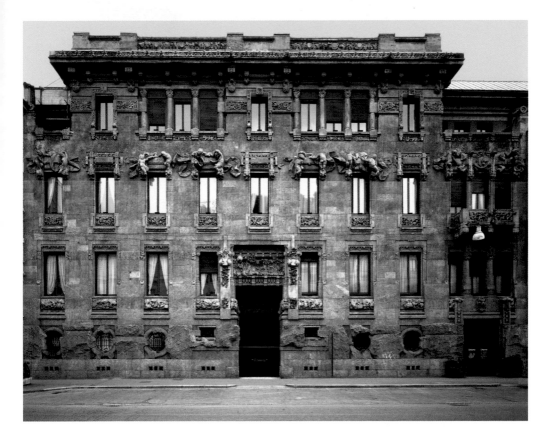

Giuseppe Sommaruga
(Milano 1867 - 1917)
Palazzo Castiglioni
1901-1904
Milano

◀ **Alessandro Mazzucotelli**
(Lodi 1865 - Milano 1938)
Casa Maffei
Wrought iron balcony
Balkon in Schmiedeeisen
Balcon en fer forgé
Smeedijzeren balkon
1909
Torino

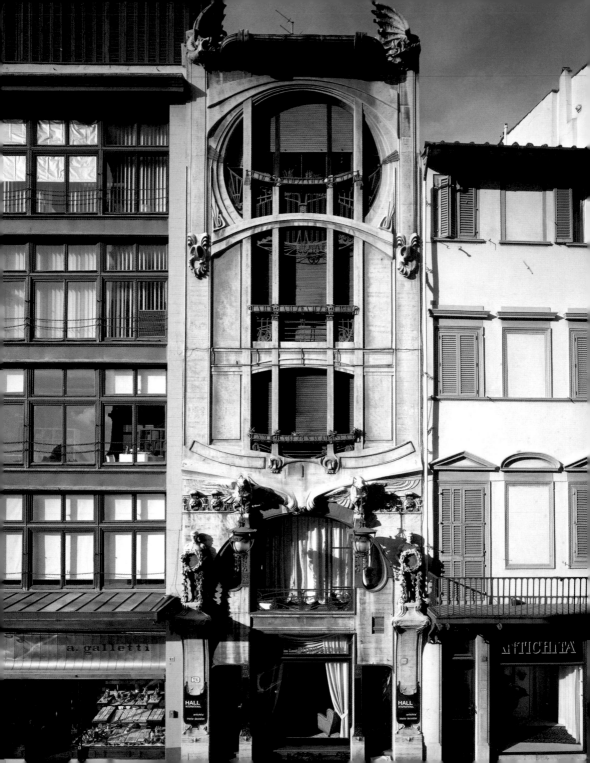

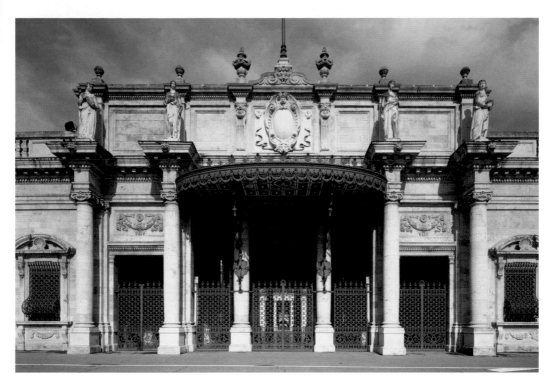

Ugo Giovannozzi
(Firenze 1876 - Roma 1957)
Thermal baths Il Tettuccio
Thermalbad Il Tettuccio
Établissement thermal Il Tettuccio
Thermale Oord Il Tettuccio
1916
Montecatini Terme, Pistoia

◄ **Giovanni Michelazzi**
(Firenze 1879 - 1920)
Casa-galleria
Maison-galerie
Huisgalerie
1911
Firenze

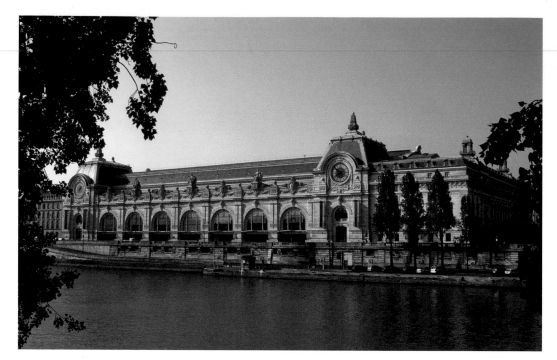

▌ Originally a railway station (Gare d'Orsay) since 1986 the museum houses a wonderful collection of Impressionist art. Built in the eclectic style, a monumental stone facade masks the load-bearing structure behind in metal and glass.

▌ Das Gebäude, das seit 1986 die repräsentativsten Werke des Impressionismus beherbergt, war ursprünglich ein Bahnhof (Gare d'Orsay) im eklektischen Stil. Eine monumentale Steinfassade maskiert die inneren tragende Strukturen aus Glas und Metall.

▌ Cet édifice accueille depuis 1986 - entre autres - les œuvres les plus représentatives de l'école impressionniste. Il s'agissait à l'origine d'une gare de chemins de fer (la "gare d'Orsay") construite en 1898-1900 en style composite. Une façade de pierre monumentale masque les structures portantes en métal.

▌ Het gebouw, dat vanaf 1986 de werken van de meest representatieve kunstenaars van het impressionisme onderbrengt, was oorspronkelijk een treinstation (La Gare d'Orsay), gebouwd in eclectische stijl. Een monumentale voorgevel van steen, verbergt de interne draagstructuur van glas en metaal.

Victor Laloux
(Tours 1850 - Paris 1937)
Musée d'Orsay
Façade on the Seine
Fassade zur Seine
Façade côté Seine
Voorgevel richting de Seine
1898-1900
Paris

▶ **Hector Guimard**
(Paris 1867 - New York 1942)
Métro entrance
Metroeingang
Entrée de la station de métro Porte Dauphine, et détail de la marquise
Ingang van het metrostation
1899
Paris

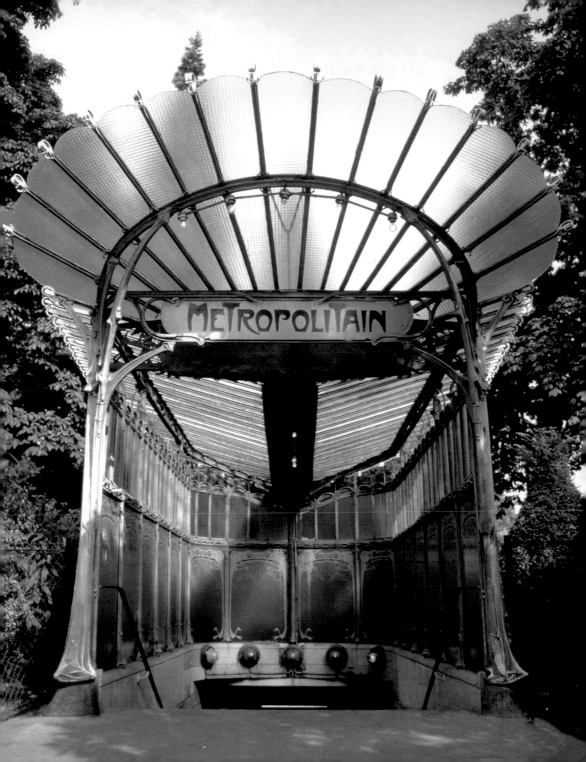

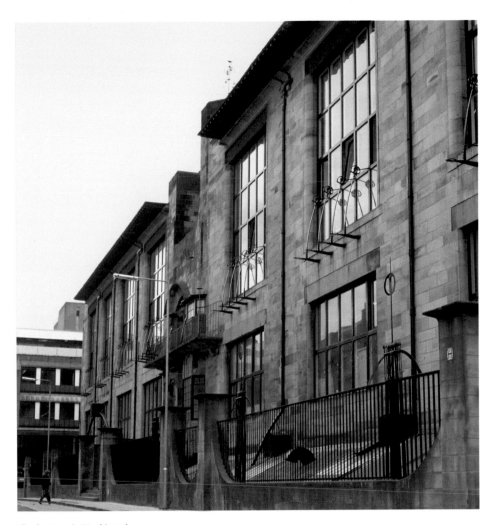

Charles Rennie Mackintosh
(Glasgow 1868 - London 1928)
Glasgow School of Art
1896-1909
Glasgow

◀ **Hector Guimard**
(Paris 1867 - New York 1942)
Castel Béranger
Façade on rue de la Fontaine
Fassade auf Rue de la Fontaine
Rue La Fontaine
Voorgevel op de Rue de la Fontaine
c. 1897-1898
Paris

▌ *"Flames, the undertow of the waves, and
everything that appears elusive…"*
▌ *"Flammen, Rollbrandung, alles
Ungreifbare, was ihr wünscht…"*
▌ *"Des flammes, des vagues avec des
remous, tout ce que vous voudrez
d'insaisissable …"*
▌ *"Vlammen, het omslaan van de golven en
alles dat men ongrijpbaar acht…"*
Hector Guimard

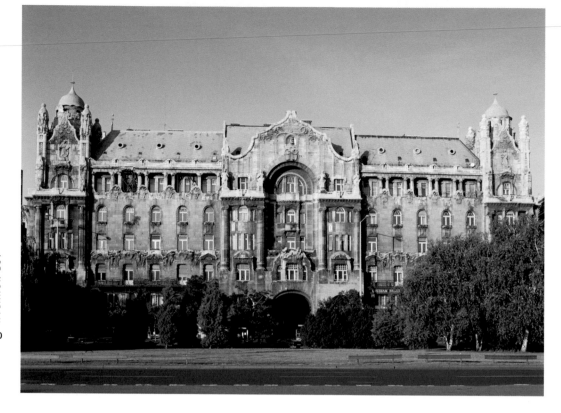

Zsigmond Quittner
(Budapest 1857 - Wien 1918)
Jozsef and Laszlo Vago
(Nagyvárad 1877 - Budapest 1947)
(Nagyvárad 1875 - Budapest 1933)
Gresham Palace
Gresham Palast
Palais Gresham
Gresham Paleis
c. 1906
Budapest

▶ **Antonín Balšánek**
(Český Brod 1865 - Praha 1921)
Osvald Polívka
(Lince 1859 Enns - Praha 1931)
Municipal House, apse mosaic
Rathaus, Ansicht des Apsismosaiks
Maison municipale, mosaïque de l'abside
Gemeentehuis, Aanzicht van het mozaïek van de abside
1905-1911
Praha

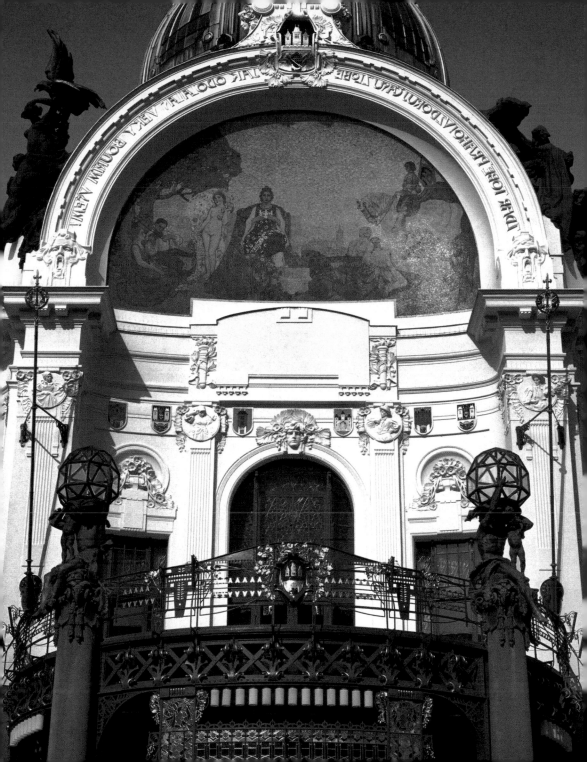

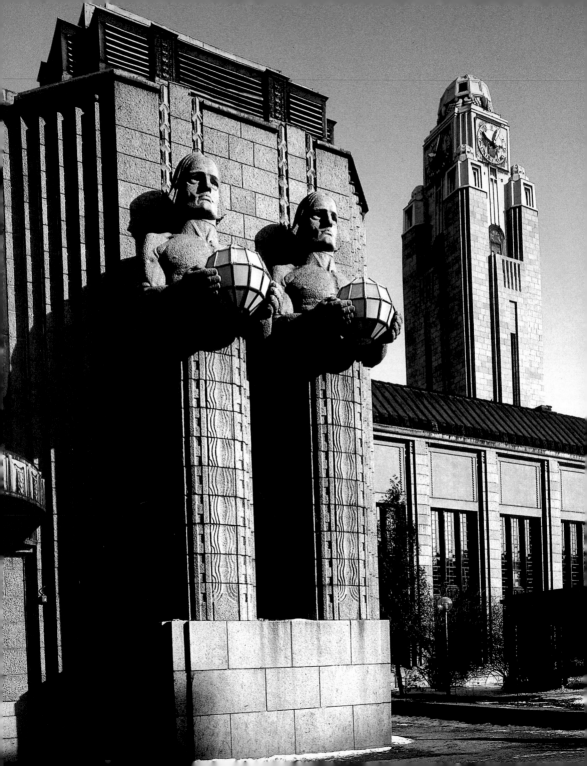

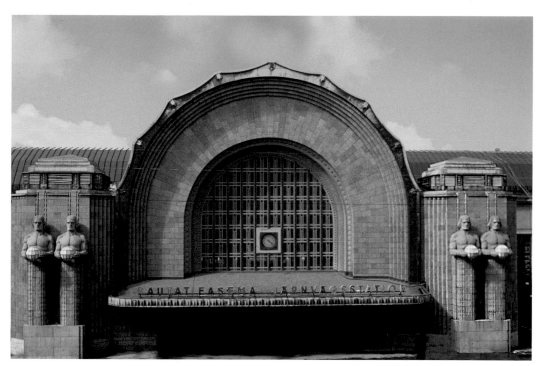

Eliel Saarinen
(Rantasalmi 1873 - Bloomfield Hills 1950)
Railway station
Bahnhof
Gare centrale
Treinstation
1910-1914
Helsinki

Praha
U Novaku building, detail of Liberty decoration
U Novaku Gebäude, Detail des Liberty-Dekors
Palais U Novaku, détail de la décoration dans le style Liberty
Gebouw U Novaku, detail van de Jugendstil decoratie

▶ Louis Comfort Tiffany
(New York 1848 - 1933)
Laurelton Hall
Architectural detail
Architektonische Elemente
Éléments architectoniques
Architectonische elementen
c. 1904
Oyster Bay, New York

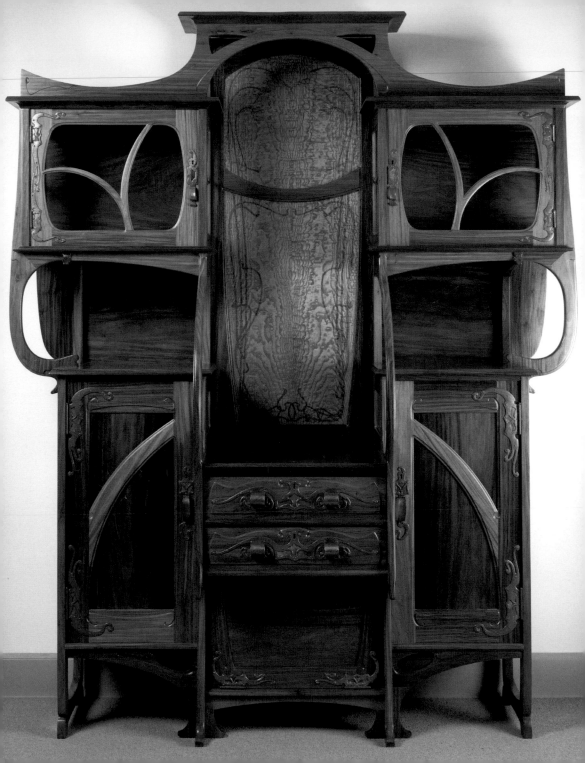

Furniture

Art Nouveau reached its
most complete expression
in furniture, with significant
contributions from Prague
and Finland. Tables, chairs,
cupboards, among the many
pieces produced, adopted
floral and metamorphic detail,
inspired by nature, or with
linear forms uniting function
and elegance in imaginative
design. Furniture design
was also influenced by the
idea that furniture should
harmonise with the building
intended to house it.

Mobiliar

Im Mobiliar findet der Jugendstil eine seiner
vollkommensten Ausdrucksformen der
Art Nouveau und erlebt auch in Prag und
Finnland eine beachtenswerte Entwicklung.
Die unzählig gestalteten Gegenstände wie
Tische, Stühle, Anrichten bedienen sich
geradliniger Module oder floraler und
metamorpher Motive, die von der Natur
inspiriert sind. Im Gesamten kommt es zu
einer Verbindung der Funktionalität mit
Eleganz und Launenhaftigkeit der Formen.
Bei der Schöpfung von Mobiliar spielt auch
eine Planungsidee mit hinein, die den
Zusammenhang und die Harmonie zwischen
dem Möbelstück selbst und dem Bauwerk, in
dem es stehen soll, sucht.

Mobilier

L'Art Nouveau trouve dans le mobilier
une de ses expressions les plus achevées,
avec un développement remarquable
aussi à Prague et en Finlande. Parmi
les très nombreux objets réalisés, les
tables, les sièges, les buffets et les
crédences utilisent des motifs floraux
et protéiformes, inspirés de la nature
ou de modules linéaires - l'ensemble
unissant la fonctionnalité à l'élégance
et l'inventivité des formes. La création
du mobilier est influencée aussi par
une conception globale qui recherche
la cohérence et l'harmonie entre le
mobilier et l'édifice qui est destiné à
l'accueillir.

Meubilair

De Art Nouveau kan zich in meubilair
het meest volledig uitdrukken, met ook
een aanzienlijke ontwikkeling in Praag
en Finland. Tafels, stoelen en kasten;
de vele verwezenlijkte items maakten
gebruik van op de natuur geïnspireerde
bloemachtige en metamorfische
motieven, of van lineaire modules, alles
om functionaliteit te verenigen met
de elegantie en de grilligheid van de
vormen. De creatie van meubilair wordt
ook beïnvloed door het idee van een
ontwerp dat zoekt naar een samenhang
en harmonie tussen het meubilair
en het gebouw waar het zal worden
ondergebracht.

2

Art Nouveau furniture
Art Nouveau Möbel
Mobilier Art Nouveau
Meubilair Art Nouveau

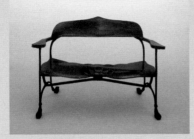

Antoni Gaudí workshop
Pew
Kirchenbank
Banc d'église
Kerkbank
1875
Museum of Modern Art,
New York

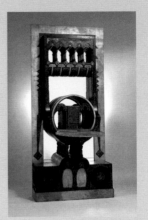

Carlo Bugatti
Desk
Sekretär
Bureau
Secretaire
c. 1895
Metropolitan Museum of Art,
New York

1870　　　**1875**　　　**1880**　　　**1885**　　　**1890**

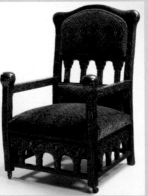

Louis Comfort Tiffany, Samuel Colman
Armchair
Lehnstuhl
Fauteuil
c. 1891-1892
Metropolitan Museum of Art, New York

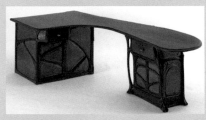

Hector Guimard
Desk
Schreibtisch
Secrétaire
Bureau
c. 1899
Museum of Modern Art, New York

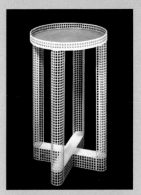

Josef Hoffmann
Flower table
Blumentisch
Table
Tafel Flower
1910
Victoria and Albert Museum, London

1895 **1900** **1905** **1910**

Henri Van de Velde
Desk and chair
Schreibtisch und Stuhl
Bureau et chaise
Bureau en stoel
1897-1898
Kunstgewerbemuseum, Staatliche Museen zu Berlin, Berlin

Charles Rennie Mackintosh
Chair
Stuhl
Chaise
Stoe
1897
Museum of Modern Art,
New York

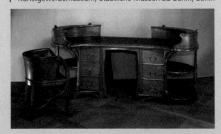

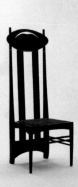

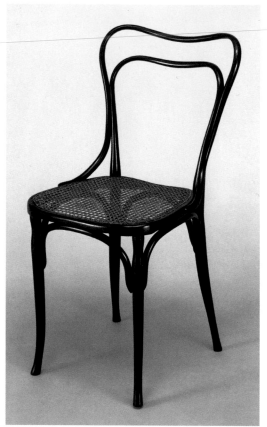

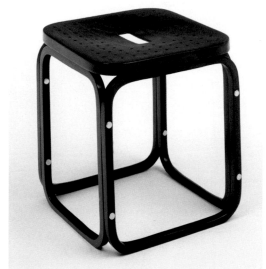

Adolph Loos
(Brno 1870 - Wien 1933)
Chair, wood
Stuhl, Holz
Chaise, bois
Stoel, hout
1899
86,4 x 44,3 x 51,9 cm / 34 x 17.4 x 20.4 in.
Museum of Modern Art, New York

Otto Wagner
(Penzing, Wien 1841 - Wien 1918)
Stool, wood and alluminium
Hocker, Holz und Aluminium
Tabouret, bois et aluminium
Kruk, hout en aluminium
1904
47 x 40,6 x 40,6 cm / 18.5 x 15.9 x 15.9 in.
Museum of Modern Art, New York

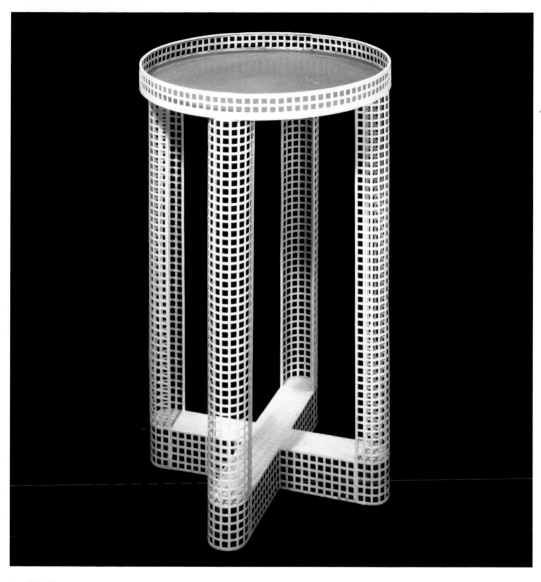

Josef Hoffmann
(Pirnitz 1870 - Wien 1956)
Flower table, zinc
Blumentisch, weißer Zink
Table, zinc émaillé blanc
Tafel Flower, wit zink
1910
ø 41 cm; h. 68 cm / 16.14 in.; 26.7 in.
Victoria and Albert Museum, London

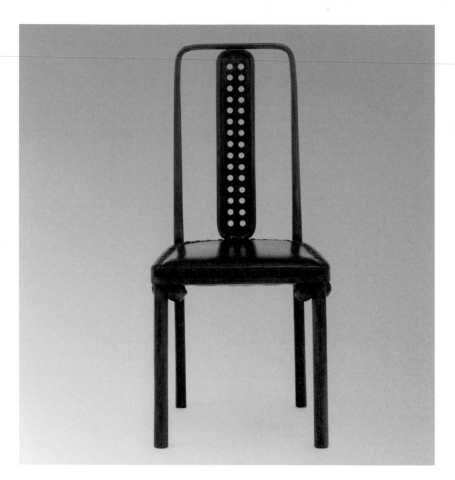

Josef Hoffmann
(Pirnitz 1870 - Wien 1956)
Puckersdorf chair, wood and upholstery
Stuhl Purkersdorf, Holz mit Verkleidung
Chaise Purkersdorf, bois et revêtement
Purkersdorf stoel, hout en bekleding
1906
99,1 x 44,5 x 41,9 cm / 39 x 17.5 x 16.4 in.
Museum of Modern Art, New York

▶ **Josef Hoffmann**
(Pirnitz 1870 - Wien 1956)
'Sitzmachine', armchair with reclining back, Model No.670, maple
'Sitzmaschine', Lehnstuhl mit verstellbarer Rückenlehne, Modell Nr. 670, Ahorn
'Sitzmaschine', fauteuil à dossier inclinable, modèle n° 670, hêtre plié et panneaux de sycomore
'Sitzmaschine', fauteuil met verstelbare rugleuning, model Nr. 670, esdoornhout
c. 1905
110,5 x 71,7 x 81,3 cm / 43.5 x 28,22 x 32 in.
Museum of Modern Art, New York

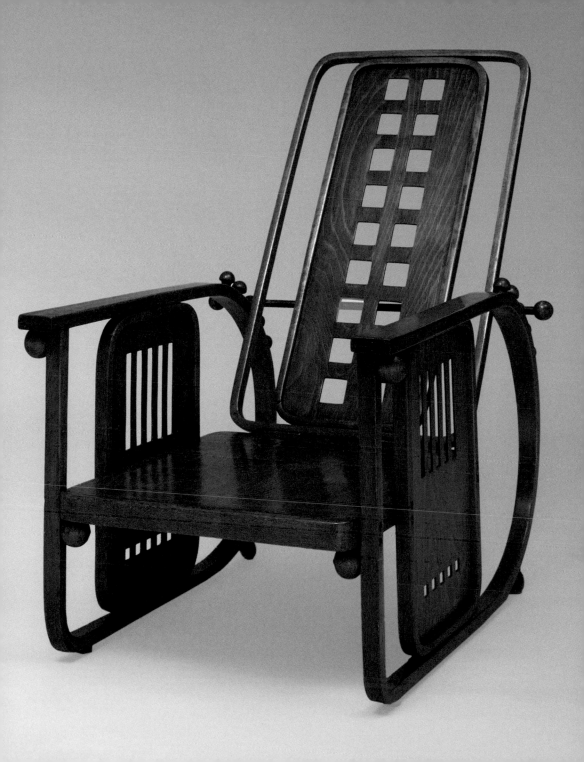

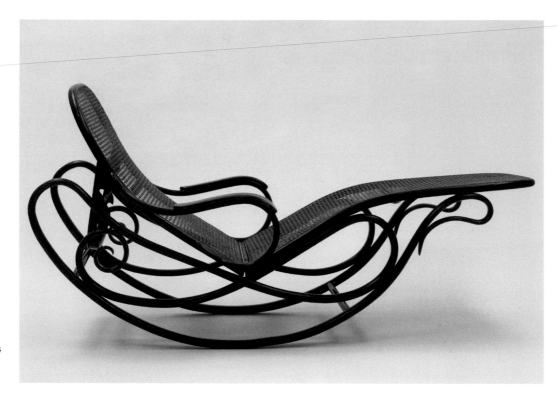

Gebrüder Thonet
Rocking chair with adjustable back, Model No. 7500, bentwood (beech) and bamboo
Schaukelstuhl mit verstellbarer Rückenlehne, Model Nr. 7500, Bugholz (Buche) und Bambus
Fauteuil à bascule à dossier réglable, modèle n° 7500, bois tourné (hêtre) et bambou
Schommelstoel met regelbare rugleuning, model Nr. 7500, gebogen (beuken) hout en bamboe
c. 1880
94 x 69,8 cm / 37 x 27.4 in.
Museum of Modern Art, New York

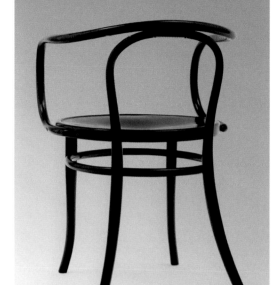

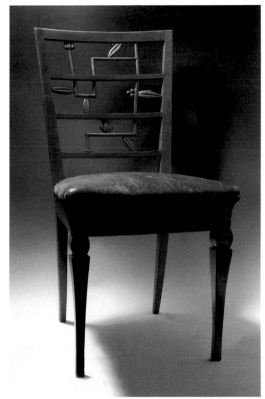

Gebrüder Thonet
Armchair Model No. 6009 later B9, beechwood
Lehnstuhl Modell Nr. 6009 und B9, Buche
Fauteuil modèle n° 6009, puis B9, hêtre
Fauteuil model Nr. 6009 later B9, beuken
c. 1904
72,7 x 53 x 55,7 cm / 28.6 x 20.8 x 21.9 in.
Museum of Modern Art, New York

Otto Prutscher
(Wien 1880 - 1949)
Chair, wood
Stuhl, Holz
Chaise, bois
Stoel, hout
c. 1920

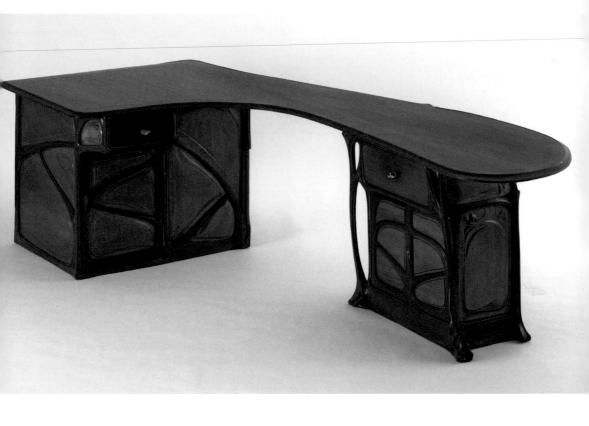

Hector Guimard
(Paris 1867 - New York 1942)
Desk, olive wood with ash panels
Schreibtisch, Olivenholz mit Brettern aus Esche
Secrétaire, bois d'olivier avec panneaux de frêne
Bureau, olijfhout met essenhouten panelen
c. 1899
73 x 256,5 x 21,3 cm / 28.7 x 100.9 x 8.3 in.
Museum of Modern Art, New York

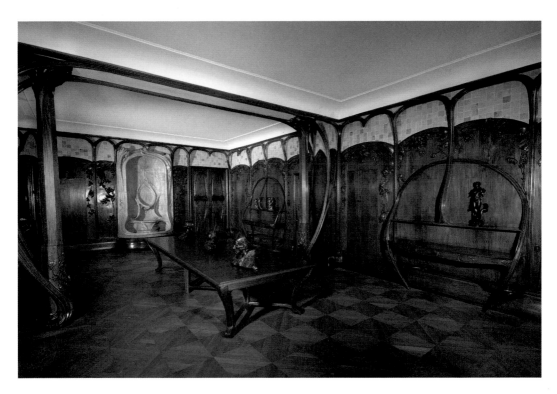

Alexandre-Louis-Marie Charpentier
(Paris 1856 - Neuilly-sur-Seine 1909)
Alexandre Bigot
(Mer 1862 - Paris 1927)
Dining room, mahogany, oak, poplar, gilt bronze, enamelled stoneware
Speisesaal, Mahagoni, Eiche, Pappel, Bronze vergoldet, Steingut lackiert
Salle à manger, acajou, chêne, peuplier, bronze doré, grès émaillé
Eetzaal, mahoniehout, eikenhout, populierhout, verguld brons, geëmailleerd grès
c. 1901
346 x 1055 x 621 cm / 136.2 x 415.3 x 244.4 in.
Musée d'Orsay, Paris

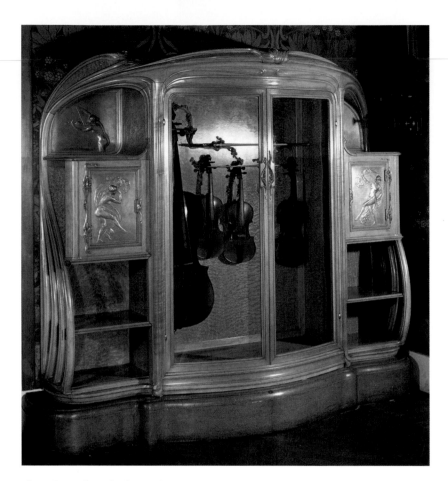

Alexandre-Louis-Marie Charpentier
(Paris 1856 - Neuilly-sur-Seine 1909)
Cupboard for string instruments, mahogany
Musikinstrumente Kasten, Mahagoni
Armoire à quatuor à cordes, bois de charme ciré, bronze doré
Kast voor muziekinstrumenten, mahoniehout
1901
200 x 235 x 64 cm / 78.7 x 92.5 x 25 x 1 in.
Musée des Arts Decoratifs, Paris

▶ **Gustav Serrurier-Bovy**
(Liège 1858 - 1910)
Cabinet-vetrine, red narra wood, ash, copper, glass and enamel
Schrank-Vitrine, Rotes meranti, Esche, Kupfer, Email, Glas
Petit meuble vitrine, bois de narra rouge, frêne, cuivre, émail, verre
Glaskabinet, rood narrahout, essenhout, koper, emaille, glas
1899
248,9 x 213,4 x 63,5 cm / 97,9 x 84 x 24.9 in.
Metropolitan Museum of Art, New York

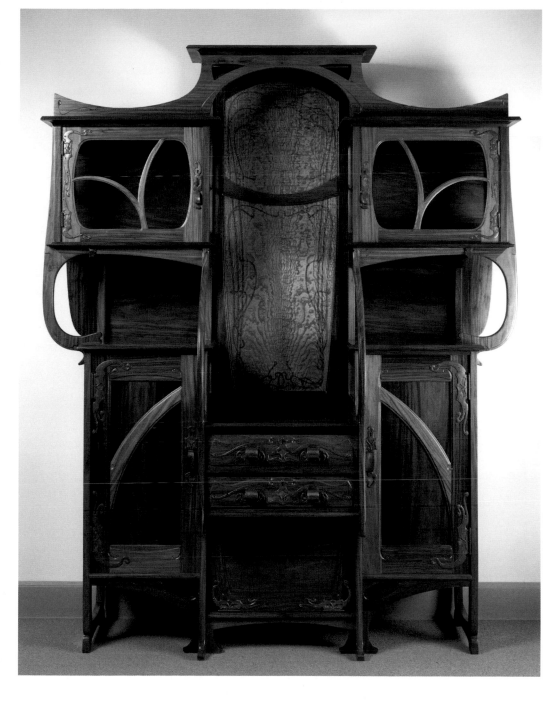

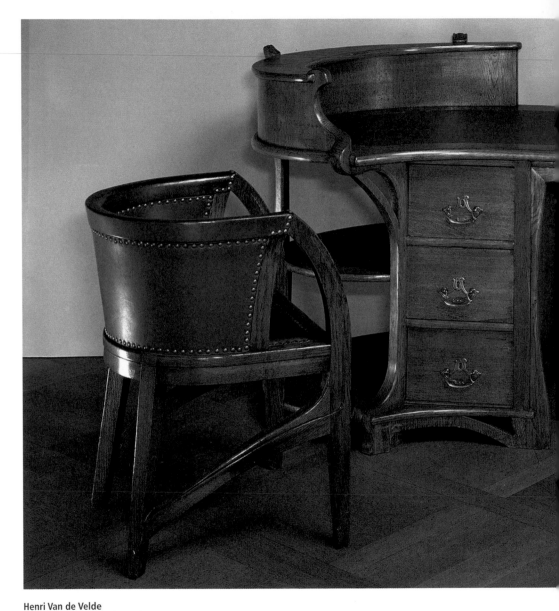

Henri Van de Velde
(Antwerpen 1863 - Zürich 1957)
Desk and chair
Schreibtisch und Stuhl
Bureau et chaise
Bureau en stoel
1897-1898
Kunstgewerbemuseum, Staatliche Museen zu Berlin, Berlin

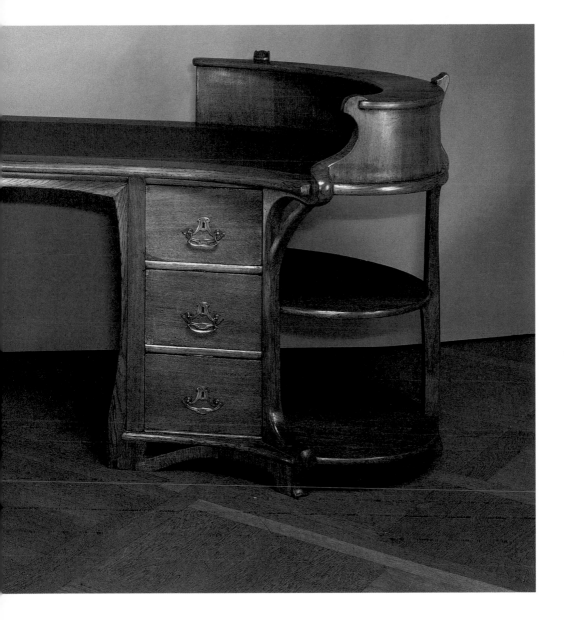

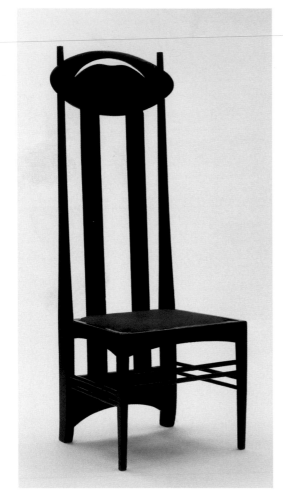

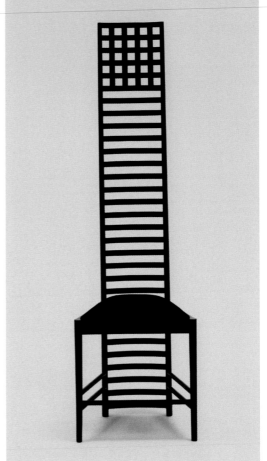

Charles Rennie Mackintosh
(Glasgow 1868 - London 1928)
Chair, oak
Stuhl, Eiche
Chaise, chêne et soie
Stoel, eikenhout
1897
138,1 x 50,8 x 45,7 cm / 54.3 x 19.9 x 17.9 in.
Museum of Modern Art, New York

Charles Rennie Mackintosh
(Glasgow 1868 - London 1928)
Ladderback chair, wood
Stuhl 'Ladderback', Holz
Chaise 'Ladderback', bois
'Ladderback' stoel, hout
1902
140,4 x 40,7 x 34,3 cm / 55.2 x 16 x 13.5 in.
Museum of Modern Art, New York

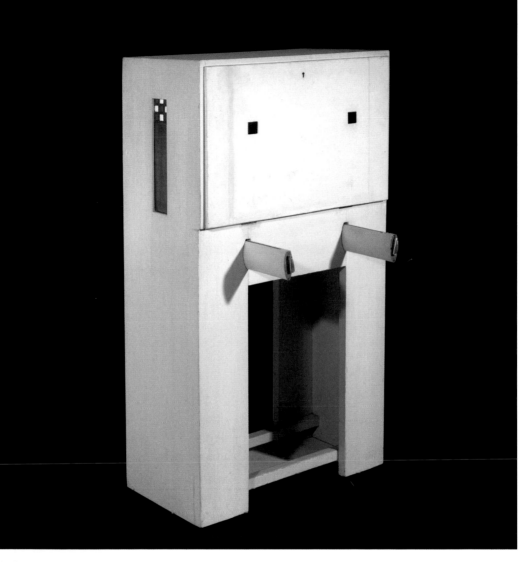

Charles Rennie Mackintosh
(Glasgow 1868 - London 1928)
Desk, white painted wood
Klappsekretär, Holz, weiß lackiert
Secrétaire à abattant, bois laqué blanc
Secretaire à abattant, wit gelakt hout
1904
121 cm / 47.9 in.
Musée d'Orsay, Paris

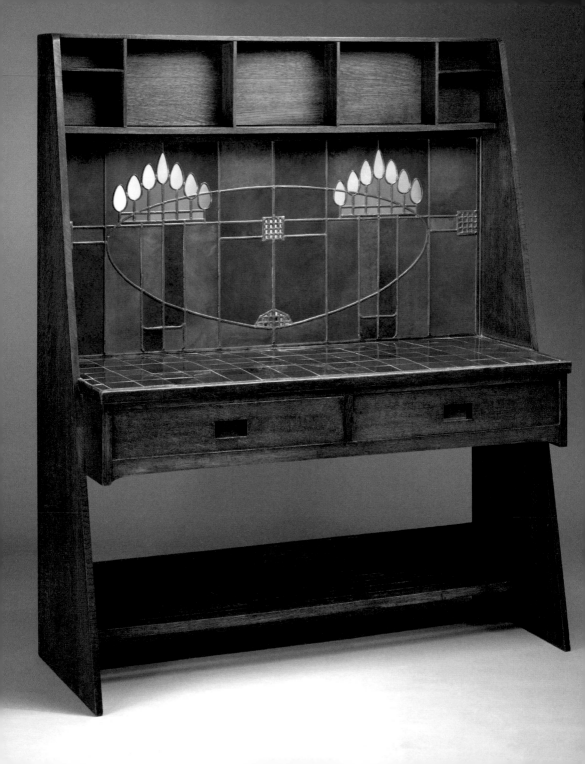

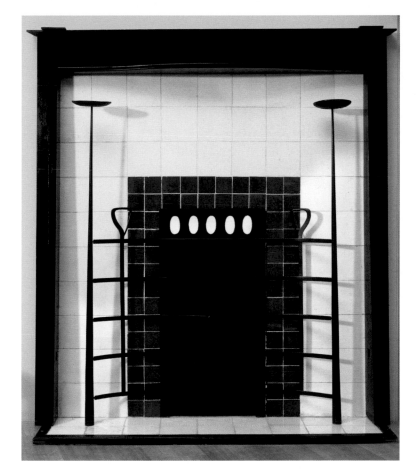

Charles Rennie Mackintosh
(Glasgow 1868 - London 1928)
Fireplace from the Willow Tea-rooms, iron, ceramic
Feuerstelle der Willow Tearooms, Eisen, Keramik
Cheminée des salons de thé Willow, fer, céramique
Open haard uit de Willow Tearooms, ijzer, keramiek
1904
173,5 x 163 x 41 cm / 68.3 x 64.1 x 16.1 in.
Victoria and Albert Museum, London

◀ **Charles Rennie Mackintosh**
(Glasgow 1868 - London 1928)
Washstand, oak, ceramic tiles, coloured and mirror glass, lead
Waschtisch, Eiche, gefärbte und spiegelverglaste Keramikziegel, blei
Lavabo, chêne, carreaux de céramique, verre coloré et miroirs, plomb
Wastafel, eikenhout, tegels van gekleurd keramiek en spiegelglas, lood
1904
160,7 x 130,2 x 51,8 cm / 63.2 x 51.2 x 20.3 in.
Metropolitan Museum of Art, New York

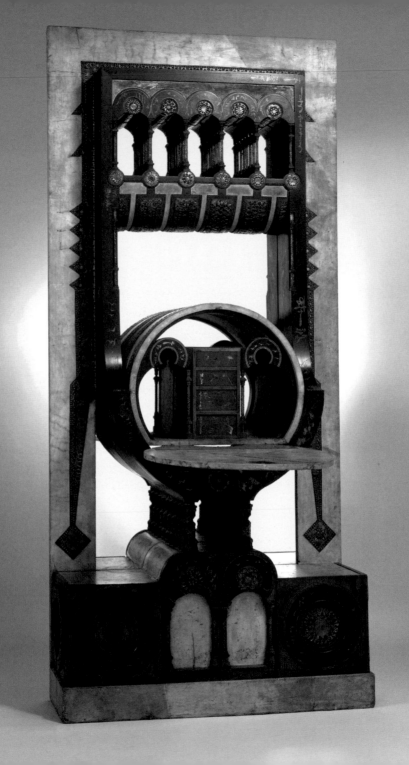

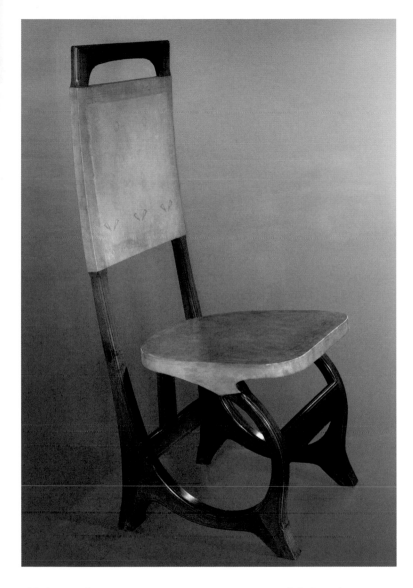

◀ **Carlo Bugatti**
(Milano 1855 - Molsheim 1940)
Desk, walnut, pewter, copper, vellum, and mirror
Sekretär, Nuss, Zinn, Kupfer, Pergament und Spiegel aus Glas
Bureau, noyer, étain, cuivre, parchemin et miroir
Secretaire, notenhout, tin, koper, perkament en spiegelglas
c. 1895
223,5 x 100,3 x 31,1 cm / 87.9 x 39.4 x 12.2 in.
Metropolitan Museum of Art, New York

Carlo Bugatti
(Milano 1855 - Molsheim 1940)
Chair, wood covered with parchment
Stuhl, Acajou Pergament
Chaise, acajou et parchemin
Stoel, acajou pergament
c. 1903-1904
114 x 453 x 5 cm / 44.8 x 17.8 x 1.9 in.
Musée d'Orsay, Paris

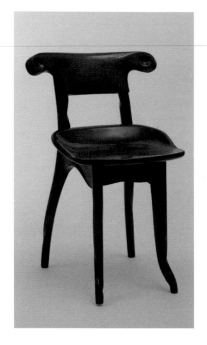

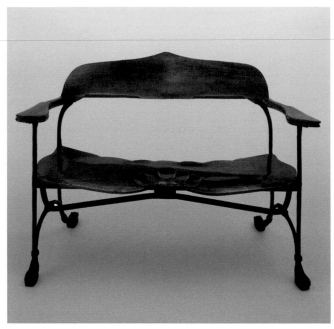

Antoni Gaudí (Reus 1852 - Barcelona 1926)
Chair, oak
Stuhl, Eiche
Chaise, chêne
Stoel, eikenhout
1875
75,2 x 52,7 x 38,7 cm / 29.6 x 20.7 x 15.2 in.
Museum of Modern Art, New York

Antoni Gaudí (Reus 1852 - Barcelona 1926)
Pew, wood and brass
Kirchenbank, Holz und Messing
Banc d'église, chêne et fer forgé
Kerkbank, hout en messing
1875
73 x 101,6 x 101,6 cm / 28.7 x 39.9 x 39.9 in.
Museum of Modern Art, New York

▶ **Louis Comfort Tiffany**
(New York 1848 - 1933)
Samuel Colman
(Portland 1832 - 1920)
Armchair, oak and silk
Lehnstuhl, Eiche, Seide
Fauteuil, chêne et soie
Fauteuil, eikenhout, zijde
c. 1891-1892
114,3 x 71,1 x 64,8 cm / 44.9 x 27.9 x 25.5 in.
Metropolitan Museum of Art, New York

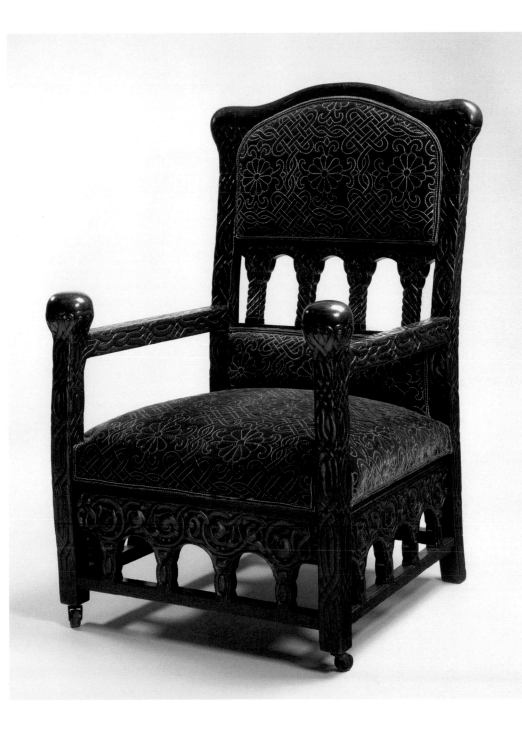

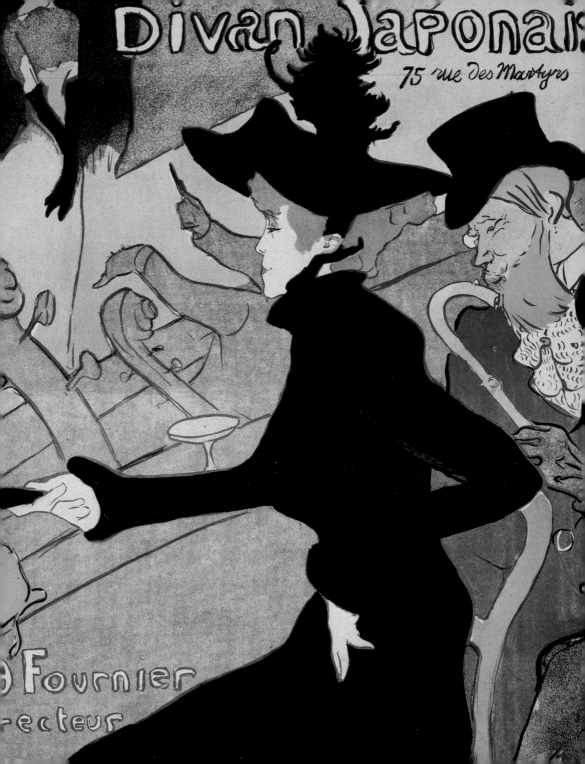

Prints, drawings, illustrations

Illustration, like prints and drawings, are one of the most exciting chapters of modernism. Advertising posters, books and periodicals, affiches of every kind, were enlivened by figures in the new style, sophisticated and exuberant, either swiftly and spontaneously executed or conceived in the spirit of elegant decadence.

Kunstdrucke, Grafik, Illustration

Eines der leidenschaftlichsten Kapitel des Modernismus bilden Illustration, Kunstdruck und Grafik. Werbeplakate, Buch- und Zeitschriftenillustrationen sowie die unterschiedlichsten Affiches werden mit Gestalten belebt, die im neuen Stil gezeichnet sind, jedesmal fließend mit Raffinesse und Frische, spontan und rasch in der Ausführung, oder mit dem Geist eleganter Dekadenz.

3

Imprimés, arts graphiques, illustration

L'illustration - par l'estampe et le graphisme - constitue l'un des domaines les plus féconds du modernisme. Publicités, illustrations de livres et de revues, affiches en tout genre se peuplent et s'animent de personnages et de figures traités dans le style nouveau, toujours décliné avec autant de fraîcheur que de raffinement, dans une grande spontanéité d'exécution, ou bien dans l'esprit d'un élégant décadentisme.

Prenten, grafische kunst, illustraties

De illustratie, zoals de prent en de grafische vormgeving, vertegenwoordigt één van van de meest fervente episodes van het modernisme. Pamfletten, boek- en tijdschriftillustraties en affiches met verschillende onderwerpen, verlevendigd met volgens de nieuwe stijl ontworpen figuren, steeds weer afwijkend door verfijndheid en frisheid, door spontaniteit en snelheid van uitvoering, of door decadente elegantie.

I. Jahrg. Heft I.

Einzelpreis 2 Kronen.

UER·SACRUM

ORGAN·DER
UEREINIGUNG
BILDENDER
KUENSTLER
ÖSTERREICHS·

JANUAR
·1898·

·JAEHRLICH·12·HEFTE
IM·ABONNEMENT·6Fi=10M·

Verlag Gerlach & Schenk, Wien, VI/1.

Alle Rechte vorbehalten.

Alfred Roller
(Brünn 1864 - Wien 1935)
Cover of the first issue of the magazine *Ver Sacrum*, lithograph
Titelseite der 1. Ausgabe der Zeitschrift *Ver Sacrum*, Lithographie
Couverture du n° 1 de la revue *Ver Sacrum*, lithographie
Omslag van het eerste nummer van het tijdschrift *Ver Sacrum*, lithografie
1898

GUSTAV KLIMT OM
„MUSIK"

Gustav Klimt
(Baumgarten, Wien 1862 - Wien 1918)
Music, illustration for the magazine *Ver Sacrum*, lithograph
Musik, Abbildung für die Zeitschrift *Ver Sacrum*, Lithographie
La Musique, illustration pour la revue *Ver Sacrum*, lithographie
Muziek, illustratie voor het tijdschrift *Ver Sacrum*, lithografie
1901
25 x 23,2 cm / 9.8 x 9.1 in.
Christian Brandstaetter Collection, Wien

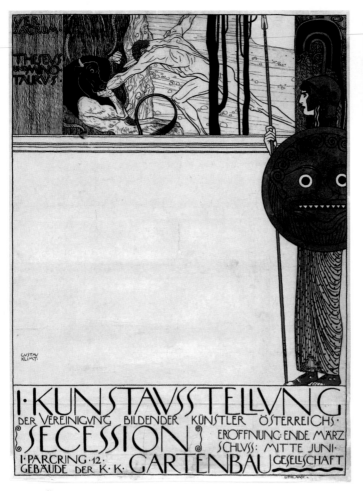

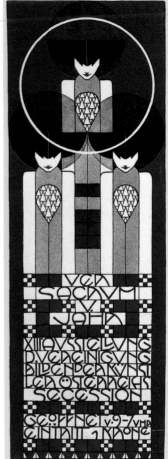

Gustav Klimt
(Baumgarten, Wien 1862 - Wien 1918)
Poster for the first exhibition of the Viennese Secession, lithograph
Poster für die erste Ausstellung der Wiener Sezession, Lithographie
Affiche pour la première exposition de la Sécession viennoise, lithographie
Poster voor de Eerste tentoonstelling van de Weense Secessie, lithografie
1898
9,5 x 68,6 cm / 3.7 x 27 in.
Museum of Modern Art, New York

Koloman Moser
(Wien 1868 - 1918)
Poster for the 13th exhibition of the Viennese Secession, lithograph
Plakat für die 13e. Ausstellung der Wiener Sezession, Lithographie
Affiche pour la 13e exposition de la Sécession viennoise, lithographie
Pamflet voor de dertiende tentoonstelling van de Weense Secessie, lithografie
1902

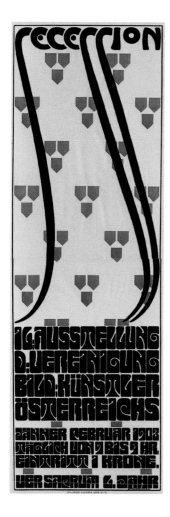

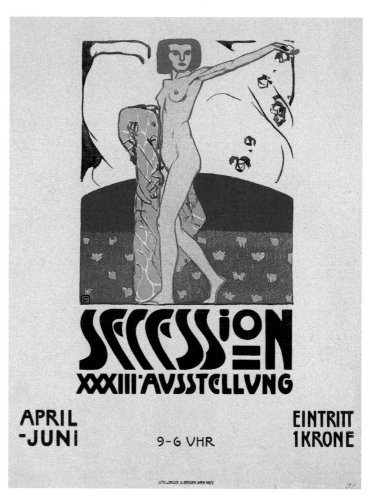

Alfred Roller
(Brünn 1864 - Wien 1935)
Poster for the 16th exhibition of the Viennese Secession, lithograph
Poster für die 16. Ausstellung der Wiener Sezession, Lithographie
Affiche pour la 16e exposition de la Sécession viennoise, lithographie
Poster voor de zestiende tentoonstelling van de Weense Secessie, lithografie
January-February 1903

Otto Friedrich
(Györ, Ungary 1862 - Wien 1937)
Poster for the 33th exhibition of the Viennese Secession, lithograph
Poster für die 33. Ausstellung der Wiener Sezession, Lithographie
Affiche pour la 33e exposition de la Sécession viennoise, lithographie
Poster voor de drie-en-dertigste tentoonstelling van de Weense Secessie, lithografie
April-June 1909

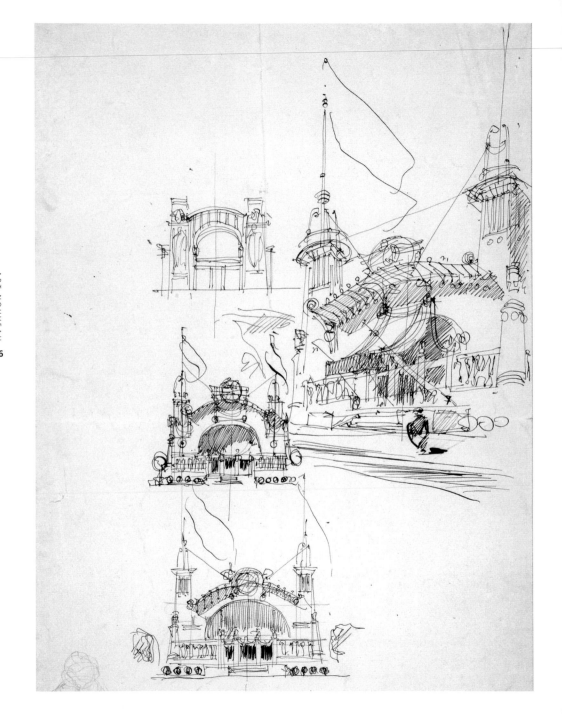

Joseph Maria Olbrich
(Troppau 1867 - Düsseldorf 1908)
Poster for the first exhibition of the Viennese
Secession, lithograph
Poster für die erste Ausstellung der Wiener
Sezession, Lithographie
Affiche pour la première exposition de la
Sécession viennoise, lithographie
Poster voor de Eerste tentoonstelling van de
Weense Secessie, lithografie
1898
57,8 x 50,9 cm / 22.7 x 20 in.
Museum of Modern Art, New York

◀ **Joseph Maria Olbrich**
(Troppau 1867 - Düsseldorf 1908)
Study with three sketches of the Jubilee
Pavilion of the City of Wien, ink on paper
Studie mit drei Skizzen für den
Jubiläumspavillon der Stadt Wien, Tinte auf
Papier
Étude avec trois esquisses pour le Pavillon du
Jubilé de la ville de Vienne, encre sur papier
Studie met drie schetsen van het Jubileum
Paviljoen van de stad Wenen, inkt op papier
1897
33 x 19,6 cm / 12 x 7 in.
Kunstbibliothek, Staatliche Museen zu Berlin,
Berlin

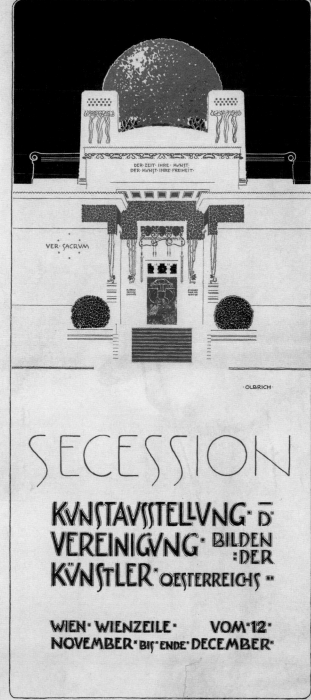

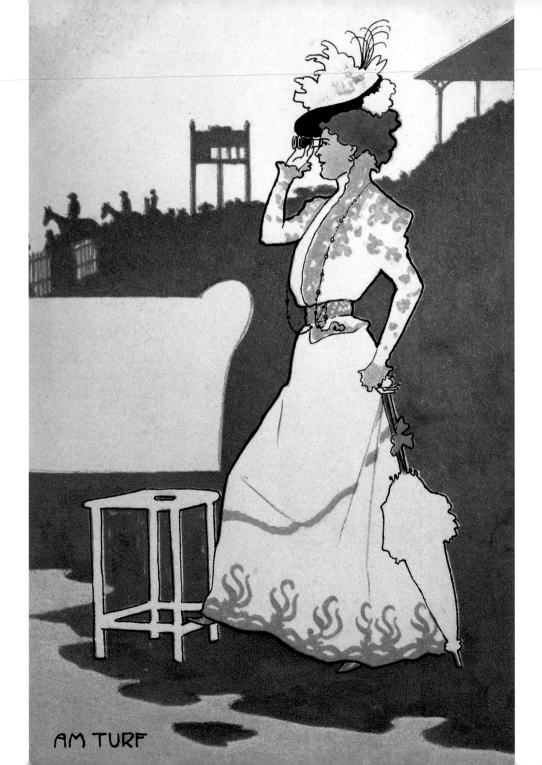

AM TURF

Egon Schiele
(Tulln 1890 - Wien 1918)
Portrait of a Woman With Large Hat, postcard of the Wiener Werkstätte (Nr. 289)
Portrait einer Frau mit großem Hut, Postkarte der Wiener Werkstätten (Nr. 289)
Portrait de femme au grand chapeau, carte postale des Wiener Werkstätte, (n° 289)
Portret van een vrouw met grote hoed, Ansichtkaart van de Wiener Werkstätte (Nr. 289)
1910

Maria Likarz
(Przemyśl 1893 - 1971)
Hats, postcard of the Wiener Werkstätte (Nr. 772)
Hüte, Postkarte der Wiener Werkstätten (Nr. 772)
Chapeaux, carte postale des Wiener Werkstätte (n° 772)
Hoeden, Ansichtkaart van de Wiener Werkstätte (Nr. 772)

◀ *At the horseraces*, postcard from the series *The Viennes*, lithograph
Beim Pferderennen, Postkarte aus der Serie *Die Wienerin*, Lithographie
Aux courses de chevaux, carte postale de la série *La Viennoise*, lithographie
Op de renbaan, ansichtkaart uit de serie *De inwoners van Wenen*, lithografie
c. 1905

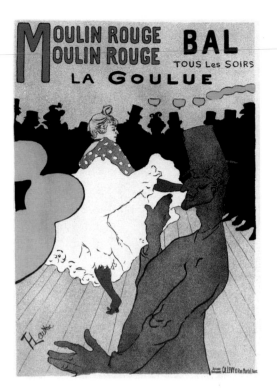

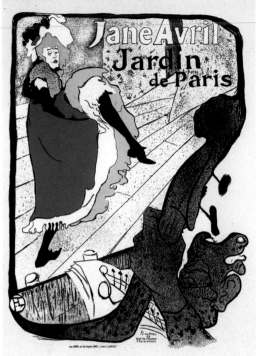

Henri de Toulouse-Lautrec
(Albi 1864 - Malromé 1901)
Moulin Rouge - La Goulue
Lithograph
Lithographie
Lithografie
1891
167 x 115 cm / 65.7 x 45.2 in.
Public Library, New York

Henri de Toulouse-Lautrec
(Albi 1864 - Malromé 1901)
Jane Avril - Jardin de Paris
Lithograph
Lithographie
Lithografie
1893
Public Library, New York

▌ *"I paint things as they are. I don't comment."*
▌ *"Ich male die Dinge wie sie sind. Ich kommentiere nicht."*
▌ *"Je peins les choses comme elles sont. Je ne fais pas de commentaires."*
▌ *"Ik schilder de dingen zoals ze zijn. Ik merk niets op."*
Henri de Toulouse-Lautrec

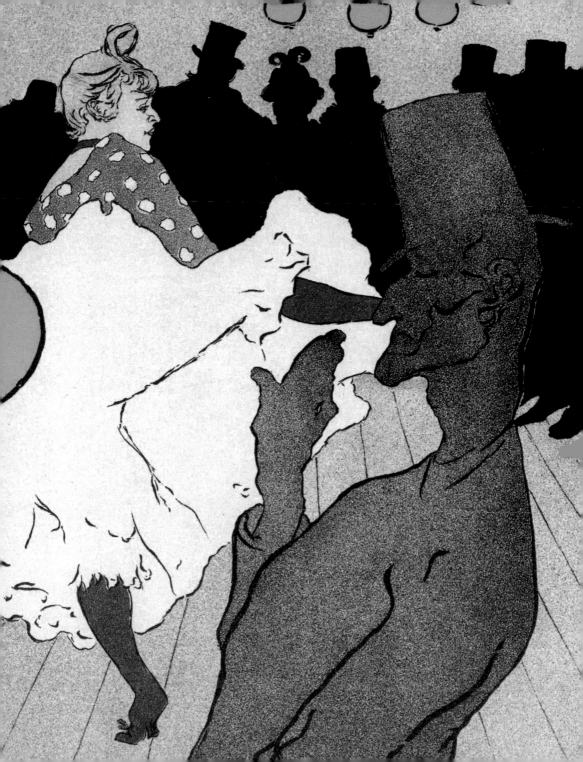

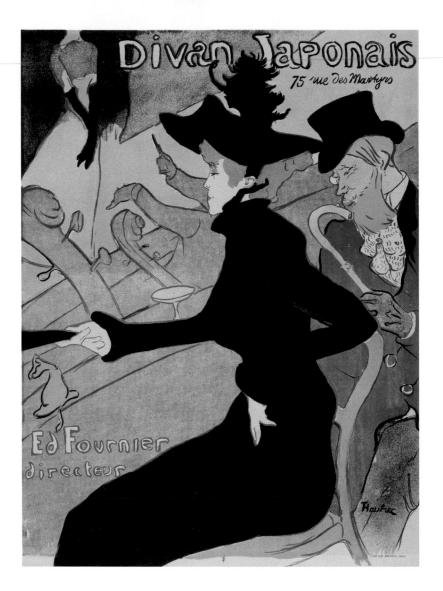

Henri de Toulouse-Lautrec
(Albi 1864 - Malromé 1901)
Divan Japonais
Lithograph
Lithographie
Lithografie
1893
80,3 x 60,7 cm / 31.6 x 23.8 in.
Museum of Modern Art, New York

▶ **Henri de Toulouse-Lautrec**
(Albi 1864 - Malromé 1901)
La Revue Blanche
Lithograph
Lithographie
Lithografie
1895
125,5 x 91,2 cm / 49.4 x 35.9 in.
Museum of Modern Art, New York

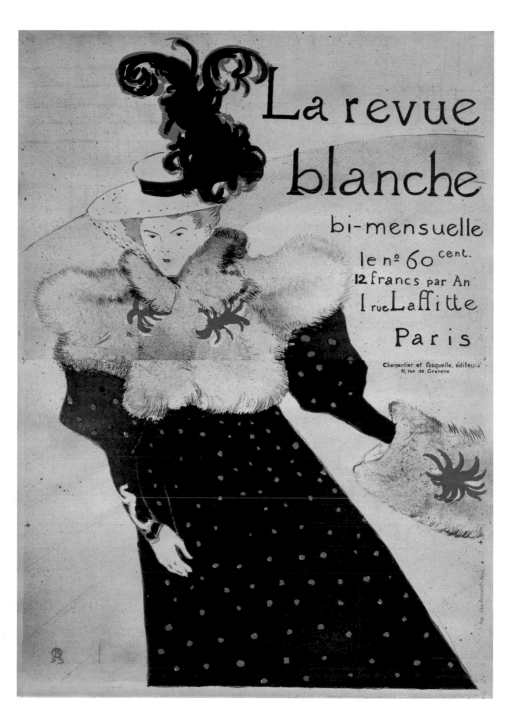

TOUS LES SOIRS à 10 HEURES à LA
COMÉDIE PARISIENNE
RUE BOUDREAU (RUE AUBER - près L'OPÉRA)

La Loïe Fuller

DANS SA CRÉATION NOUVELLE

SALOMÉ

de FEURÉ

IMP. P. LEMÉNIL ASNIÈRES (Seine)

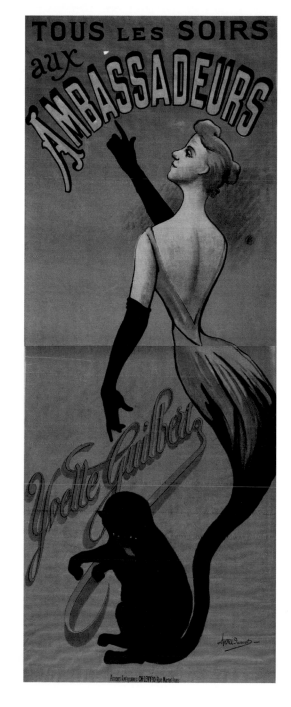

Henri Dumont
(France 1859-1921)
Tous les Soirs aux Ambassadeurs, Yvette Guilbert
Lithograph
Lithographie
Lithografie
1900
208,28 x 81,28 cm / 81.9 x 31.9 in.
Museum of Modern Art, New York

◀ **Georges De Feure**
(Paris 1868 - 1928)
*Comédie Parisienne, La Loïe Fuller, Dans Sa Création
Nouvelle, Salomé*
Lithograph
Lithographie
Lithografie
1900
129,5 x 92,7 cm / 50.9 x 36.4 in.
Museum of Modern Art, New York

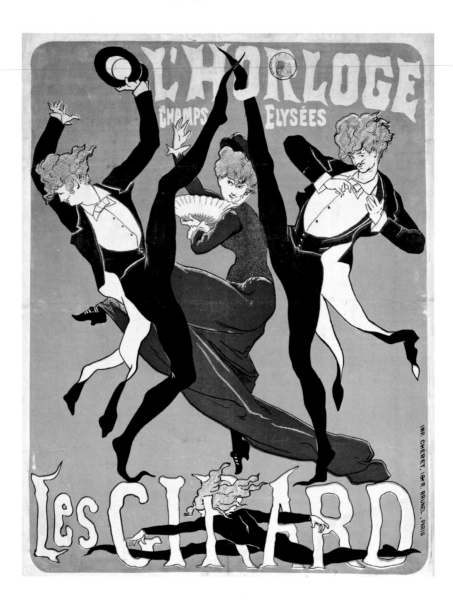

Jules Chéret
(Paris 1836 - Nice 1932)
L'Horloge Champs Elysées, Les Girard
Lithograph
Lithographie
Lithografie
1879
57,4 x 43,1 cm / 22.5 x 16.9 in.
Museum of Modern Art, New York

▶ **Jules Chéret**
(Paris 1836 - Nice 1932)
Folies-Bergère, L'Arc en Ciel, Ballet Pantomine en Trois Tableaux
Lithograph
Lithographie
Lithografie
1893
123,9 x 86,7 cm / 48.7 x 34.1 in.
Museum of Modern Art, New York

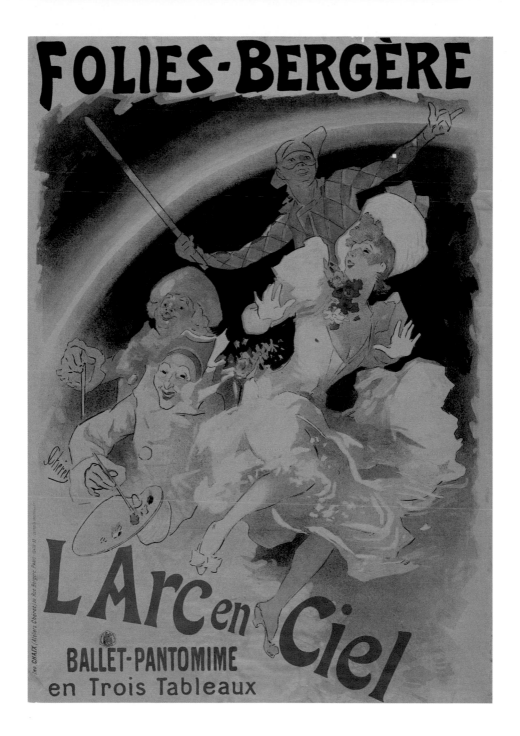

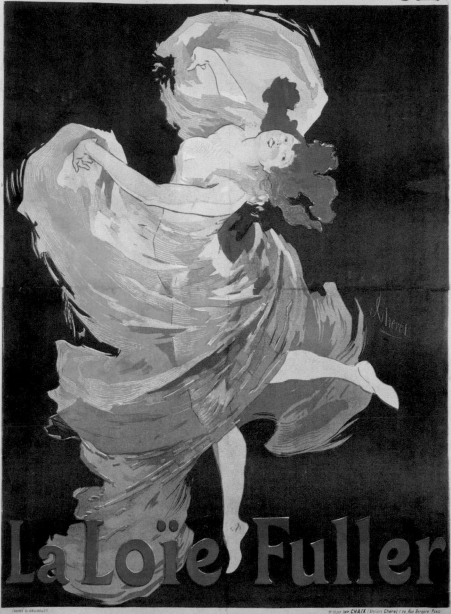

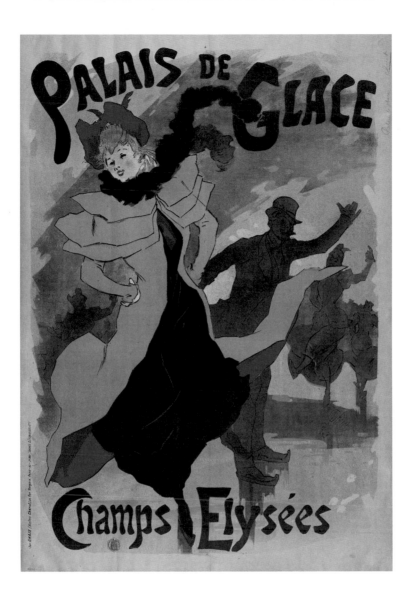

◀ **Jules Chéret**
(Paris 1836 - Nice 1932)
Folies-Bergère, La Loïe Fuller
Lithograph
Lithographie
Lithografie
1893
123,8 x 87 cm / 48.7 x 34.2 in.
Victoria and Albert Museum, London

Jules Chéret
(Paris 1836 - Nice 1932)
Palais de Glace, Champs Élysées
Lithograph
Lithographie
Lithografie
1900
246,4 x 87 cm / 97 x 34.2 in.
Museum of Modern Art, New York

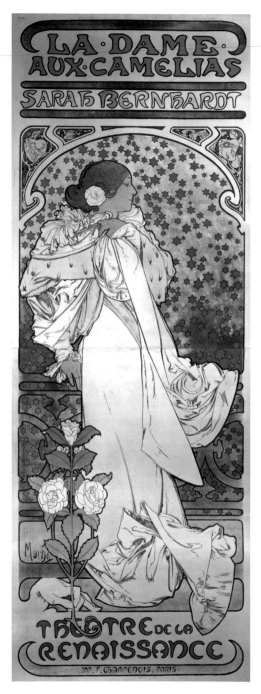

Alphonse Mucha
(Ivančice 1860 - Praha 1939)
La Dame aux Camélias
Lithograph
Lithographie
Lithografie
1896
208 x 75 cm / 81.8 x 29.5 in.
Musée des Arts décoratifs, département de la Publicité, Paris

▶ **Alphonse Mucha**
(Ivančice 1860 - Praha 1939)
The West End Review
Lithograph
Lithographie
Lithografie
1898
307 x 218 cm / 120.8 x 85.8 in.

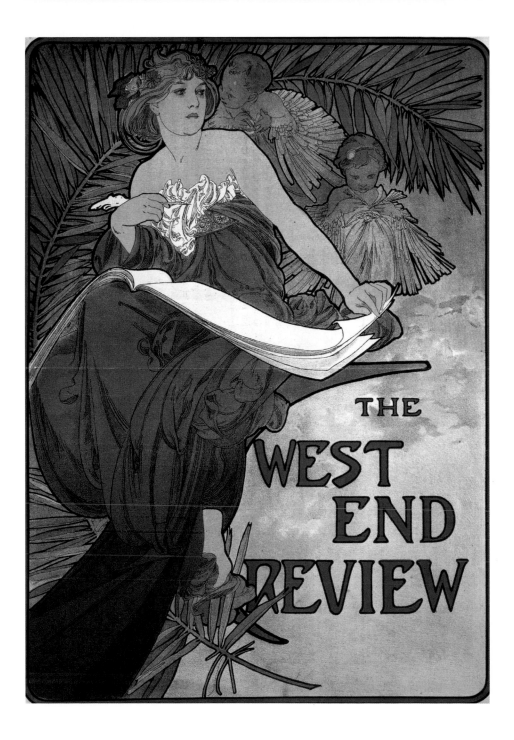

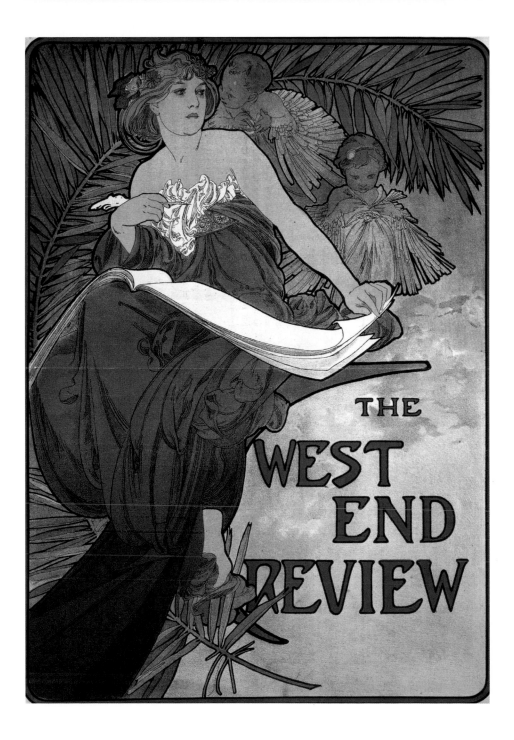

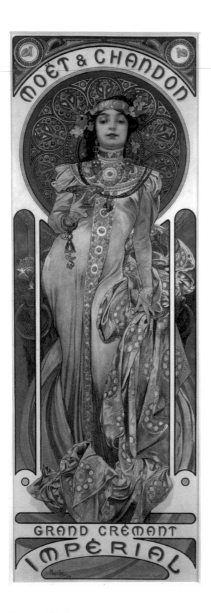

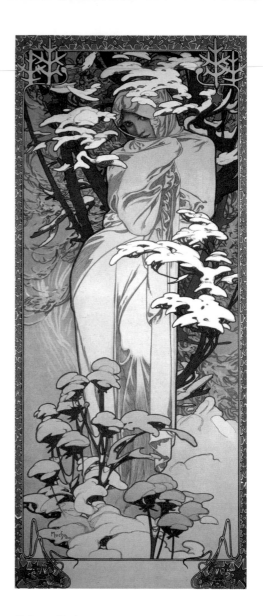

Alphonse Mucha
(Ivančice 1860 - Praha 1939)
Moët & Chandon Grand Crémant Impérial
Lithograph
Lithographie
Lithografie
1899
60 x 20 cm / 23.6 x 7.8 in.

Alphonse Mucha
(Ivančice 1860 - Praha 1939)
The seasons: winter, lithograph
Die Jahreszeiten: Der Winter, Lithographie
Les saisons : l'hiver, lithographie
De seizoenen: De winter, lithografie
1900
73 x 32 cm / 28.7 x 12.5 in.

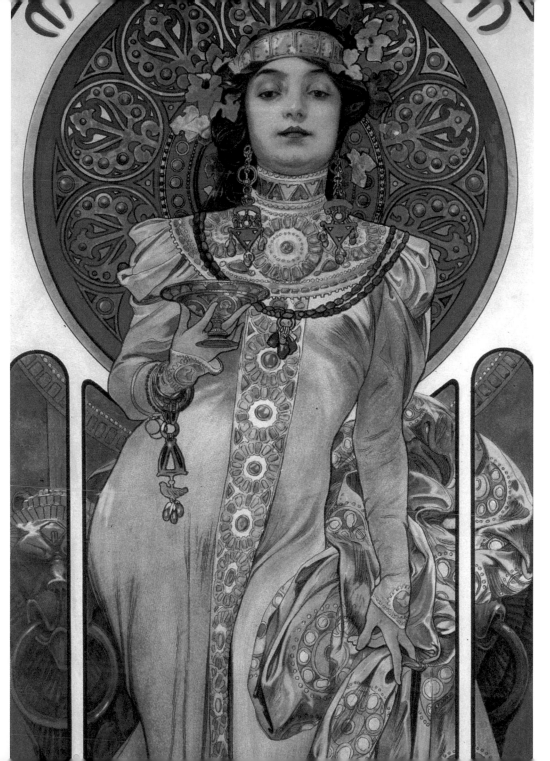

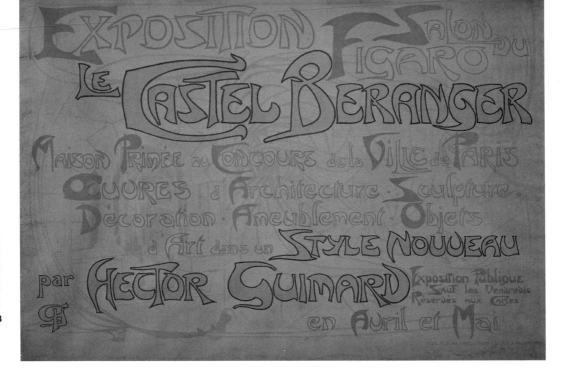

Hector Guimard
(Paris 1867 - New York 1942)
Salon du Figaro, Le Castel Beranger
Lithograph
Lithographie
Lithografie
1900
88,9 x 125 cm / 34.9 x 49.2 in.
Museum of Modern Art, New York

▶ **Eugène Grasset**
(Schweiz 1845 - Sceaux 1917)
Encre L. Marquet, La meilleure de toutes les encres
Lithograph
Lithographie
Lithografie
1892
121,8 x 80,8 cm / 47.9 x 31.8 in.
Museum of Modern Art, New York

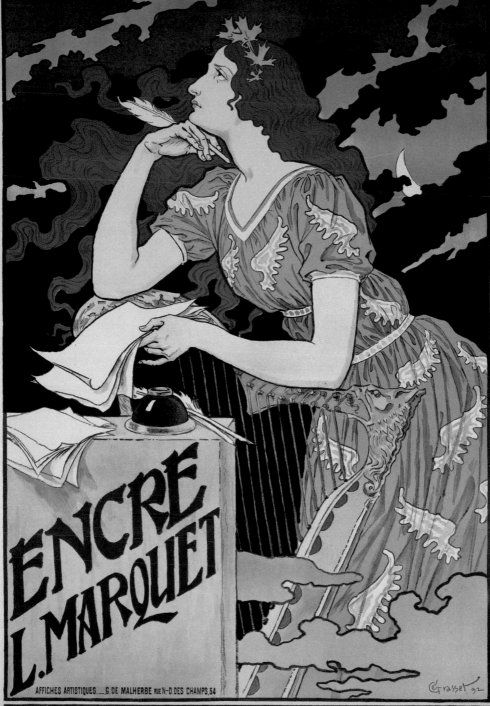

ENCRE
L. MARQUET

AFFICHES ARTISTIQUES.—G. DE MALHERBE RUE N-D DES CHAMPS, 54

LA MEILLEURE DE TOUTES LES ENCRES

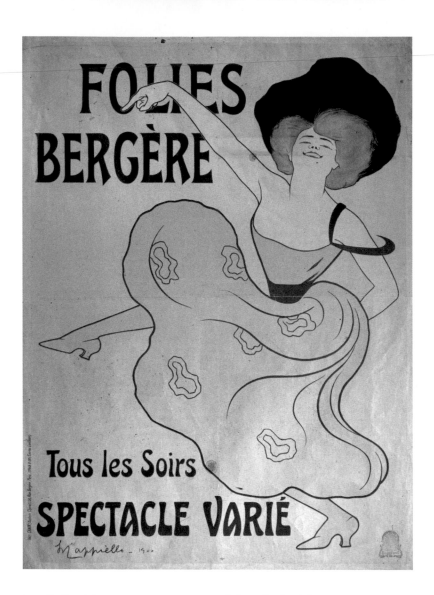

Leonetto Cappiello
(Livorno 1875 - Cannes 1942)
Folies Bergère, Tous les soirs spectacle varié
Lithograph
Lithographie
Lithografie
1900
130 x 95 cm / 51.1 x 37.4 in.
Musée des Arts décoratifs, département Publicité,
Paris

▶ **Leonetto Cappiello**
(Livorno 1875 - Cannes 1942)
Pilules Pink
Lithograph
Lithographie
Lithografie
1910
200 x 129 cm / 78.7 x 50.7 in.
Musée des Arts décoratifs, département Publicité,
Paris

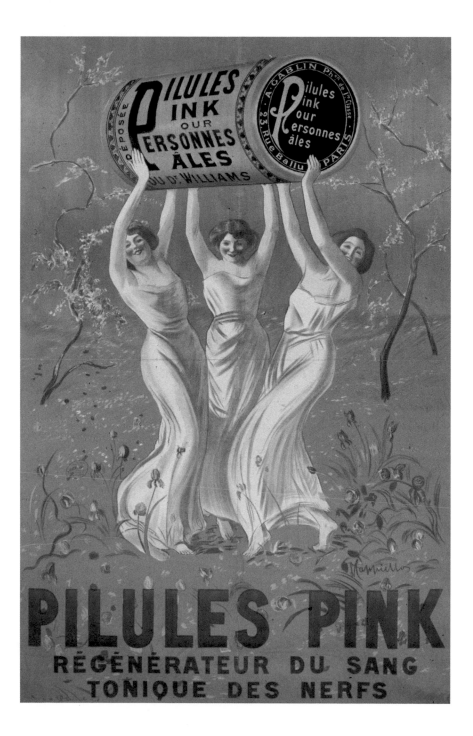

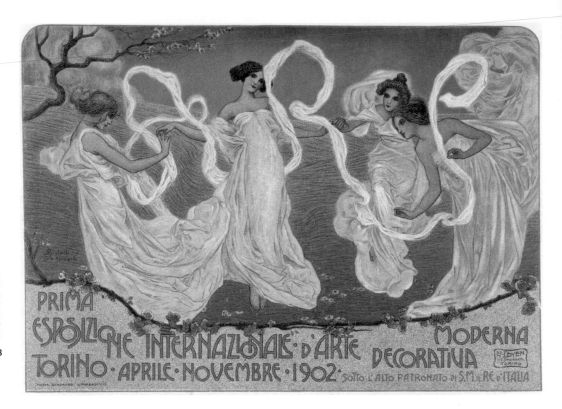

Leonardo Bistolfi
(Casale Monferrato 1859 - Torino 1933)
Poster designed for the First International Exhibition of Modern Decorative Art, Turin
Plakat, entworfen für die erste Internationale Ausstellung der Modernen Bildenden Künste in Turin
Affiche pour la première Exposition internationale d'Art décoratif moderne, Turin
Pamflet ontworpen voor de Eerste Internationale Expositie van Moderne Decoratieve Kunst, Turijn
1902
Victoria and Albert Museum, London

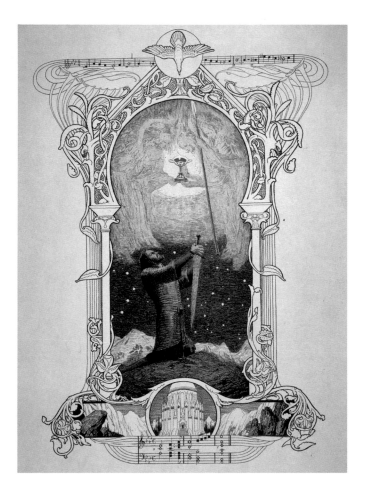

Franz Stassen
(Hanau 1869 - Berlin 1849)
The libretto *Parsifal: A knight bowing down before the Holy Grail*
Titelblatt des *Parsifal: Ritter, kniend vor dem Heiligen Gral*
Livret de *Parsifal : Un chevalier agenouillé devant le Saint-Graal*
Het libretto *Parsifal: Een ridder knielend voor de Heilige Graal*
1901
British Library, London

Carlos Schwabe
(Altona, Holstein 1877 - Avon 1926)
Salon Rose Croix
Lithograph
Lithographie
Lithografie
1892
198 x 80,5 cm / 77.9 x 31.6 in.
Museum of Modern Art, New York

▶ **Peter Behrens**
(Hamburg 1868 - Berlin 1940)
A.E.G. - Metallfadenlampe
Lithograph
Lithographie
Lithografie
1907
69,2 x 52,7 cm / 27.2 x 20.7 in.
Museum of Modern Art, New York

ALLGEMEINE ELEKTRICITÆTS GESELLSCHAFT

A·E·G·METALLFADENLAMPE

ZIRKA EIN WATT PRO KERZE

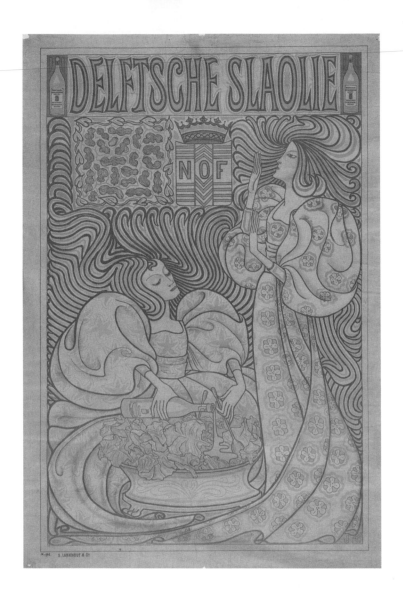

Jan Toorop
(Purworejo 1858 - Den Haag 1928)
Delftsche Slaolie
Lithograph
Lithographie
Lithografie
1894
91,44 x 60,96 cm / 36 x 2.4 in.
Museum of Modern Art, New York

▶ **Jan Toorop**
(Purworejo 1858 - Den Haag 1928)
Het Hoogeland Beekbergen
Lithograph
Lithographie
Lithografie
1896
93,5 x 68,5 cm / 36.8 x 26.9 in.
Museum of Modern Art, New York

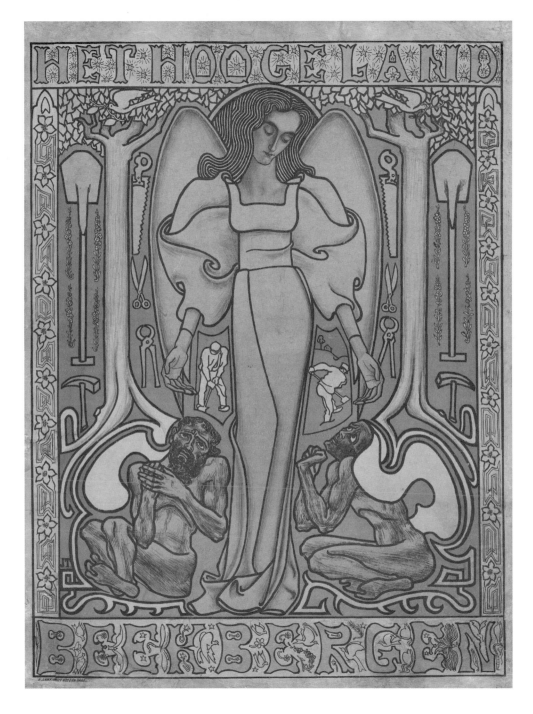

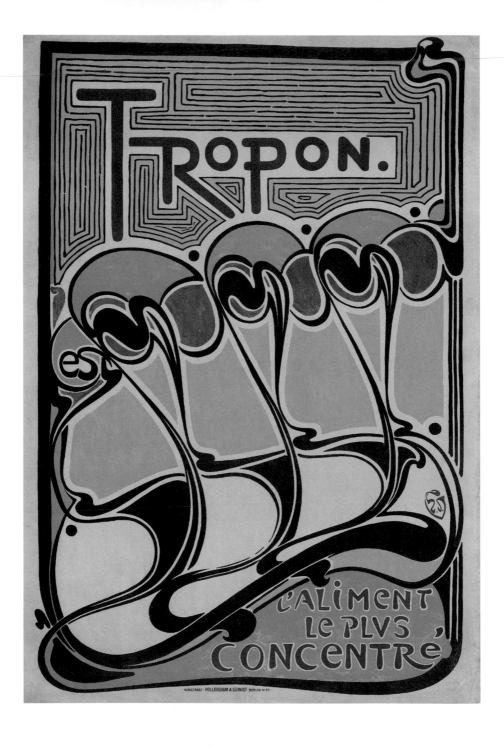

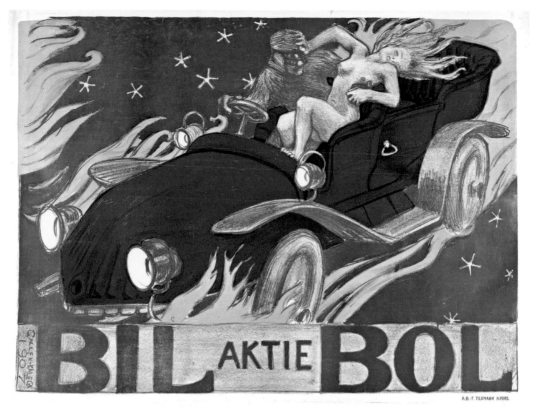

Akseli Gallen-Kallela
(Pori 1865 - Stockholm 1931)
Bil aktie Bol
Lithograph
Lithographie
Lithografie
1907
87 x 114 cm / 34.2 x 44.8 in.
Museum of Modern Art, New York

◄ **Henri Van de Velde**
(Antwerpen 1863 - Zürich 1957)
Tropon, L'aliment le plus concentré
Lithograph
Lithographie
Lithografie
1899
111,8 x 77,2 cm / 44 x 30.3 in.
Museum of Modern Art, New York

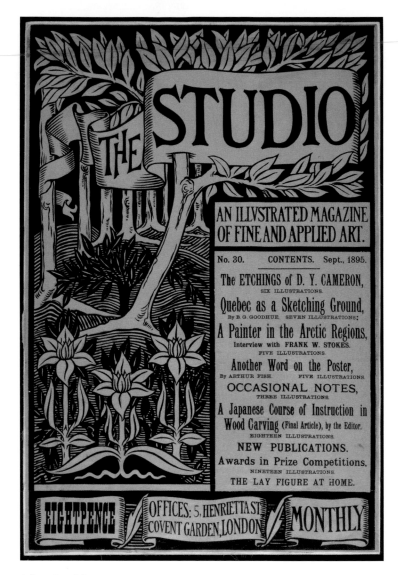

Aubrey Beardsley
(Brighton 1872 - Menton 1898)
The Studio: An Illustrated Magazine of Fine and Applied Art, Nr. 30
Design for the first edition, relief lithograph
Entwurf für die erste Ausgabe, Reliefdruck und Papier
Dessin pour le premier tirage, gravure en relief et papier
Ontwerp voor de eerste druk, hoogdruk en papier
1895
Victoria and Albert Museum, London

▶ **Aubrey Beardsley**
(Brighton 1872 - Menton 1898)
Oscar Wilde, *Salomè - The Climax*
Engraving
Strichgravur
Gravure au trait
Lijngravure
1894
Victoria and Albert Museum, London

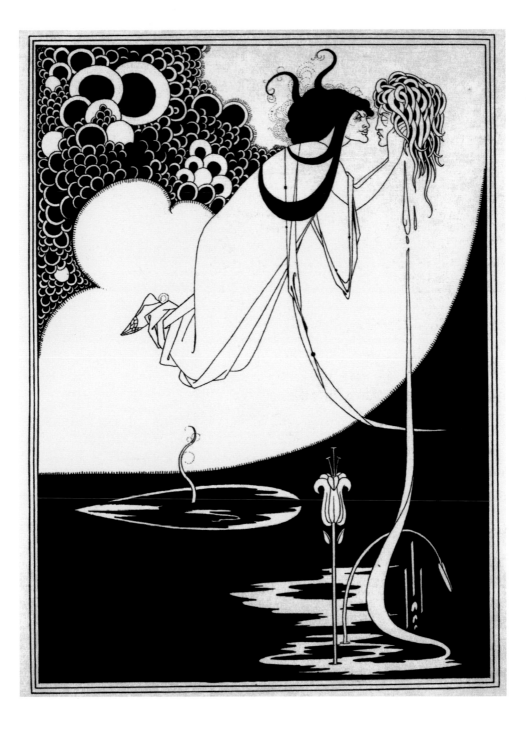

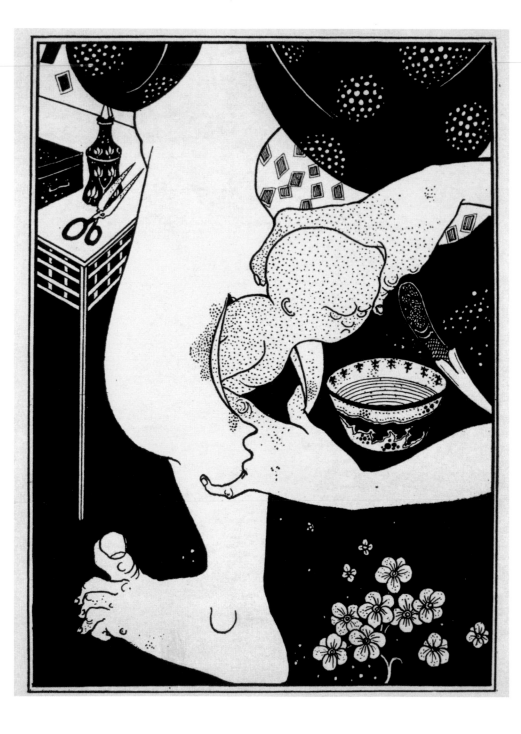

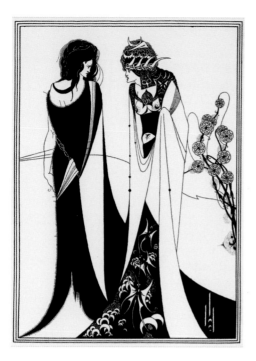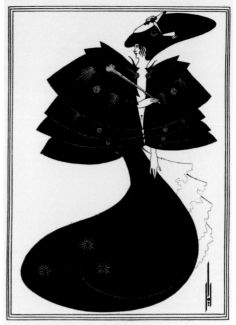

Aubrey Beardsley
(Brighton 1872 - Menton 1898)
Oscar Wilde, *Salomè*
John the Baptist and Salomè, engraving
Johannes und Salomè, Strichgravur
Jean- Baptiste et Salomè gravure au trait
Johannes en Salomè, lijngravure
1894
Victoria and Albert Museum, London

Aubrey Beardsley
(Brighton 1872 - Menton 1898)
Oscar Wilde, *Salomè*
The black cloak, engraving
Der schwarze Mantel, Strichgravur
Le Manteau noir, gravure au trait
De zwarte mantel, lijngravure
1894
Victoria and Albert Museum, London

◄ **Aubrey Beardsley**
(Brighton 1872 - Menton 1898)
Birth from the calf of the leg, engraving
Geburt aus der Wade, Strichgravur
La naissance du mollet, gravure au trait
Geboorte vanuit de kuit, lijngravure
1894
Victoria and Albert Museum, London

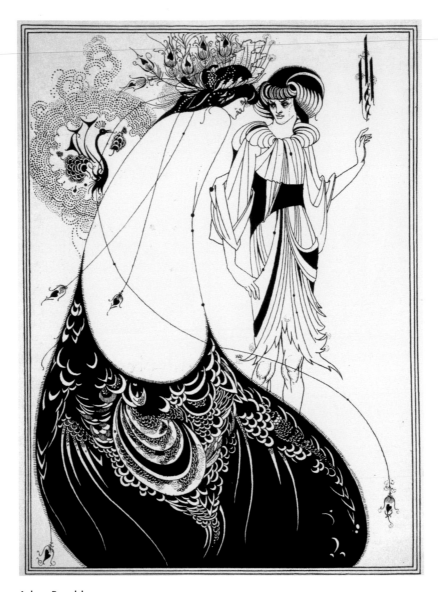

Aubrey Beardsley
(Brighton 1872 - Menton 1898)
Oscar Wilde, *Salomè*
The Peacock Skirt, engraving
Der Pfauenrock, Strichgravur
La Jupe-paon, gravure au trait
De jurk-pauw, lijngravure
1894
Victoria and Albert Museum, London

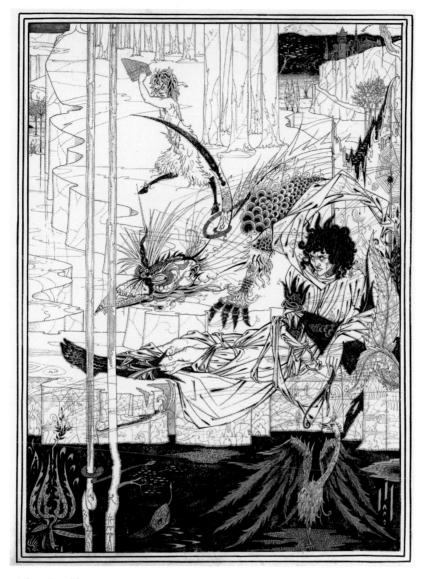

Aubrey Beardsley
(Brighton 1872 - Menton 1898)
Sir Thomas Malory, *Le Morte d'Arthur*
How King Arthur saw the Questing Beast, pen, ink and watercolour on paper
Wie König Artus das Biest sah, das er jagte, Füllfeder, Tinte und Aquarell auf Papier
Comment le roi Arthur vit la bête en chasse, plume, encre et aquarelle sur papier
Hoe koning Arthur het speurdende beest zag, pen, inkt en aquarel op papier
1893
Victoria and Albert Museum, London

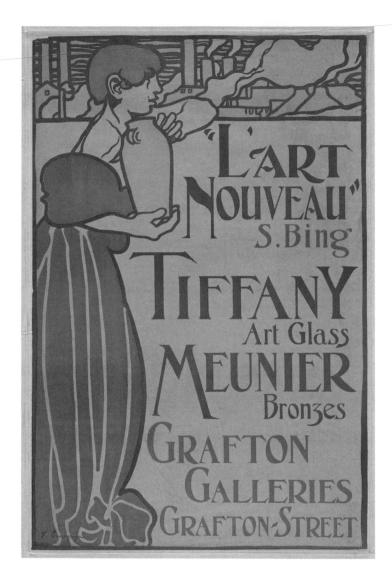

Frank Brangwyn
(Brugge 1867 - Ditchling 1956)
Grafton Galleries
Lithograph
Lithographie
Lithografie
1898
75,6 x 49,5 cm / 29.7 x 19.4 in.
Museum of Modern Art, New York

▶ **Arthur Rackham**
(London 1867 - Limpsfield 1939)
Friedrich de la Motte Fouqué, *Undine*
Illustration, pen, ink and watercolour
Abbildung, Füllfeder, Tinte und Aquarell
Illustration, plume, encre et aquarelle
Illustratie, pen, inkt en aquarel
1909
Staatliche Museen zu Berlin,
Kunstbibliothek, Berlin

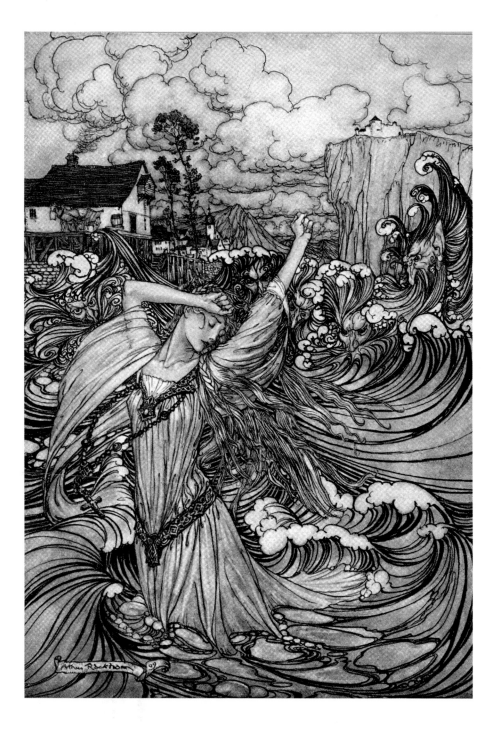

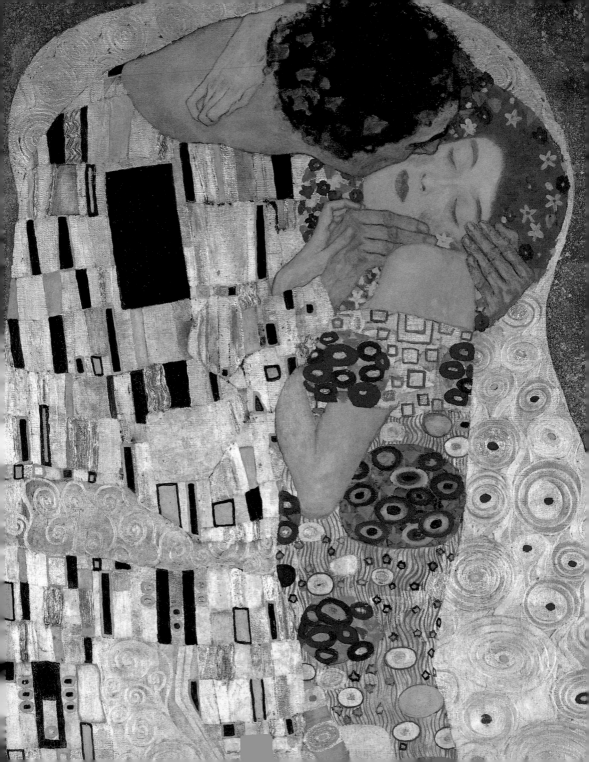

Painting and sculpture

Painting and sculpture were also influenced by Art Nouveau, while remaining opening to other trends of the late nineteenth and early twentieth century. Among the best exponents of the style were Klimt, Munch, Beardsley, Toorop, Hodler, Toulouse-Lautrec, whose works range from the treatment of cultured and literary themes to examples of formal elegance, from dynamic linear incisiveness to arcane allusions to symbolism.

Malerei und Bildhauerei

Im Jugendstil finden auch Malerei und Bildhauerei ihre Offenbarung. Sie verschmelzen dabei mit einigen zeitgenössischen künstlerischen Strömungen der Wende vom 19. zum 20. Jahrhundert. Zu den berühmtesten Werken zählen jene von Klimt, Munch, Beardsley, Toorop, Hodler und Toulouse-Lautrec, deren Stilebenen von Kultur und Literatur bis hin zu formalen Kostbarkeiten, von dynamischer Schärfe der Linienführung bis hin zu geheimnisvollen Anspielungen des Symbolismus schweifen.

4

Peinture et sculpture

La peinture et la sculpture trouvent aussi une expression particulière dans l'Art Nouveau, tout en se mêlant parfois à certains courants artistiques proches du tournant du siècle. Parmi les œuvres les plus exemplaires figurent celles de Klimt, Munch, Beardsley, Toorop, Hodler et Toulouse-Lautrec, dans une palette de registres qui vont de la culture littéraire à la préciosité formelle et de la dynamique incisive du trait aux allusions mystérieuses du symbolisme.

Schilderkunst en beeldhouwkunst

Ook de schilderkunst en de beeldhouwkunst vinden hun uiting in de Art Nouveau, hoewel ze zich nog laten beïnvloeden door enkele contemporaine artistieke stromingen van het einde van de negentiende eeuw en het begin van de twintigste eeuw. Onder de meest representatieve werken vallen de werken van Klimt, Munch, Beardsley, Toorop, Hodler en Toulouse-Lautrec, van wie de werken variëren van het literaire thema tot aan formele waarden en van de dynamische scherpte van de lijn tot aan de esoterische toespelingen van het symbolisme.

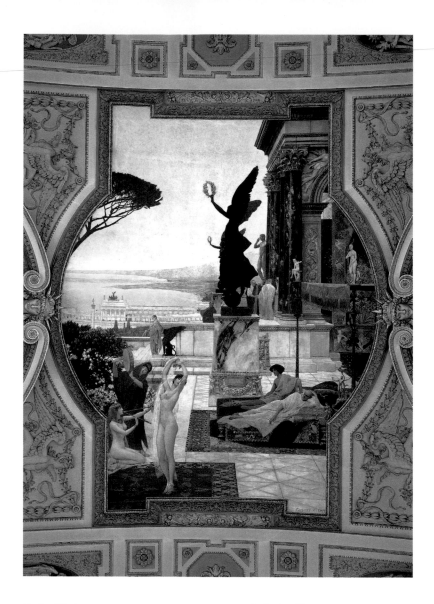

Gustav Klimt
(Baumgarten, Wien 1862 - Wien 1918)
Theatre in Taormina, oil and plaster
Das antike Theater von Taormina, Öl und stuck
Le Théâtre antique de Taormine, huile sur stuc
Het antieke theater van Taormine, olieverf en stuc
1886-1888
750 x 400 cm / 295.2 x 157.4 in.
Burgtheater, Wien

▶ **Gustav Klimt**
(Baumgarten, Wien 1862 - Wien 1918)
Pallas Athene, oil on canvas
Pallas Athene, Öl auf Leinwand
Pallas Athéna, huile sur toile
Pallas Athéna, olieverf op doek
1898
75 x 75 cm / 29.5 x 29.5 in.
Historisches Museum der Stadt Wien, Wien

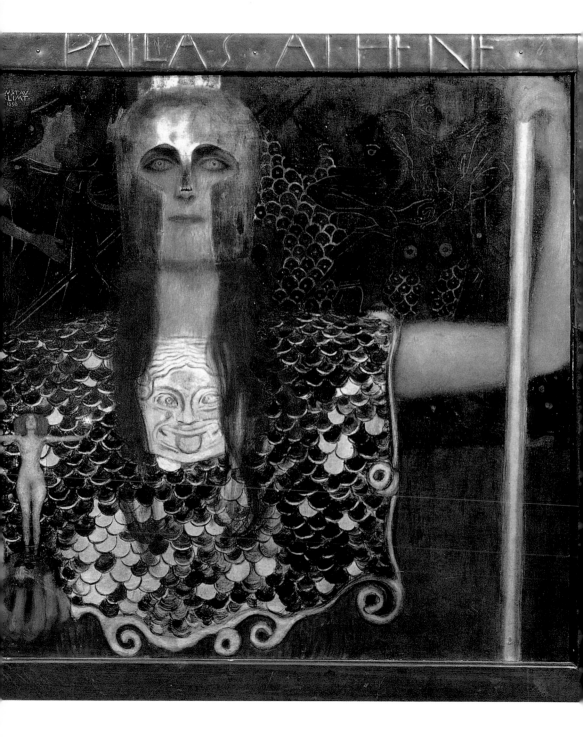

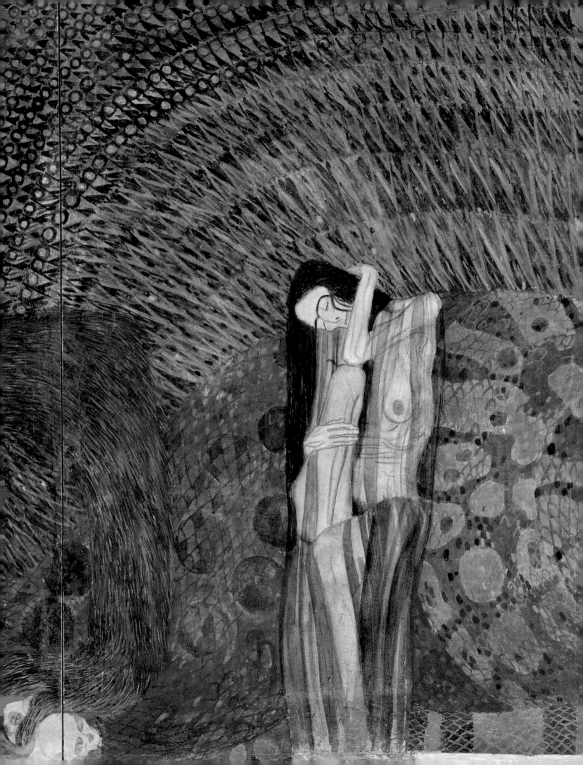

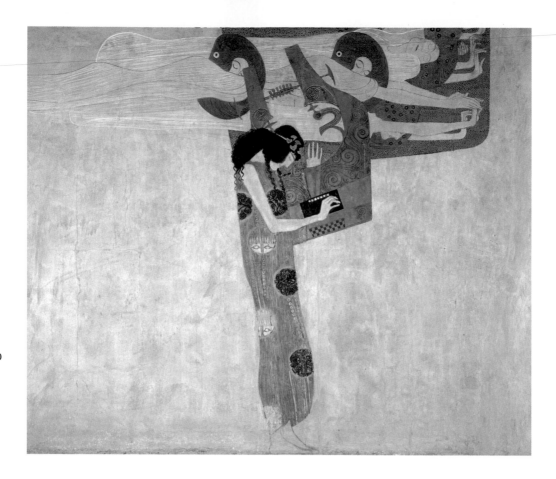

Gustav Klimt
(Baumgarten, Wien 1862 - Wien 1918)
Allegory of poetry, detail of *The Beethoven Frieze*, casein on plaster
Allegorie der Poesie, Detail des *Beethoven-Frieses*, Kasein auf Stuck
Allégorie de la Poésie, détail de la *Frise Beethoven*, caséine sur stuc
Allegorie van de Poëzie, detail van de *Beethovenfries*, caseïne op stuc
1902
h. 220 cm / 86.6 in.
Sezession Museum, Wien

◀ **Gustav Klimt**
(Baumgarten, Wien 1862 - Wien 1918)
Personification of gnawing sorro, detail of *The Beethoven Frieze*, casein on plaster
Personifizierung der nagenden Sorge, Detail *des Beethoven-Frieses*, Kasein auf Stuck
Personnification du souci qui ronge, détail de la *Frise Beethoven*, caséine sur stuc
Personificatie van het knagende leed, detail *van de Beethovenfries*, caseïne op stuc
1902
h. 220 cm / 86.6 in.
Sezession Museum, Wien

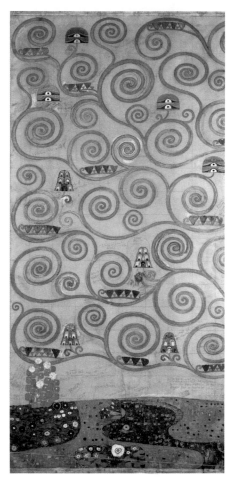
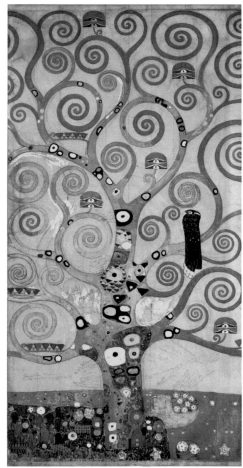

Gustav Klimt
(Baumgarten, Wien 1862 - Wien 1918)
Sketches for frieze in Stoclet Palace, watercolour and pencil
Skizzen für den Fries des Stoclet Palastes, Aquarell und Bleistift
Esquisse pour la frise du Palais Stoclet, aquarelle et crayon
Schetsen voor de fries van het Stocletpaleis, aquarel en potlood
1905-1909
Museum für angewandte Kunst, Wien

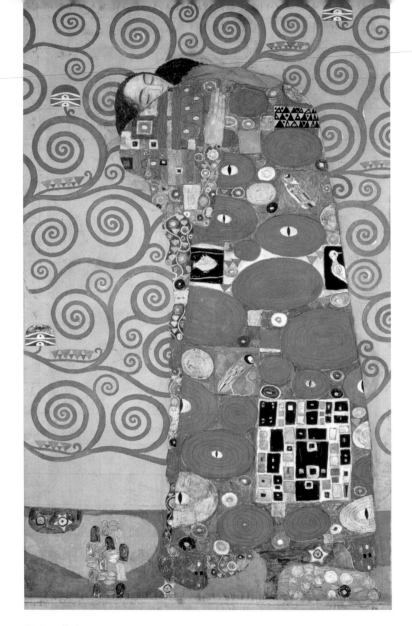

Gustav Klimt
(Baumgarten, Wien 1862 - Wien 1918)
Sketches for frieze in Stoclet Palace, watercolour and pencil
Skizzen für den Fries des Stoclet Palastes, Aquarell und Bleistift
Esquisse pour la frise du Palais Stoclet, aquarelle et crayon
Schetsen voor de fries van het Stocletpaleis, aquarel en potlood
1905-1909
Museum für angewandte Kunst, Wien

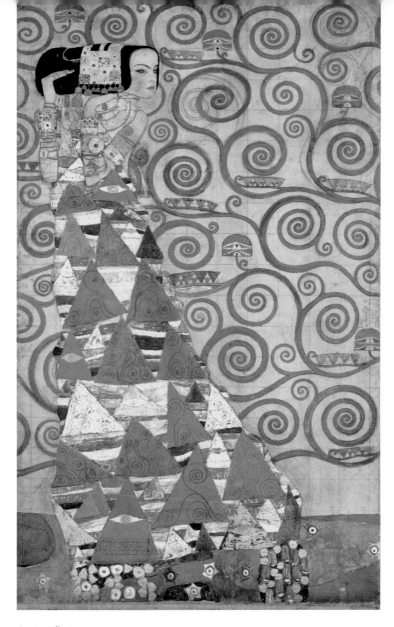

Gustav Klimt
(Baumgarten, Wien 1862 - Wien 1918)
Sketches for frieze in Stoclet Palace, watercolour and pencil
Skizzen für den Fries des Stoclet Palastes, Aquarell und Bleistift
Esquisse pour la frise du Palais Stoclet, aquarelle et crayon
Schetsen voor de fries van het Stocletpaleis, aquarel en potlood
1905-1909
Museum für angewandte Kunst, Wien

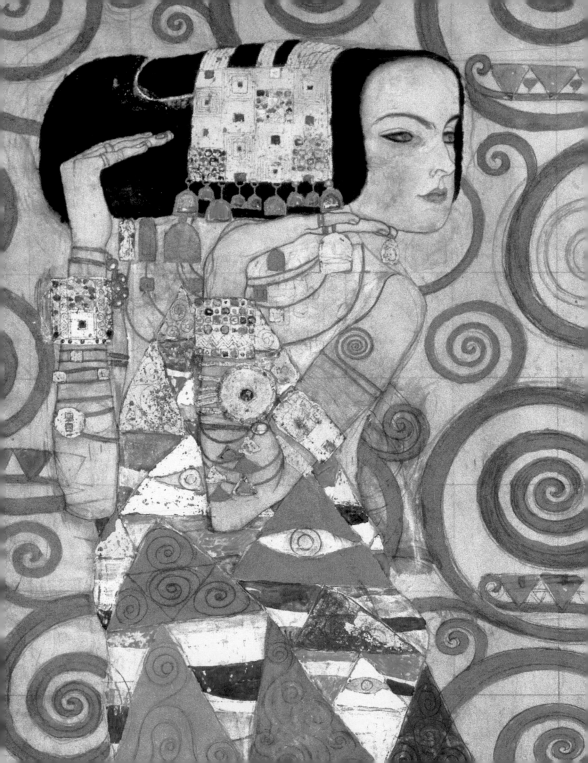

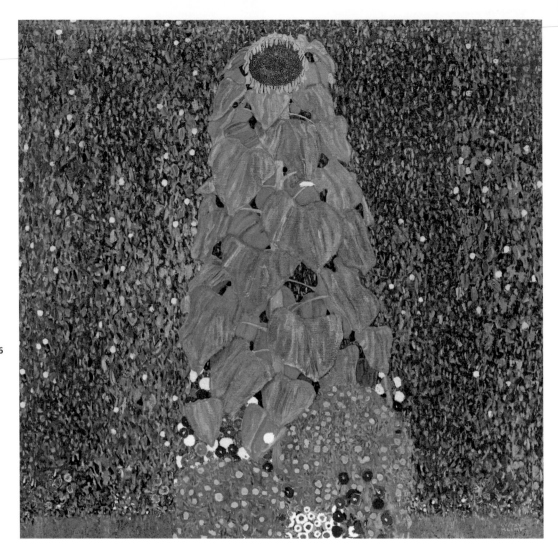

Gustav Klimt
(Baumgarten, Wien 1862 - Wien 1918)
Sunflower, oil on canvas
Sonnenblume, Öl auf Leinwand
Tournesol, huile sur toile
Zonnebloem, olieverf op doek
c. 1906-1907
Richard Parker Collection, Wien

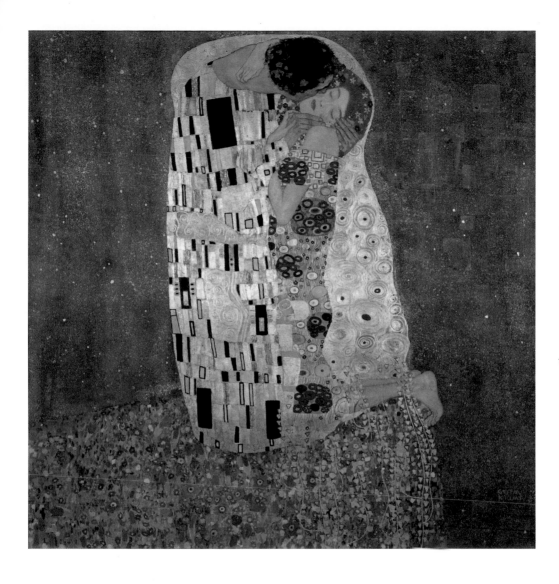

Gustav Klimt
(Baumgarten, Wien 1862 - Wien 1918)
The kiss, oil on canvas
Der Kuss, Öl auf Leinwand
Le Baiser, huile sur toile
De kus, olieverf op doek
1907-1908
180 x 180 cm / 70.8 x 70.8 in.
Österreichische Galerie Belvedere, Wien

▌ *"I can paint and draw. I believe this myself and a few other people say that this is the case."*
▌ *"Ich male die Dinge wie sie sind. Ich kommentiere nicht."*
▌ *"Je suis fort en peinture et en dessin ; je le crois moi-même et les autres le disent aussi."*
▌ *"Ik ben goed in schilderen en tekenen; ik geloof dit zelf en anderen vertellen mij dit ook."*
Gustav Klimt

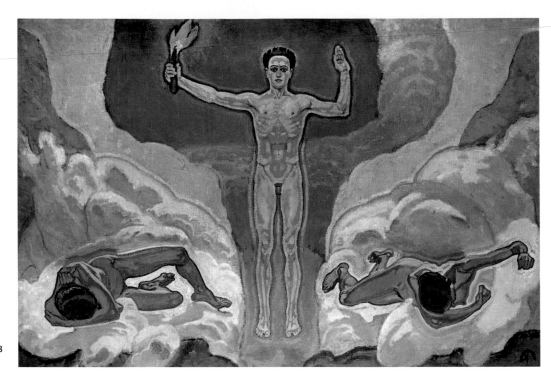

Koloman Moser
(Wien 1868 - 1918)
Light, oil on canvas
Das Licht, Öl auf Leinwand
La Lumière, huile sur toile
Het licht, olieverf op doek
1913
123 x 180,5 cm / 8.4 x 71 in.
Private Collection / Privatkollektion / Collection privée / Privécollectie

▶ **Koloman Moser**
(Wien 1868 - 1918)
Venus in a grotto, oil on canvas
Venus in der Grotte, Öl auf Leinwand
Vénus dans la grotte, huile sur toile
Venus in de grot, olieverf op doek
1913
150 x 99 cm / 59 x 38.9 in.
Leopold Museum, Wien

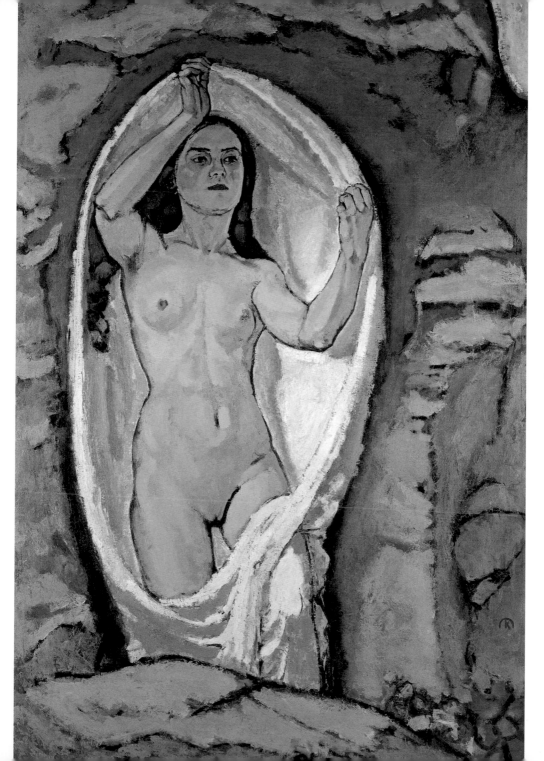

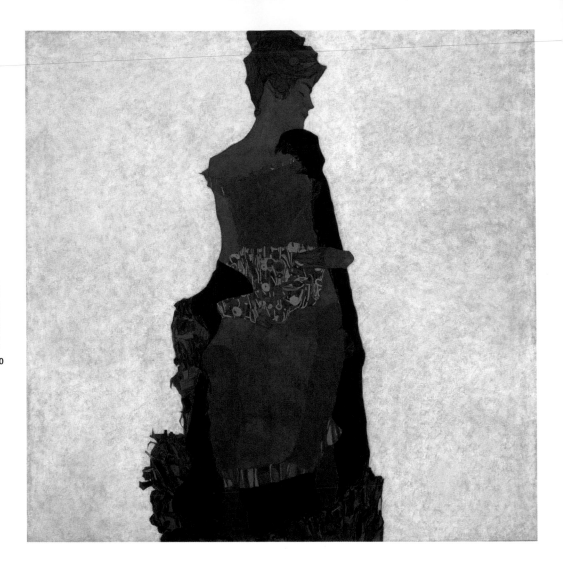

Egon Schiele
(Tulln 1890 - Wien 1918)
Portrait of Gerti Schiele, mixed technique on canvas
Portrait von Gerti Schiele, Mischtechnik auf Leinwand
Portrait de Gerti Schiele, technique mixte sur toile
Portret van Gerti Schiele, verschillende technieken op doek
1909
139,5 x 140,5 cm / 54.9 x 55.3 in.
Museum of Modern Art, New York

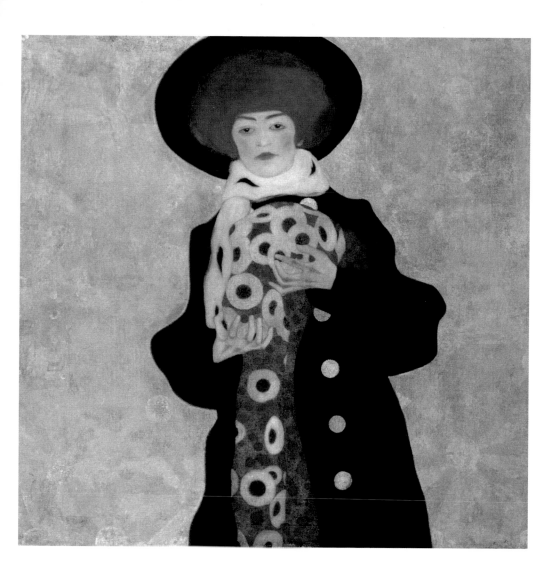

Egon Schiele
(Tulln 1890 - Wien 1918)
Portrait of a woman in a black hat (Gertrude Schiele), oil and metallic wash
Portrait einer Frau mit schwarzem Hut (Gertrude Schiele), Öl und Metallfarbe
Portrait de femme au chapeau noir (Gertrude Schiele), huile et teinte métallique
Portret van een vrouw met zwarte hoed (Gertrude Schiele), olieverf en metaalverf
1909
100 x 99,8 cm / 39.3 x 39.2 in.
Georg Waechter Memorial Foundation, Genève

▌ *"Art cannot be modern. Art is primordially eternal."*
▌ *"Kunst kann nicht modern sein. Kunst ist in ihrem Ursprung ewig."*
▌ *"L'art ne peut pas être moderne. L'art est fondamentalement éternel."*
▌ *"Kunst kan niet modern zijn. Kunst is van oorsprong eeuwig."*
Egon Schiele

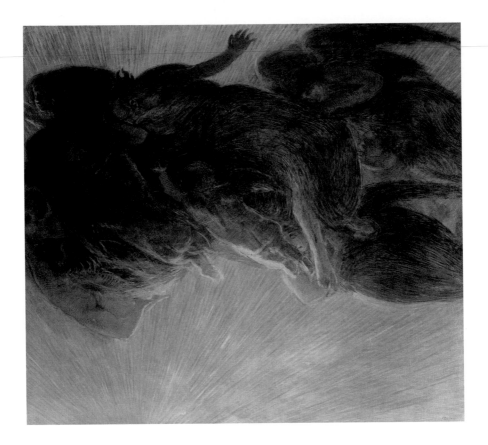

Gaetano Previati
(Ferrara 1852 - Lavagna 1920)
The creation of light, oil on canvas
Kreation des Lichts, Öl auf Leinwand
La Création de la lumière, huile sur toile
Schepping van het licht, olieverf op doek
1913
200 x 215 cm / 78.7 x 84.6 in.
Galleria d'Arte Moderna, Roma

▶ **Giovanni Segantini**
(Arco, Trento 1858 - Schafberg 1899)
The angel of life, oil on canvas
Der Engel des Lebens, Öl auf Leinwand
L'Ange de la vie, huile sur toile
De Engel des levens, olieverf op doek
1894
276 x 212 cm / 108.6 x 83.4 in.
Galleria d'Arte Moderna, Milano

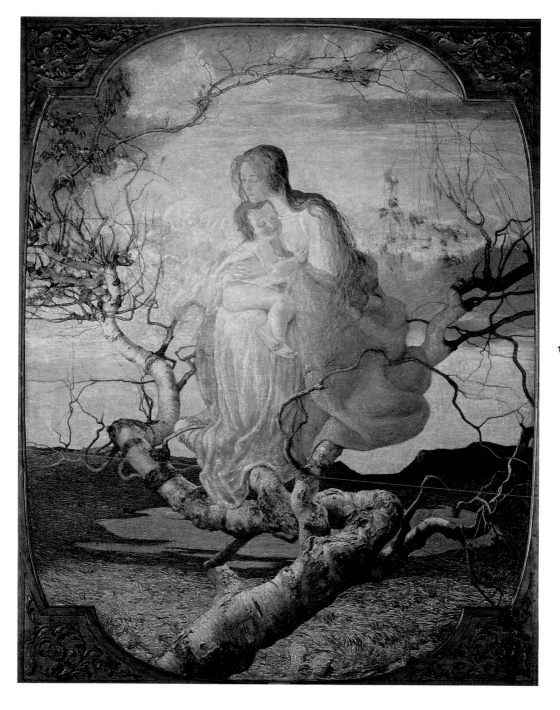

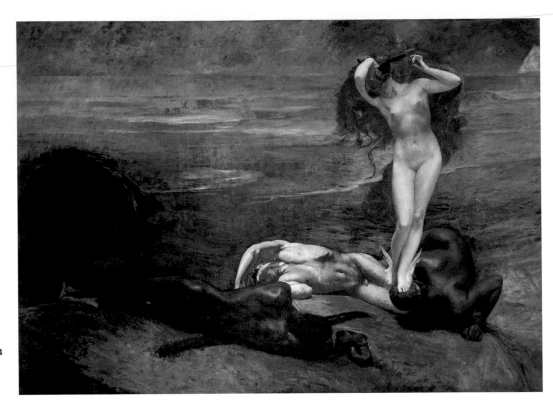

Giulio Aristide Sartorio
(Roma 1860 - 1932)
The gorgon and the heroes, diptych: oil on panel
Das Gorgon und die Helden, Öl auf Diptychon
La Gorgone et les héros, diptyque huile sur toile
De Gorgo en de helden, tweeluik olieverf op paneel
1890-1899
305 x 420 cm / 120 x 165.35 in.
Galleria d'Arte Moderna, Roma

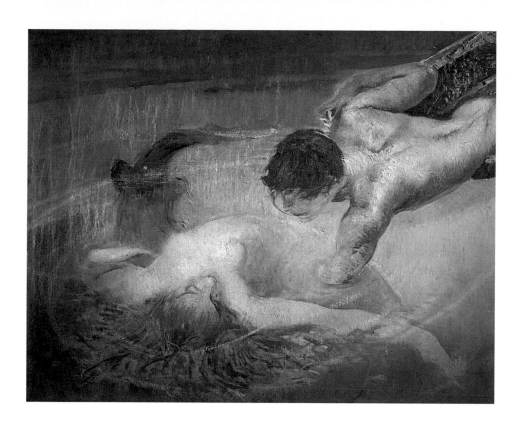

Giulio Aristide Sartorio
(Roma 1860 - 1932)
Detail *Green abyss (Ophelia)*, oil on canvas
Detail des *Grünen Abgrundes (Ophélie)*, Öl auf Leinwand
La Sirène, ou *L'Abîme vert*, huile sur toile
Detail *van de Groene Diepte (Ophelia)*, olieverf op doek
c. 1900
59 x 135 cm / 23.2 x 53.1 in.
Galleria d'Arte Moderna Ricci Oddi, Piacenza

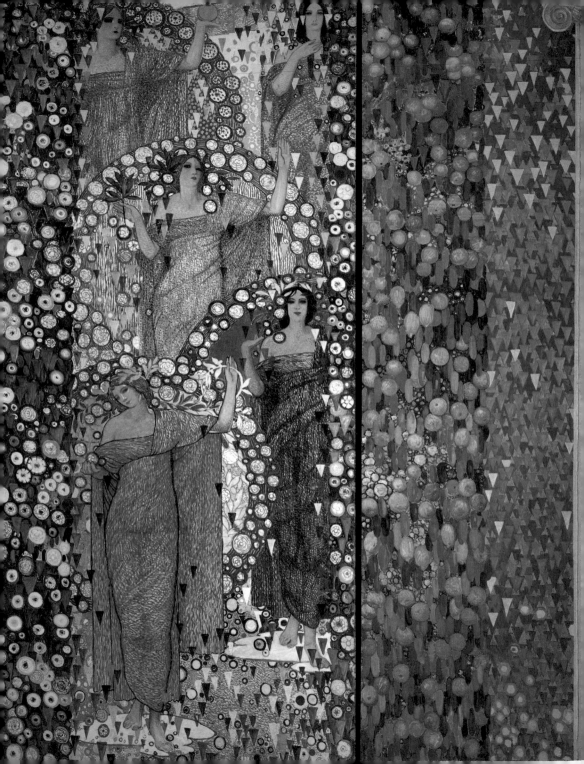

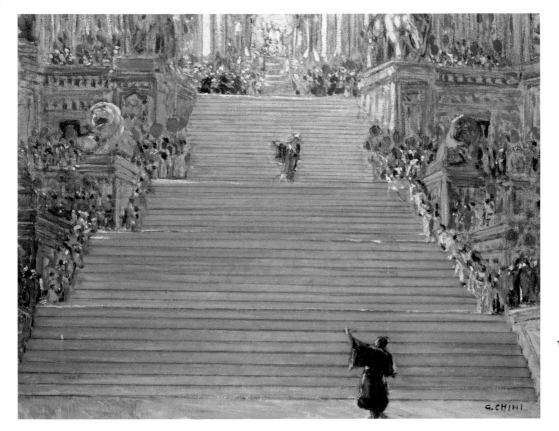

Galileo Chini
(Firenze 1873 - Lido di Camaiore, Lucca 1956)
Sketch for *Turandot*, oil on canvas
Skizze für *Turandot*, Öl auf Leinwand
Maquette pour *Turandot*, huile sur toile
Schets voor *Turandot*, olieverf op doek
c. 1925
65 x 82 cm / 25.5 x 32.2 in.

◀ **Galileo Chini**
(Firenze 1873 - Lido di Camaiore, Lucca 1956)
Classical Spring, tempera, oil, plaster and gold on canvas
Der klassische Frühling, Tempera, Öl, Stuck und Gold auf Tafel
Le Printemps classique, détrempe, huile, stuc et or sur toile
De klassieke lente, tempera, olieverf, stuc en goud op doek
1914
h. 400 cm / 157.4 in.
Accademia d'Arte D. Scalabrino, Montecatini Terme (Pistoia)

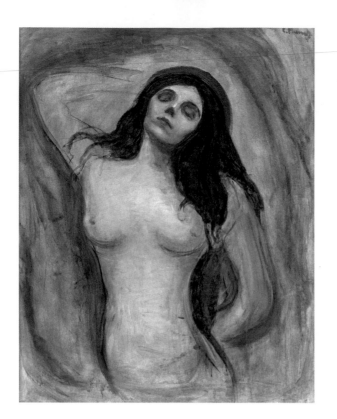

Edvard Munch
(Løten 1863 - Ekely, Oslo 1944)
Madonna (Woman in love), oil on canvas
Madonna (Verliebte Frau), Öl auf Leinwand
Madone (Femme amoureuse), huile sur toile
Madonna (Verliefde vrouw), olieverf op doek
1894
90 x 71 cm / 35.4 x 27.9 in.
Hamburger Kunsthalle, Hamburg

▶ **Edvard Munch**
(Løten 1863 - Ekely, Oslo 1944)
The scream, oil on canvas
Der Schrei, Öl auf Leinwand
Le Cri, huile sur toile
De schreeuw, olieverf op doek
1893
91 x 73 cm / 35.8 x 28.7 in.
Nasjonalgalleriet, Oslo

▮ *"From my rotting body, flowers shall grow and I am in them: this is eternity."*
▮ *"Aus meinem verwesenden Körper werden Blumen wachsen und ich werde in ihnen sein: das ist Ewigkeit."*
▮ *"De mon corps en putréfaction des fleurs pousseront et je serai au dedans d'elles : voilà l'éternité."*
▮ *"Uit mijn rottend lichaam zullen bloemen groeien en ik ben in ze en dat is eeuwigheid."*
Edvard Munch

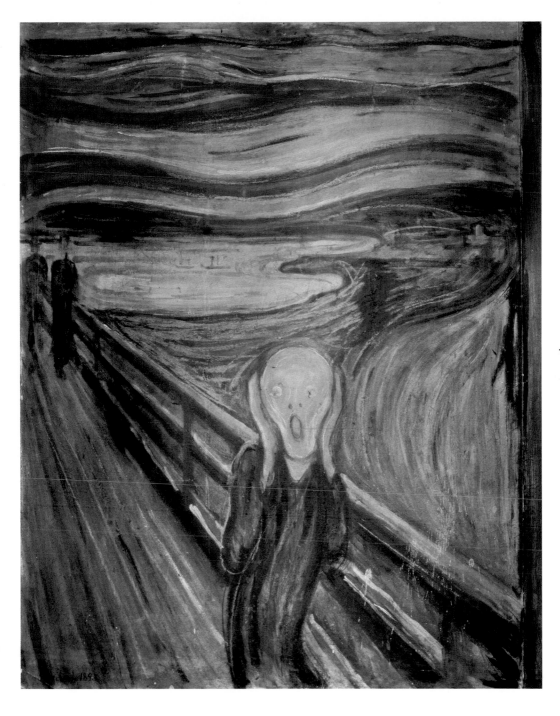

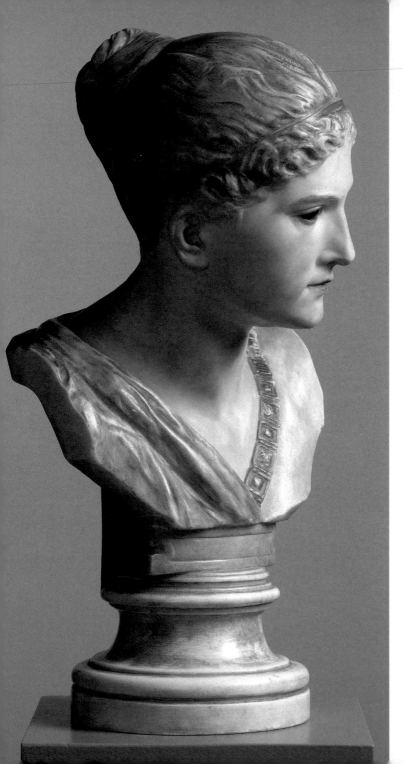

Max Klinger
(Leipzig 1857 - Großjena 1920)
Cassandra
Marble painted with watercolour, amber
Marmor, mit Farben und Wasser bemalt,
Bernstein
Marbre peint à l'eau, ambre
Marmer beschilderd met waterverf, amber
1895
62 x 31 x 27 cm / 24.4 x 12.2 x 10.6 in.
Hamburger Kunsthalle, Hamburg

▶ **Louis-Ernest Barrias**
(Paris 1841 - 1905)
Nature Reveals Herself to Science
Die Natur offenbart sich der Wissenschaft
La Nature se dévoilant à la science
De natuur onthult haarzelf aan de
wetenschap
1899
200 x 85 x 55 cm / 78.7 x 33.4 x 21.6 in.
Musée d'Orsay, Paris

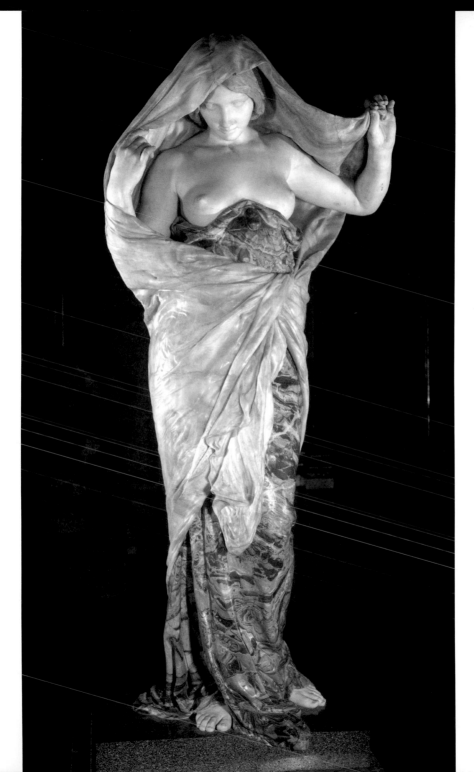

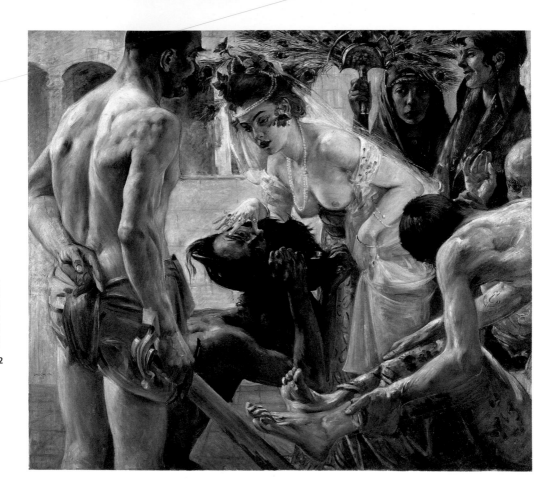

Lovis Corinth
(Tapiau 1858 - Zandvoort 1925)
Salomè II
Oil on canvas
Öl auf Leinwand
Huile sur toile
Olieverf op doek
1899-1900
127 x 147 cm / 49.9 x 57.8 in.
Museum der bildenden Künste, Leipzig

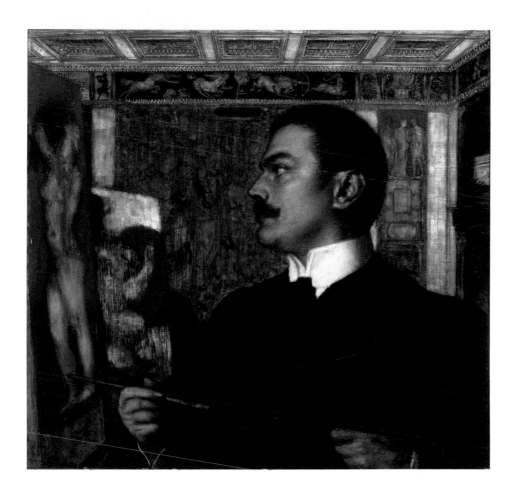

Franz von Stuck
(Tettenweiss 1863 - München 1928)
Self-portrait in the studio, oil on panel
Selbstportrait im Atelier, Öl auf Tafel
Autoportrait dans l'atelier, huile sur bois
Zelfportret in het atelier, olieverf op paneel
1905
72,5 x 76 cm / 28.5 x 29.9 in.
Nationalgalerie, Staatliche Museen zu Berlin, Berlin

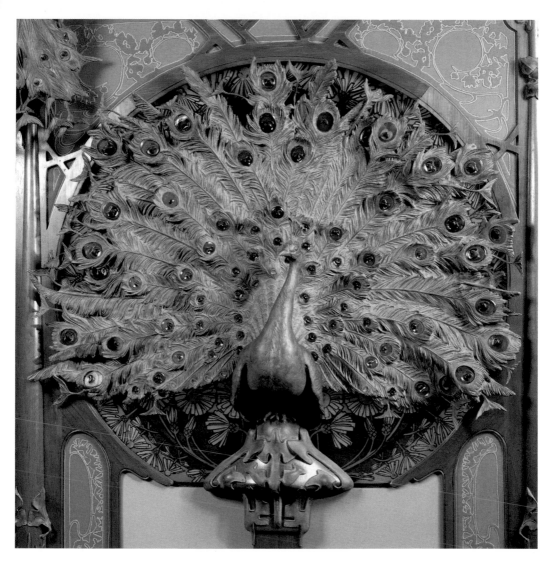

◄ **Henri de Toulouse-Lautrec**
(Albi 1864 - Malromé 1901)
Loïe Fuller aux Folies-Bergère
Oil on card
Öl auf Karton
Huile sur carton
Olieverf op karton
1893
63,2 x 45,3 cm / 24.8 x 17.8 in.
Musée Toulouse-Lautrec, Albi

Alphonse Mucha
(Ivančice 1860 - Praha 1939)
Peacock: Georges Fouquet jeweller, Paris, bronze
Pfau, Detail der Innendekoration der Juwelierwerkstatt von Georges Fouquet in Paris, Bronze
Sculpture de paon, détail de la décoration intérieure de la bijouterie Georges Fouquet à Paris, bronze
Pauw, detail van de interieurdecoratie van de juwelierszaak van Georges Fouquet in Parijs, brons
1901
Musée Carnavalet, Paris

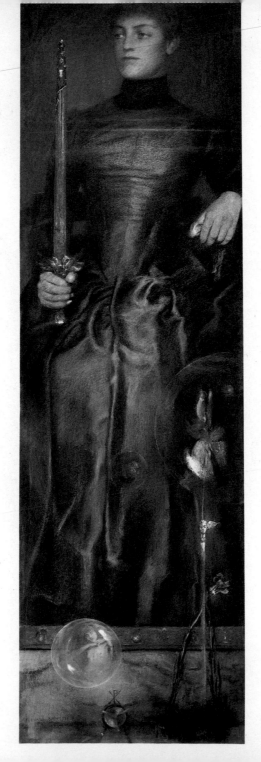

Fernand Khnopff
(Grembergen-lez-Termonde 1858 - Bruxelles 1921)
Rose, pastel on paper
Rosen, Pastell auf Papier
Rose, pastel sur papier
Rozen, pastel op papier
1912
Musée des Beaux-Arts, Tournai

◀ **Fernand Khnopff**
(Grembergen-lez-Termonde 1858 - Bruxelles 1921)
Solitude, photograph coloured with chalk
Einsamkeit, Ohne Datum Farbfotografie mit Kreide
Solitude, photographie coloriée à la craie
Eenzaamheid, foto ingekleurd met krijtjes
Hamburger Kunsthalle, Hamburg

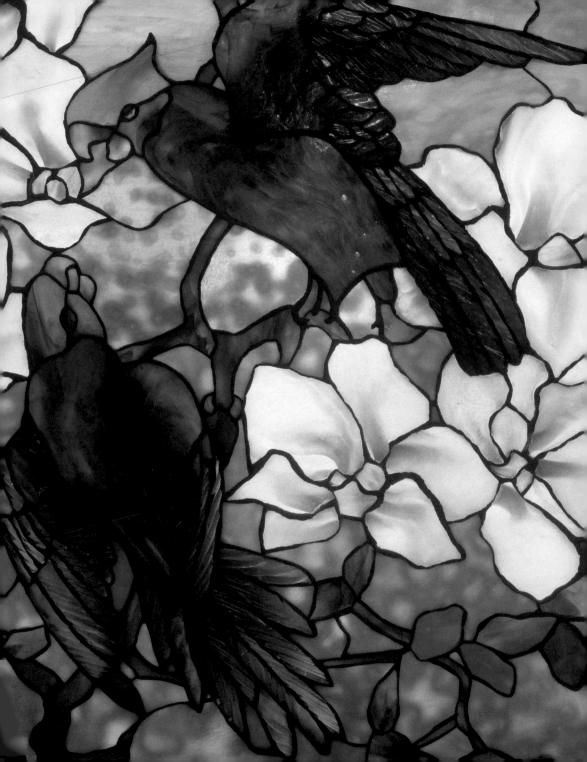

Glass

Glass perfectly satisfied the modernist quest for sophisticated and unusual effects and provided some of the finest results. Tiffany, Lalique and other glassmakers created extraordinary vases, glasses, windows and boxes, adopting new techniques and material to produce metamorphic, polychrome pieces often inspired by nature.

Glas

Die modernistische Suche nach auserlesenen und wunderlichen Lösungen hat auch auf die Bearbeitung von Glas, die im Jugendstil ihren Höhepunkt erreicht, großen Einfluss. Tiffany, Lalique und andere Künstler dieser Kunstrichtung ersinnen mit neuen Techniken und Materialkombinationen außerordentliche Vasen, Gläser, Glasfenster, Schatullen und gelangen so zu metamorphen, bunten Ergebnissen, die der Neigung nach von der Natur beeinflusst sind.

5

L'art du verre

La recherche moderniste de solutions esthétiques raffinées et bizarres influe notamment sur le travail du verre que l'Art Nouveau va porter à son apogée. Tiffany, Lalique, Gallé et bien d'autres artistes voués à cet art inventent de très exceptionnels vases, verres, vitraux et coffrets, grâce à de nouvelles techniques et combinaisons de matériaux qui donnent des résultats protéiformes et polychromes, tendant à s'inspirer de la nature.

Glaswerk

Het modernistische onderzoek naar verfijnde en vreemde oplossingen beïnvloedt het glasbewerken, dat de Art Nouveau naar ongekende hoogte bracht, aanzienlijk. Tiffany, Lalique en andere kunstenaars toegwijd aan deze kunst, ontwierpen bijzondere vazen, glazen, ramen en sieradenkistjes, met nieuwe technieken en materialencombinaties, waardoor er metamorfische en polychrome oplossingen werden bereikt, geïnspireerd op de natuur.

Art Nouveau glass
Art Nouveau glas
Verrerie Art Nouveau
Glaswerken Art Nouveau

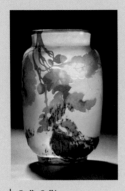

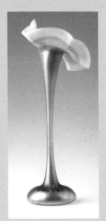

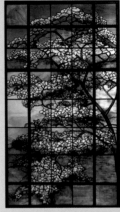

Louis Comfort Tiffany
Dogwood
Hartriegelgewächse
Sanguinelle
Kornoelj
c. 1900 -1915
Metropolitan Museum of Art, New York

Emile Gallé
Oakleaf vase
Vaas Oakleaf
c. 1895
Victoria and Albert Museum, London

Louis Comfort Tiffany
Vase
Vaas
1900
Museum of Modern Art,
New York

1890	**1895**	**1900**	**1905**	**1910**

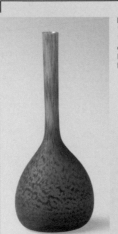

Daum Frères
Vase
Vaas
c. 1900
Museum of Modern Art,
New York

Otto Prutscher
Glass with a long stem
Langstieliges Glas
Verre à long pied
Glas met lange steel
1907
Private Collection / Privatkollektion /
Collection privée / Privécollectie

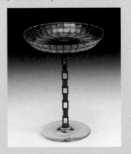

Josef Hoffmann
Liquer glasses, blown glass
Likörgläser
Verres à liqueur
Likeurglazen
c. 1908
Museum of Modern Art,
New York

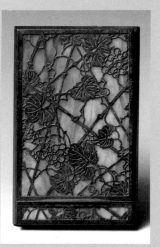

Louis Comfort Tiffany
Notebook holder
Notizbuchhalter
Support pour bloc-notes
Notitieboekhouder
c. 1910-1920
Metropolitan Museum of Art,
New York

1915 **1920** **1925** **1930**

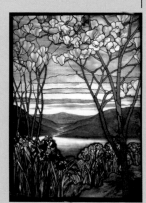

Louis Comfort Tiffany
Magnolia and irises
Magnolien und Iris
Magnolias et iris
Magnolia's en irissen
1908
Metropolitan Museum of Art, New York

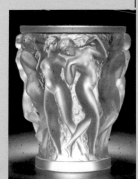

René Lalique
Baccantes vase
Vase Bacchante
Vase bacchante
Vaas Bacchanten
1927

Louis Comfort Tiffany
(New York 1848 - 1933)
Window, leaded glass, framed
Fenster, Bleiglas, Gerahmt
Vitrail pour fenêtre, vitrail au plomb, encadré
Raam, glas-in-lood, omlijst
c. 1892
h. 72,1 cm / 28.3 in.
Metropolitan Museum of Art, New York

▶ **Louis Comfort Tiffany**
(New York 1848 - 1933)
Vase, green favrile glass with metal lustre
Vase, grünes Favrile-Glas geblasen, mit Metallüberzug
Vase, verre favrile soufflé vert à lustre métallique
Vaas, groen geblazen favrile glas met metaalglans
1896
h. 32,7 cm / 12.8 in.
Victoria and Albert Museum, London

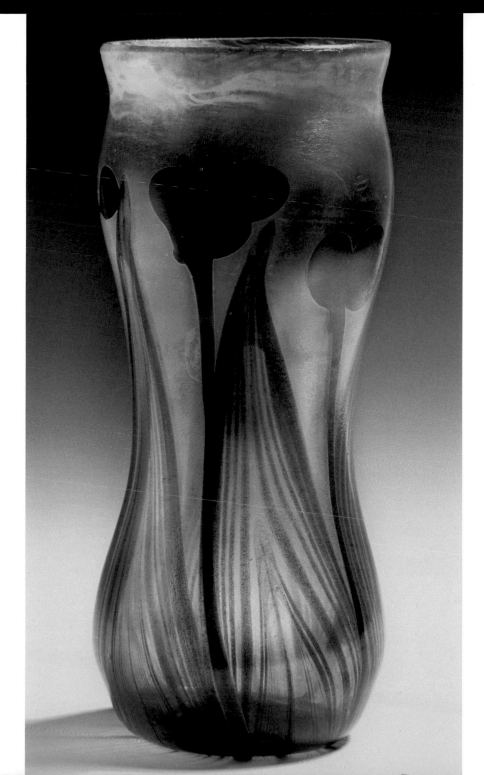

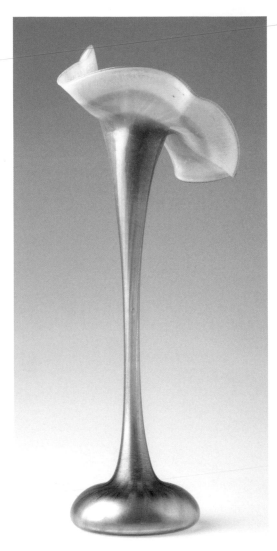

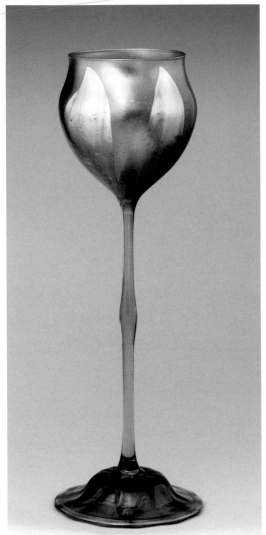

Louis Comfort Tiffany
(New York 1848 - 1933)
Vase, favrile glass
Vase, Favrile-Glas
Vase, verre favrile
Vaas, favrile glas
1900
h. 16 cm / 6.2 in.
Museum of Modern Art, New York

Louis Comfort Tiffany
(New York 1848 - 1933)
Vase, favrile glass
Vase, Favrile-Glas
Vase, verre favrile
Vaas, favrile glas
1900-1902
h. 39,7 cm / 15.6 in.
Metropolitan Museum of Art, New York

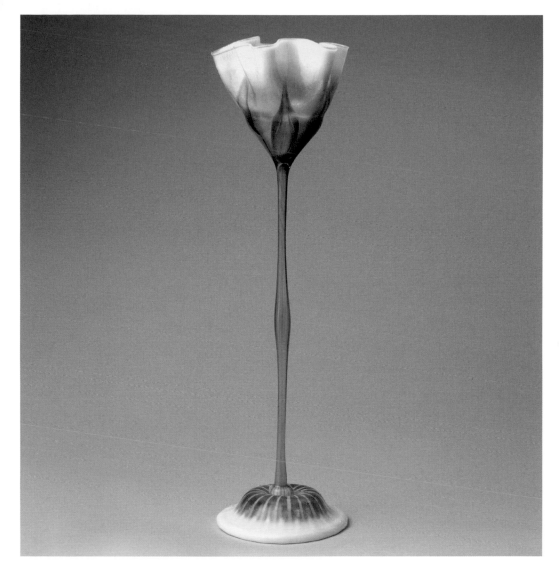

Louis Comfort Tiffany
(New York 1848 - 1933)
Vase, favrile glass
Vase, Favrile-Glas
Vase, verre favrile
Vaas, favrile glas
1900-1902
h. 47,5 cm / 18.7 in.
Metropolitan Museum of Art, New York

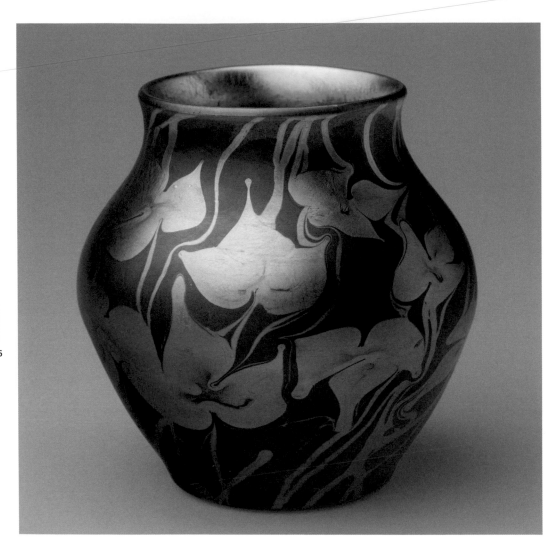

Louis Comfort Tiffany
(New York 1848 - 1933)
Vase, favrile glass
Vase, Favrile-Glas
Vase, verre favrile
Vaas, favrile glas
1902
h. 11,4 cm / 4.4 in.
Museum of Modern Art, New York

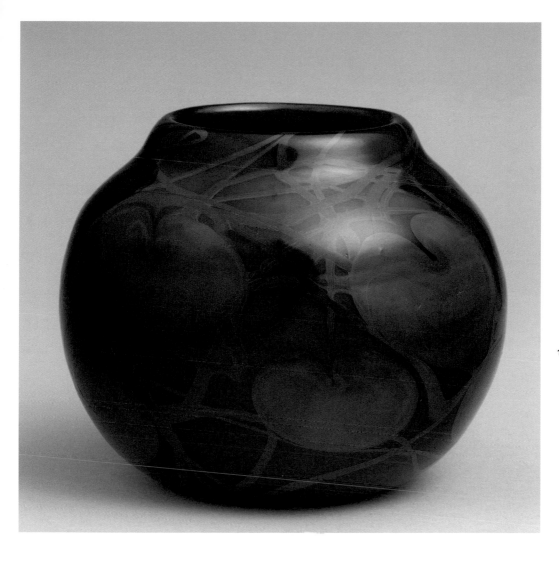

Louis Comfort Tiffany
(New York 1848 - 1933)
Vase, favrile glass
Vase, Favrile-Glas
Vase, verre favrile
Vaas, favrile glas
c.1903
h. 11,4 cm / 4.4 in.
Metropolitan Museum of Art, New York

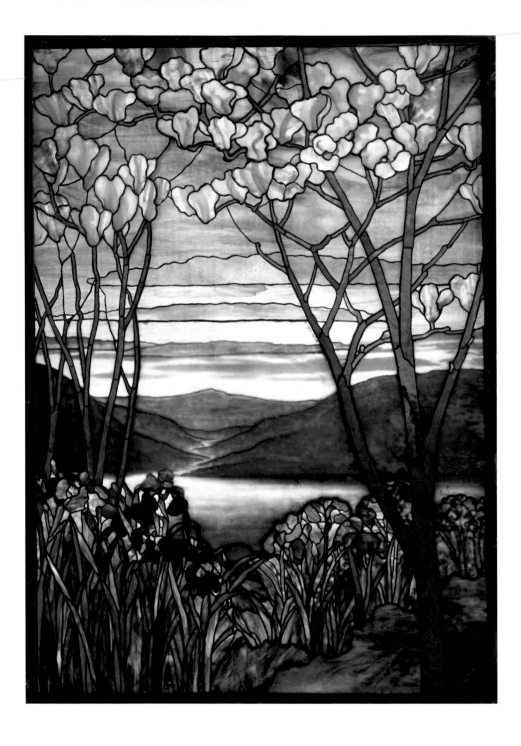

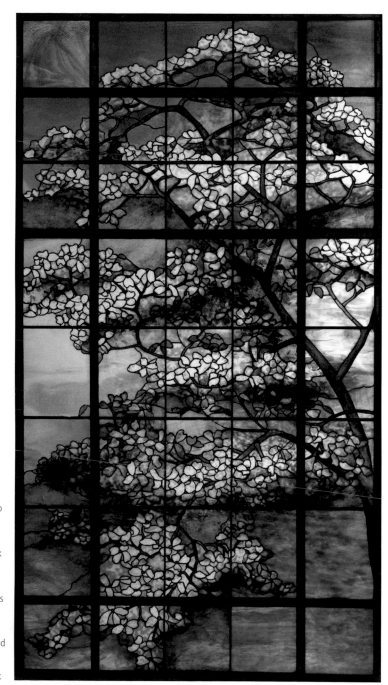

Louis Comfort Tiffany
(New York 1848 - 1933)
Dogwood, leaded favrile glass
Hartriegelgewächse, Favril-Bleiglas
Sanguinelle, verre favrile serti de plomb
Kornoelj, favrile glas-in-lood
c. 1900 -1915
h. 254 cm / 99.9 in.
Metropolitan Museum of Art, New York

◀ **Louis Comfort Tiffany**
(New York 1848 - 1933)
Magnolia and irises, leaded favrile glass
Magnolien und Iris, Favril-Bleiglas
Magnolias et iris, verre favrile serti
de plomb
Magnolia's en irissen favrile glas-in-lood
c. 1908
153 x 106,7 cm / 60.2 x 42 in.
Metropolitan Museum of Art, New York

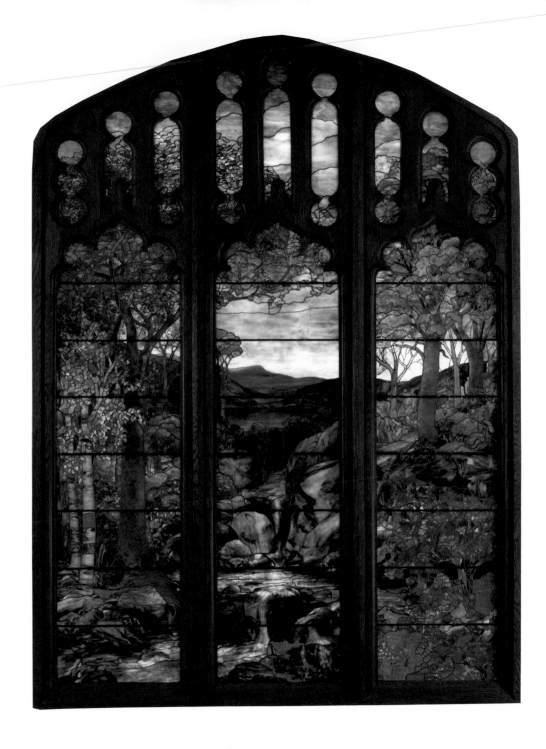

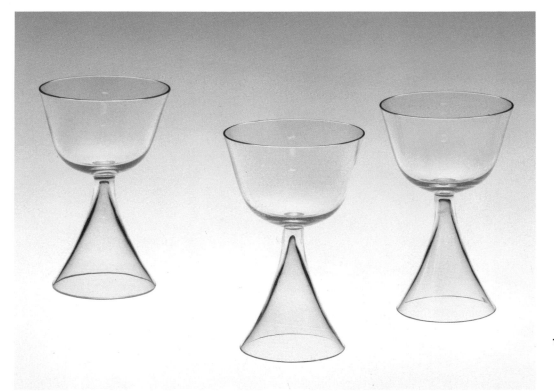

Josef Hoffmann
(Pirnjtz 1870 - Wien 1956)
Liquer glasses, blown glass
Likörgläser, geblasenes Glas
Verres à liqueur, verre soufflé
Likeurglazen, geblazen glas
c. 1908
h. 8,9 cm / 3.5 in.
Museum of Modern Art, New York

◀ **Louis Comfort Tiffany**
(New York 1848 - 1933)
Autumn landscape, favrile glass
Herbstlandschaft, Favrile-Glas
Paysage d'automne, verre favrile serti de plomb
Herfstlandschap, favrile glas
1923-1924
h. 335,3 cm / 132 x 102 in.
Metropolitan Museum of Art, New York

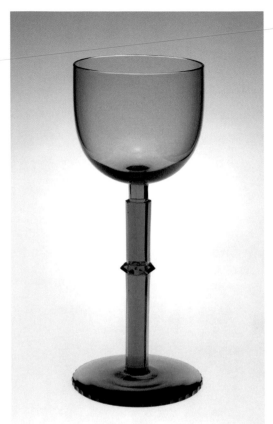

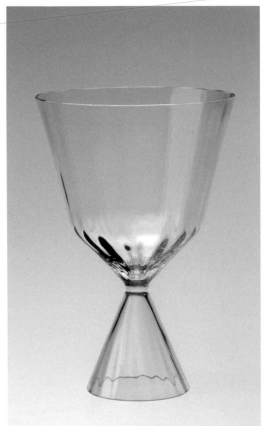

Josef Hoffmann
(Pirnitz 1870 - Wien 1956)
Wine glass, glass
Weinkelch, Glas
Verre à vin à pied, verre
Wijnkelk, wijnkelk
c. 1910
h. 19,7 cm / 7.7 in.
Metropolitan Museum of Art, New York

Josef Hoffmann
(Pirnitz 1870 - Wien 1956)
Wine glass, glass
Kelch, Glas
Verre à pied, verre
Kelk, wijnkelk
1920
h. 15 cm / 5.9 in.
Museum of Modern Art, New York

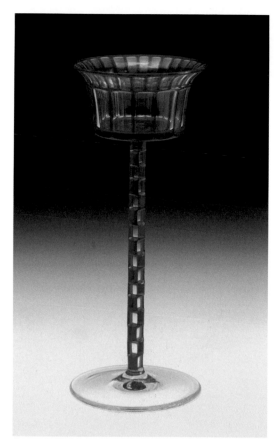

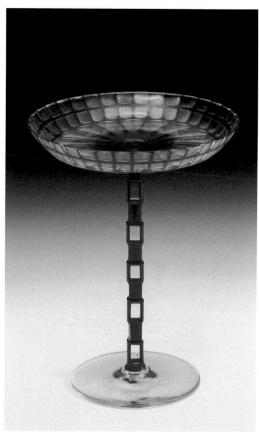

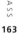

Otto Prutscher
(Wien 1880 - 1949)
Glass with a long stem, glass
Langstieliges Glas, Glas
Verre à long pied, verre
Glas met lange steel, glas
c. 1900
Private Collection / Privatkollektion / Collection privée / Privécollectie

Otto Prutscher
(Wien 1880 - 1949)
Glass with a long stem, glass
Langstieliges Glas, Glas
Verre à long pied, verre
Glas met lange steel, glas
c. 1900
Private Collection / Privatkollektion / Collection privée / Privécollectie

Daum Frères
Vase, hand-painted glass
Vase, Glas, handbemalt
Vase, verre peint à la main
Vaas, handbeschilderd glas
c. 1900
h. 21 cm / 8.2 in.
Museum of Modern Art, New York

▶ **Max Ritter von Spaun**
Phenomenon vase, glass
Vase *Phenomenon*, Glas
Vase *Phénomène*, verre
Phenomenon vaas, glas
1900
h. 21 cm / 8.2 in.
Victoria and Albert Museum, London

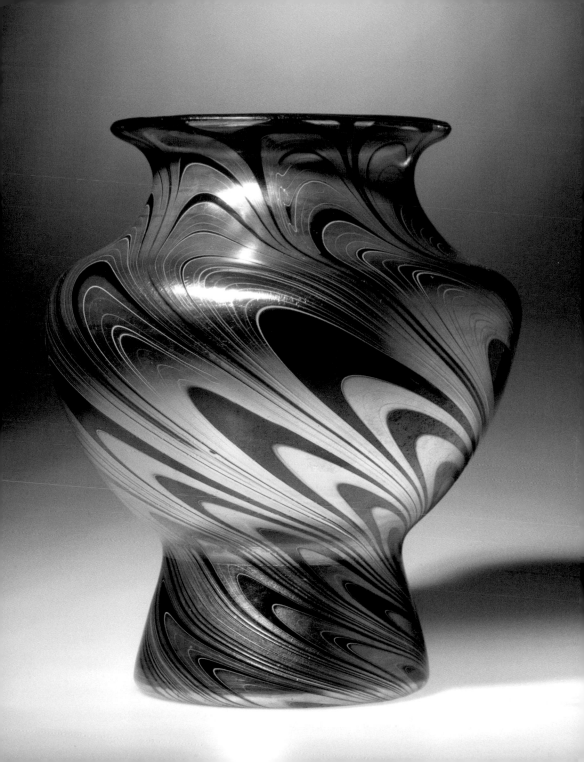

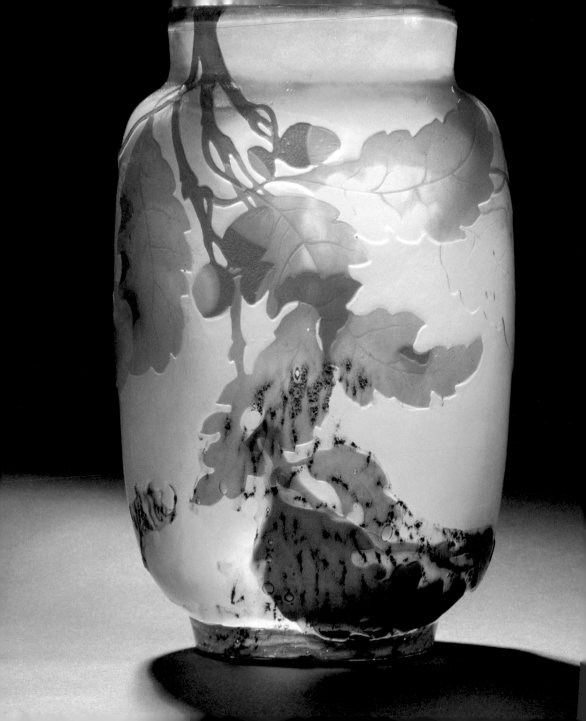

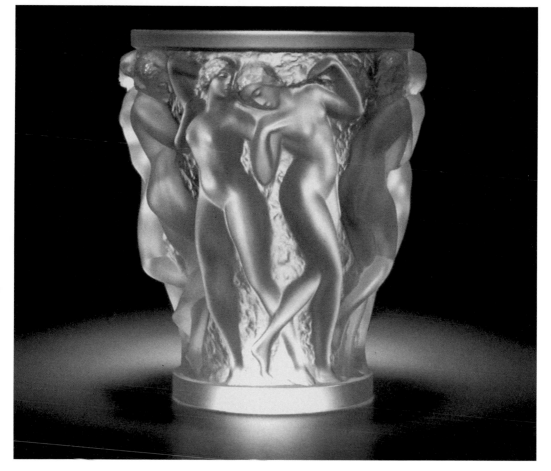

René Lalique
(Ay 1860 - Paris 1945)
Baccantes vase, glass
Vase *Bacchante*, Glas
Vase *bacchante*, verre
Vaas *Bacchanten*, glas
1927
h. 24 cm / 9.4 in.

◀ **Emile Gallé**
(Nancy 1846 - 1904)
Oakleaf vase, glass
Vase *Oakleaf*, Glas
Vase *feuille de chêne*, verre
Oakleaf vaas, glas
c. 1895
h. 25,3 cm / 9.9 in.
Victoria and Albert Museum, London

▌ *"The people are the reservoir of art for the future, and we should begin with them."*
▌ *"Das Volk ist das Reservoir der künftigen Kunst, ebendieses müssten wir einweihen."*
▌ *"Le peuple est le réservoir de l'art à venir, c'est lui qu'il faudrait initier."*
▌ *"Het volk is het reservoir van de toekomstige kunst en is dat wat zou moeten worden ingewijd."*
René Lalique

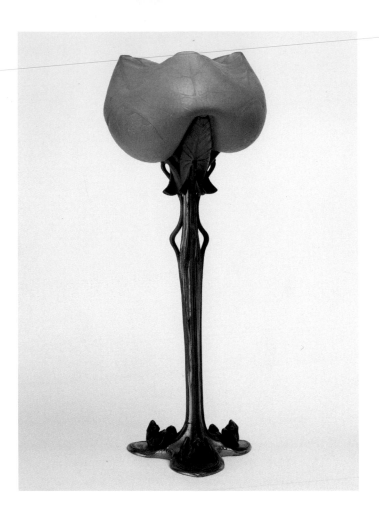

Louis Majorelle
(Toul 1859 - Nancy 1926)
Table lamp, glass and bronze
Tischlampe, Glas und Bronze
Lampe de table, verre et bronze
Tafellamp, glas en brons
1905
h. 69,2 cm / 27.2 in.
Museum of Modern Art, New York

▶ **Galileo Chini**
(Firenze 1873 - Lido di Camaiore, Lucca 1956)
Door, glass and wrought iron
Tor aus Glas und Schmiedeeisen
Portail en verre et fer forgé
Glazen en smeedijzeren poort
Grand Hotel & La Pace, Montecatini Terme (Pistoia)

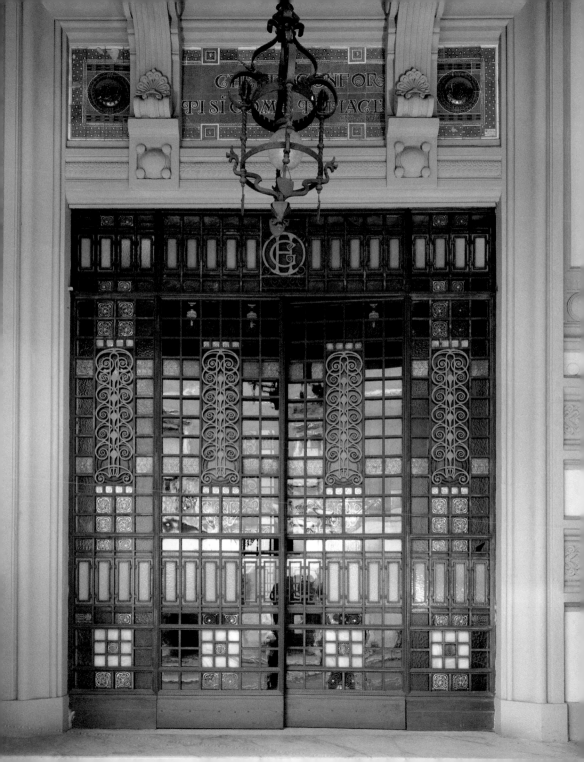

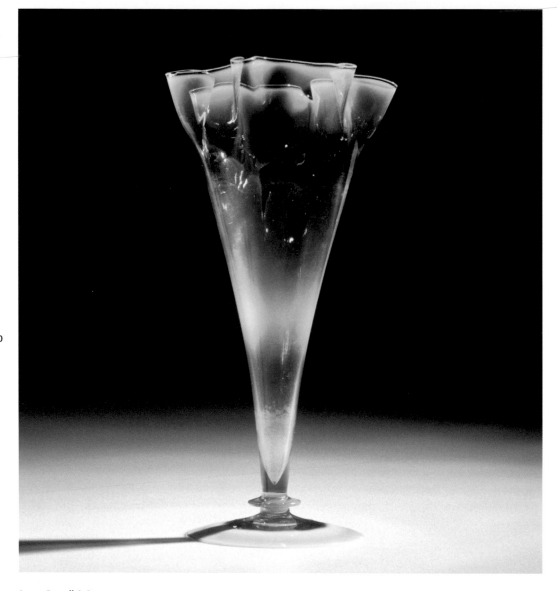

James Powell & Sons
Vase, opalescent glass
Vase, Opalglas, matt
Vase, opaline fumée
Vaas, opalen rookglas
c. 1880
h. 25,7 cm / 10.1 in.
Victoria and Albert Museum, London

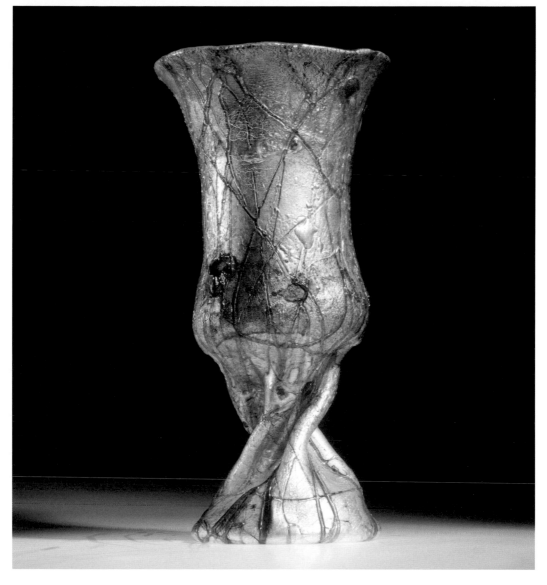

Stevens and Williams
Vase, silver leaf and green glass
Vase, Silberblatt in grünem Glas
Vase, feuille d'argent enchâssée dans du verre vert
Vaas, zilverfolie omsloten in groen glas
c. 1900
h. 32,5 cm / 12.7 in.
Victoria and Albert Museum, London

Jewellery and clothing

*Sophistication and imagination
are the preeminent qualities in Art
Nouveau jewellery. It combines
metals and precious stones and
reflects an experimentation with
a variety of form and colour in
both linear and more elaborate
combinations. These pieces,
whether delicate and minute or
larger and more flamboyant, were
an essential part of a woman's
wardrobe: this also reached the
height of elegance with designers
such as Paul Poiret and Mariano
Fortuny.*

Schmuck und Bekleidung

*Die Goldschmiedemeister des Jugendstils
ließen durch das Verbinden von Metallen
und wertvollen Steinen Kostbarkeit und
Phantasie in ihre Werke einfließen und
sie probierten eine große Vielfalt an
Farben und Formen aus, die sowohl von
Geradlinigkeit als auch vom Rhythmus
der Form geprägt waren. Diese
Gegenstände, die entweder zierlich klein
oder spektakulär groß sind, bilden einen
wesentlichen Bestandteil des weiblichen
Schmucks, der eine in sich schon sehr
elegante Bekleidung, wie unter anderem
die von Paul Poiret und Mariano Fortuny
gefertigte, vervollkommnen soll.*

6

Bijoux et vêtements

*Luxe et fantaisie sont les
qualités que les joailliers
Art Nouveau déploient dans
leurs créations, en combinant
pierres et métaux précieux, et
en expérimentant une grande
variété de formes et de couleurs
marquées par la ligne autant
que par le rythme. Ces objets,
d'une petitesse exquise ou de
dimensions ostentatoires, font
partie des parures féminines qui
complètent des vêtements eux
aussi d'une grande élégance,
comme les créations de Mariano
Fortuny et de Paul Poiret.*

Juwelen en kleding

*Kostbaarheid en fantasie zijn kwaliteiten
die de meesters van de Art Nouveau
sieraden hebben overgedragen op hun
creaties, door metalen en edelstenen te
verbinden en door te experimenteren
met een grote verscheidenheid van
vormen en kleuren, de nadruk leggend
op zowel de rechtlijnigheid als het ritme
van de vorm. Deze voorwerpen, delicaat
en klein of juist opzichtig en groot van
afmeting, zijn essentieel onderdeel van
de vrouwelijke ornamenten die een
outfit met veel elegantie completeerden,
zoals de sieraden geproduceerd door
onder anderen Paul Poiret en Mariano
Fortuny.*

Art Nouveau jewellery and clothes
Art Nouveau Schmuck und Kleidung
Bijoux et costumes Art Nouveau
Juwelen en kleding Art Nouveau

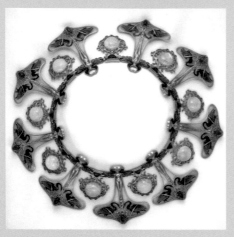

René Lalique
Necklace
Halskette
Collier
Halsketting
c. 1900
Metropolitan Museum of Art, New York

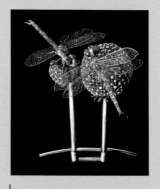

Louis Comfort Tiffany
Hair ornament
Haarschmuck
Ornement de cheveux
Haarornamenten
c. 1904
Metropolitan Museum of Art, New York

1900 **1901** **1902** **1903** **1904**

Lucien Gaillard
Moth pendant
Anhänger in Form eines Nachtfalters
Pendant d'oreille en forme de phalène
Hanger in de vorm van een nachtvlinder
c. 1900
Metropolitan Museum of Art, New York

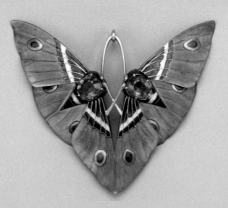

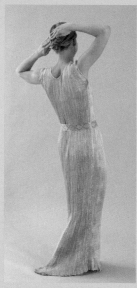

Mariano Fortuny
'Delphos' Tunic
Tunika 'Delphos'
Tunique « Delphes »
'Delphos' tunica
1907
Museum of Modern Art, New York

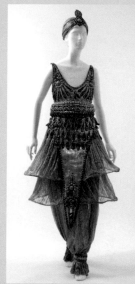

Paul Poiret
Costume (Fancy Dress)
Kostüm (Fancy Dress)
Déguisement
Kostuum (Fancy Dress)
1911
Metropolitan Museum of Art, New York

1905 **1906** **1907** **1908** **1909** **1910**

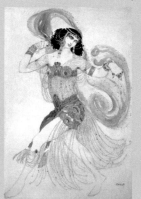

Léon Bakst
Salomé
1908
Tret'jakov Gallery, Moscow

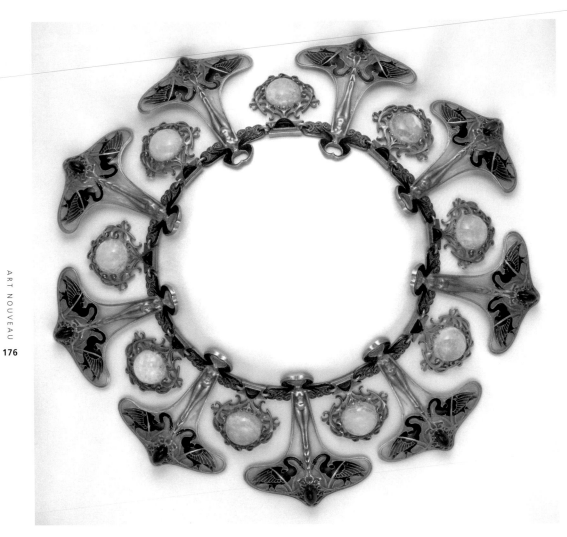

René Lalique
(Ay 1860 - Paris 1945)
Necklace, gold, enamel, Australian opal, Siberian amethyst
Halskette, Gold, Email, australischer Opal, sibirischer Amethyst
Collier, or, émail, opale d'australie, améthyste de Sibérie
Halsketting, goud, emaille, australisch opaal, siberisch amethist
c. 1900
ø 24,1 cm / 9.4 in.
Metropolitan Museum of Art, New York

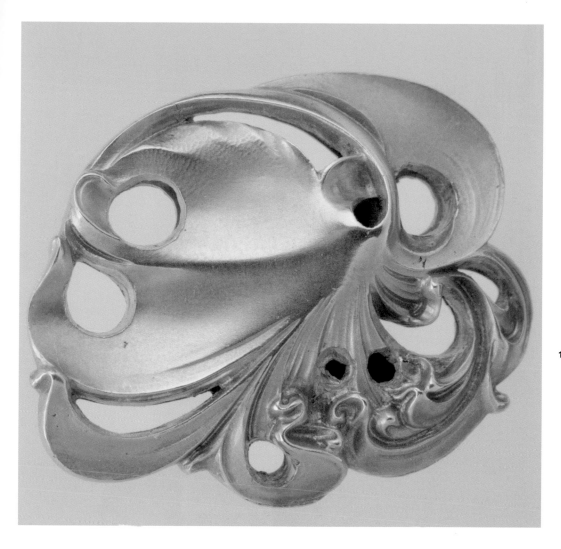

Hector Guimard
(Paris 1867 - New York 1942)
Hatpin, bronze
Hutnadel, hutnadel
Épingle à chapeau, Bronze
Hoedenspel, brons
c. 1910
2,56 x 2,56 cm / 1 x 1 in.
Museum of Modern Art, New York

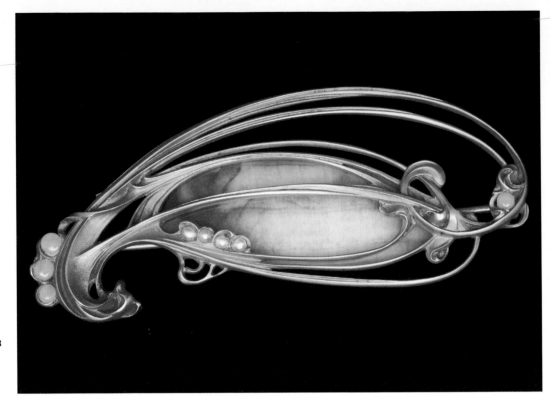

Hector Guimard
(Paris 1867 - New York 1942)
Brooch, gold, agate, pearl, moonstones
Brosche, Gold, Achat, Perlen, Mondstein
Broche, or, agate, perles, pierres de lune
Broche, goud, agaat, parels, maanstenen
1919
4,1 x 9,5 cm / 1.6 x 3.7 in.
Museum of Modern Art, New York

▶ **Lucien Gaillard**
(Paris 1861 - 1933)
Moth pendant, gold, enamel champlevé, citrine, horn
Anhänger in Form eines Nachtfalters, Gold, Champlevé-Email, Citrine, Horn Geschnitzt
Pendant d'oreille en forme de phalène, or, émail champlevé, citrines, corne sculptée
Hanger in de vorm van een nachtvlinder, hanger in de vorm van een nachtvlinder
c. 1900
7,6 x 9,2 cm / 2.9 x 3.6 in.
Metropolitan Museum of Art, New York

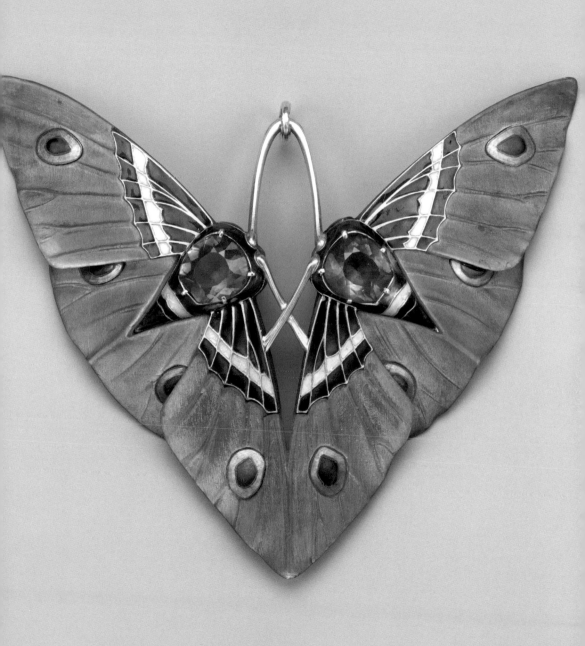

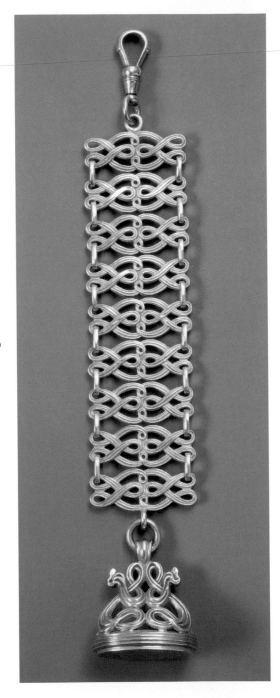

Carter Howe & Co.
Man's watch chain and seal
Herrenuhrkette und Siegel
Chaîne de montre pour homme et cachet
Heren horlogekettinkje en zegel
1890-1900
The Newark Museum, Newark

▶ **Henry Blank & Co. o Whiteside & Blank**
Brooch in the form of a woman with butterfly wings, gold, enamel, diamonds
Brosche in Form einer Frau mit Schmetterlingsflügeln, Gold, Email, Diamanten
Broche en forme de femme avec des ailes de papillon, or, émail, diamants
Broche in de vorm van een vrouw met vlindervleugels, goud, emaille, diamanten
c. 1900
The Newark Museum, Newark

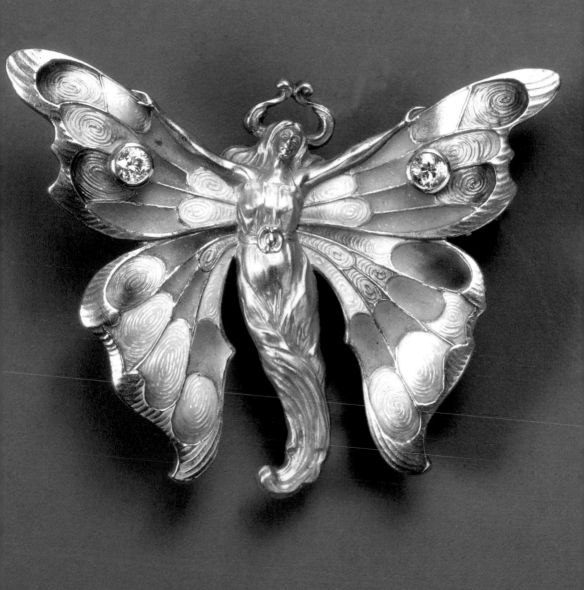

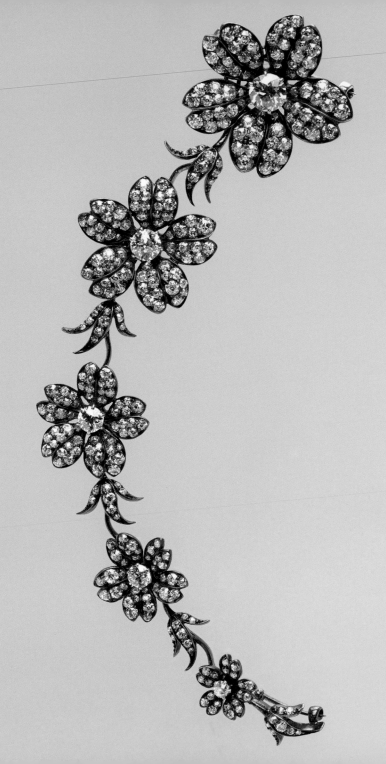

Louis Comfort Tiffany
(New York 1848 - 1933)
Hair ornament, silver, enamel, black opal, garnates
Haarschmuck, Silber, Email, schwarzer Opal und Granat
Ornement de cheveux, argent, émail, opales noires et roses, grenats
Haarornamenten, zilver, emaille, zwart opaal en graniet
c. 1904
h. 8,3 cm / 3.2 in.
Metropolitan Museum of Art, New York

◀ **Tiffany & Company**
Corsage piece, gold, diamonds
Anstecknadel, Gold, Diamanten
Chaîne de gilet, or, diamants
Corsage voor op de taille, goud, diamanten
c. 1880-1900
3 x 15,9 cm / 1.1 x 6.2 in.
Metropolitan Museum of Art, New York

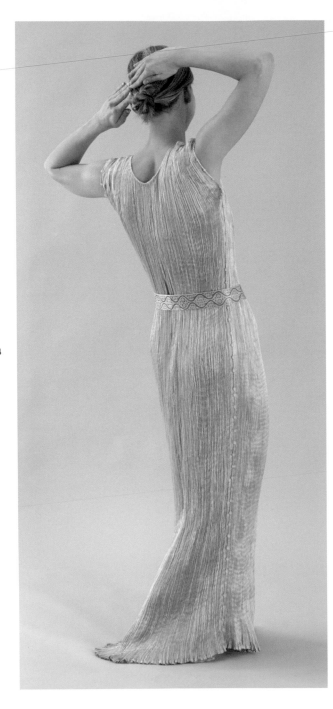

Mariano Fortuny
(Granada 1861 - Venezia 1949)
'Delphos' Tunic, silk and glass beads
Tunika 'Delphos', Seide und Glasperlen
Tunique « Delphes », et détails de la ceinture, soie et
petites perles de verre
'Delphos' tunica, zijde en glasparels
1907
153,7 x 48,3 cm / 60.5 x 19 in.
Museum of Modern Art, New York

▶ **Paul Poiret**
(Paris 1879 - 1944)
Costume (Fancy Dress), metal, silk and cotton
Kostüm (Fancy Dress), Metall, Seide, Baumwolle
Déguisement, métal, soie, coton
Kostuum (Fancy Dress), metaal, zijde, katoen
1911
Metropolitan Museum of Art, New York

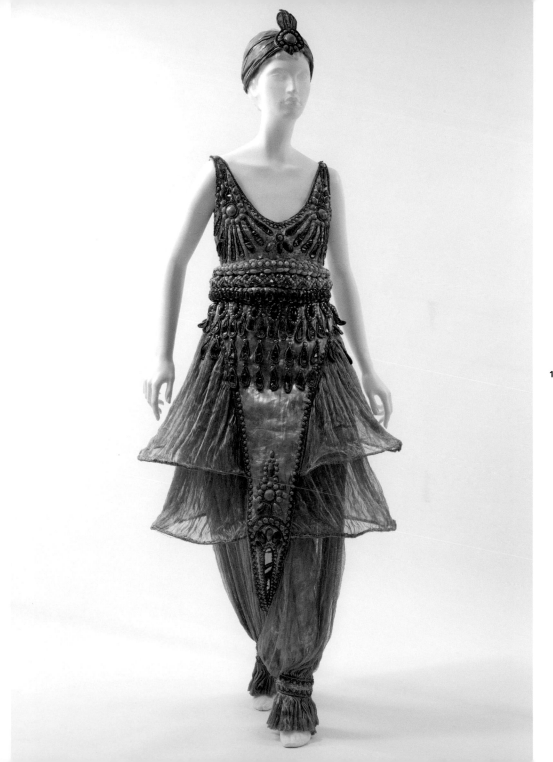

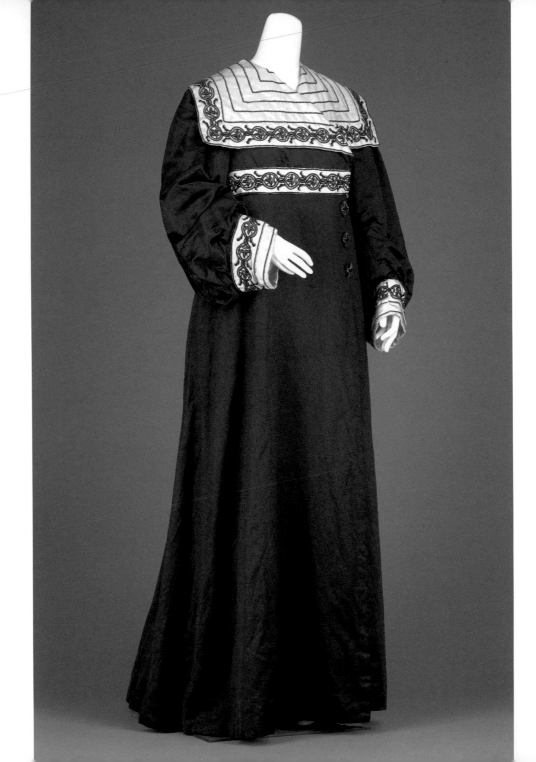

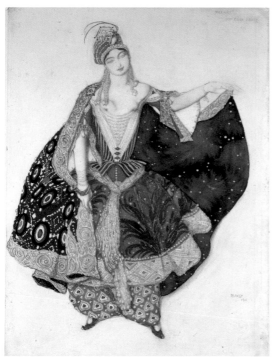 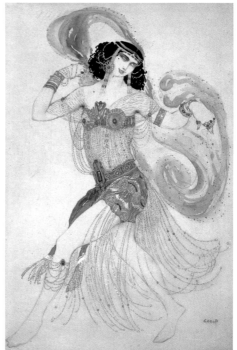

Léon Bakst
(Saint Petersburg 1866 - Paris 1924)
Drawing of costume for Roxanne, chalk, watercolour, gouache and silverpoint
Entwurf für das Kostüm von Roxanne, Kreide, Aquarell, Gouache und Silberspitze
Dessin pour le costume de Roxane, craie, aquarelle, gouache et pointe d'argent
Ontwerp voor het kostuum van Roxanne, krijt, aquarel, gouache en zilverpunt
1911
Kunstbibliothek, Staatliche Museen zu Berlin, Berlin

Léon Bakst
(Saint Petersburg 1866 - Paris 1924)
Salomé
1908
Tret'jakov Gallery, Moscow

◀ **Liberty & Co.**
Woman's coat, silk and wool
Damenmantel, Seide, Wolle
Manteau de femme, soie et laine
Overjas voor dames, zijde, wol
h. 149,9 cm / 59 in.
Museum of Fine Arts, Boston

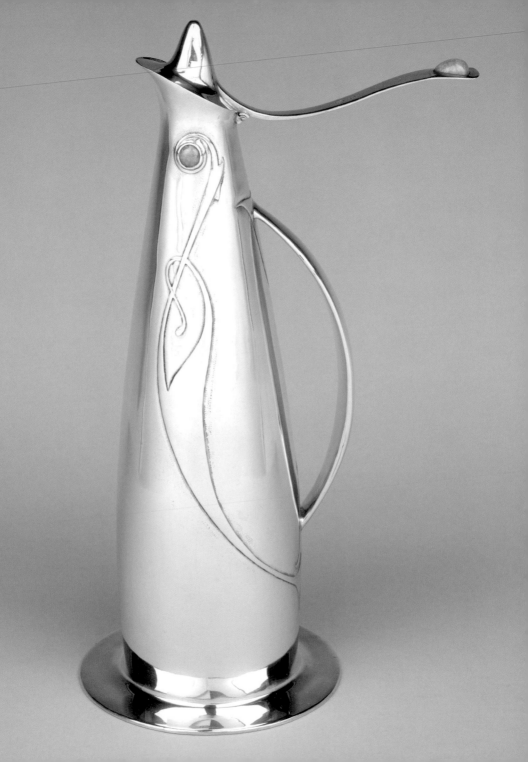

Art and craftmanship

The concept of design, now applied universally to a wide range of manufactures including household objects, was born with Art Nouveau. Artists such as Mackintosh, Hoffmann, Tiffany, Guimard, and specialised workshops produced objects in glass, metal, and wood which met the highest aesthetic and functional requirements, making art part of everyday life.

Angewandte Kuenste

Das Design entsteht im Jugendstil und ist heute ein allgemeiner Begriff, der unter anderem auf Utensilien und unzählige Gegenstände des täglichen Gebrauchs bezogen wird. Dank großer Künstler wie Mackintosh, Hoffmann, Tiffany, Guimard und Dank der Produktionswerkstätten macht der Jugendstil durch Verleihung von Eleganz, Funktionalität und Originalität aus Utensilien unterschiedlichster Materialien, von Holz über Metall bis hin zu Glas, zugängliche Kunstgegenstände.

7

Arts Mineurs

Le design - terme aujourd'hui universel qui désigne entre autres les ustensiles et innombrables objets d'usage courant - naît avec l'Art Nouveau. Grâce à des artistes comme Mackintosh, Hoffmann, Tiffany ou Guimard et aux ateliers qu'ils font travailler, l'Art Nouveau fait de l'ustensile, traité dans les matériaux les plus divers, du bois au verre en passant par le métal, un objet artistique accessible à tous, en lui conférant élégance, fonctionnalité et originalité.

Kleinere Ambachten

Design, universele term die tegenwoordig onder andere voorwerpen en ontelbare dagelijkse gebruiksvoorwerpen aanduidt, ontstond samen met de Art Nouveau, die, dankzij kunstenaars als Mackintosh, Tiffany en Guimard en de productiewerkplaatsen, ervoor zorgde dat een gebruiksvoorwerp, gemaakt van de meest uiteenlopende materialen, van hout tot metaal en tot glas; een artistiek toegankelijk voorwerp, met toegekende elegantie, functionaliteit en originaliteit, werd.

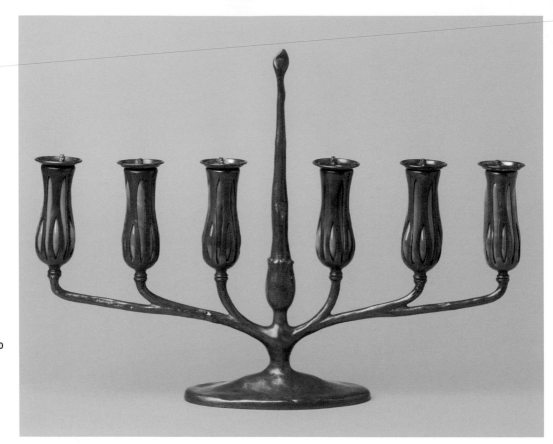

Louis Comfort Tiffany
(New York 1848 - 1933)
Six armed candlestick, bronze and green glass
Kerzenleuchter sechsarmig, Bronze und grünes Glas
Candélabre à six branches, bronze et verre vert
Kandelaber met zes armen, brons en groen glas
c. 1900
38,7 x 53,3 cm / 15.2 x 20.9 in.
Museum of Modern Art, New York

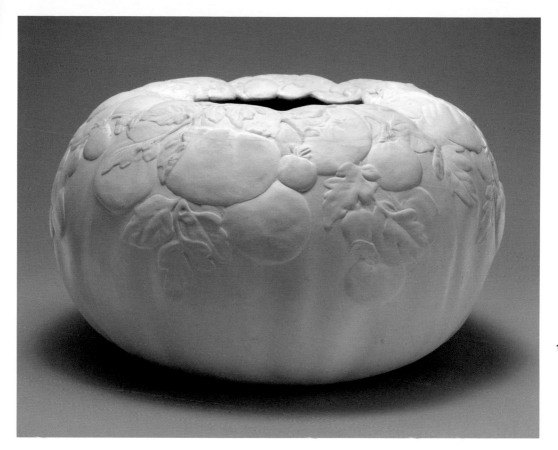

Louis Comfort Tiffany
(New York 1848 - 1933)
Vase, glazed white clay
Vase, Steingut, weiß glasiert
Vase, faïence vernissée blanche
Vaas, wit verglaasd aardewerk
c. 1904 -1914
20,3 x 34,3 cm / 7.9 x 13.5 in.
Metropolitan Museum of Art, New York

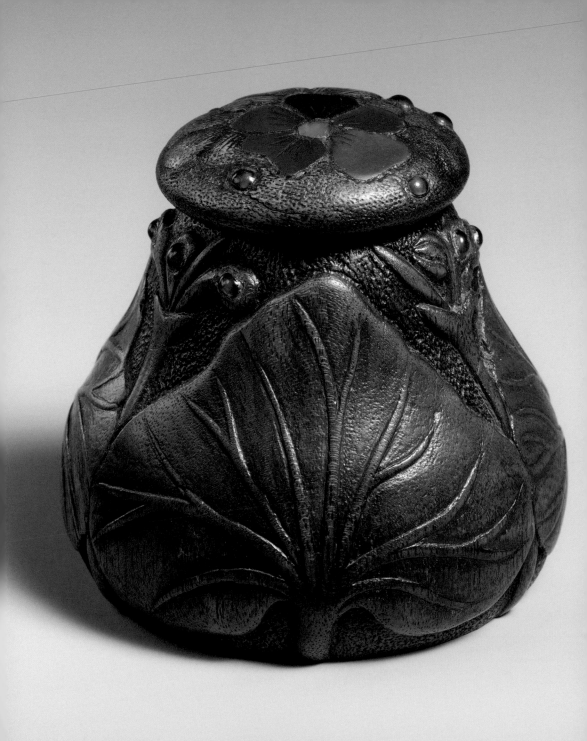

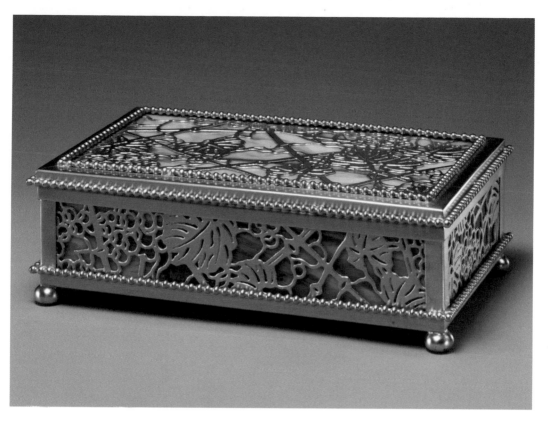

Louis Comfort Tiffany
(New York 1848 - 1933)
Covered box, gilt metal, favrile glass
Dose mit Deckel, Metall vergoldet, Favrile-Glas
Boîte avec couvercle, métal doré, verre favrile
Kistje met deksel, verguld metaal, favrile glas
c. 1905 -1920
5,4 x 16,4 x 10,2 cm / 2.1 x 6.4 x 4 in.
Metropolitan Museum of Art, New York

◄ **Louis Comfort Tiffany**
(New York 1848 - 1933)
Small pot with lid, European walnut (?), glass
Behälter mit Deckel, europäisches Nußholz (?), Glas
Boîte avec couvercle, bois de noyer, verre
Doosje met deksel, europees notenhout (?), glas
c. 1905-1913
h. 6,7 cm / 2.6 in.
Metropolitan Museum of Art, New York

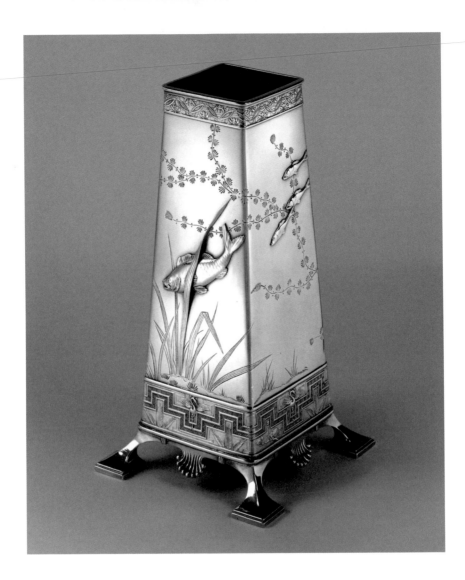

Edward C. Moore
(1827 - 1891)
Vase, silver
Vase, Silber
Vase, argent
Vaas, zilver
1873-1875
20,6 x 10,8 x 10,8 cm / 8.1 x 4.2 x 4.2 in.
Metropolitan Museum of Art, New York

▶ **Tiffany & Company**
Tray, silver, copper and gold
Tablett, Silber, Kupfer und Gold, bunt
Plateau, argent, cuivre et or
Dienblad, zilver, koper en gekleurd goud
1879-1880
2,2 x 23,2 cm / 0.8 x 9.1 in.
Metropolitan Museum of Art, New York

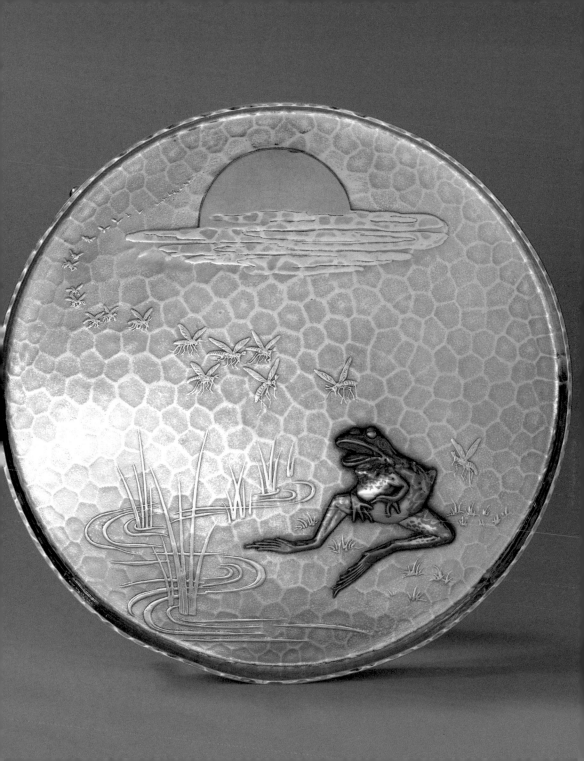

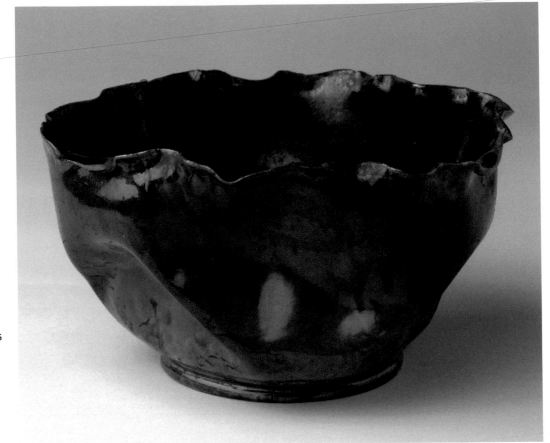

George Ohr
(Biloxi 1857 - 1918)
Bowl, glazed ceramic
Schüssel, Keramik, mit Glasur
Bol, céramique vitrifiée
Kom, verglaasd keramiek
c. 1900
10,2 x 20,3 cm / 4 x 7.9 in.
Museum of Modern Art, New York

▶ **Paul Revere Pottery**
Vase, earthenware
Vase, Steingut
Vase, faïence
Vaas, aardewerk
1915
40,6 x 22,9 cm / 15.9 x 9 in.
Metropolitan Museum of Art, New York

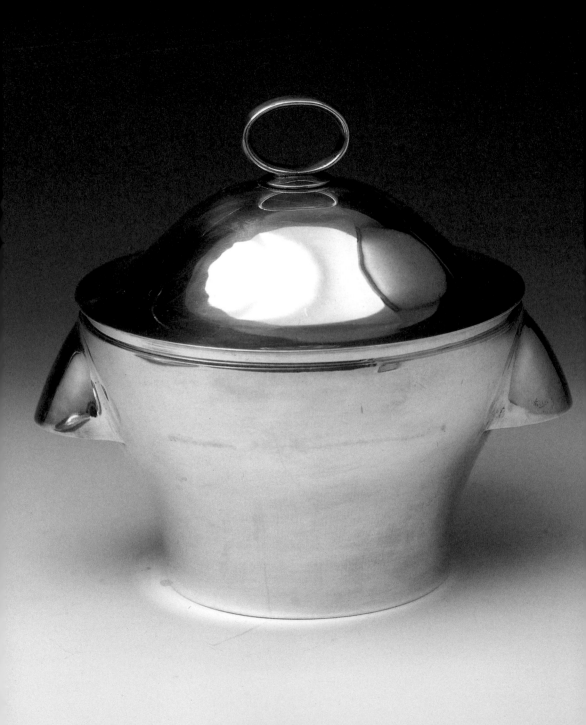

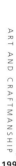

Josef Hoffmann
(Pirnitz 1870 - Wien 1956)
Oval table with high rim for the Cabaret Fledermaus
Ovales Tablett mit hohem Rand für das Kabarett Fledermaus
Tablette ovale à haut bord pour le Cabaret Fledermaus [Cabaret de la chauve-souris]
Ovalen plaat met hoge rand voor het Cabaret Fledermaus
c. 1905
Private Collection / Privatkollektion / Collection privée / Privécollectie

◄ **Josef Hoffmann**
(Pirnitz 1870 - Wien 1956)
Soup tureen with lid for the Cabaret, silver and Nickel
Suppentopf mit Deckel für das Kabarett Fledermaus, Silber und Nickel
Soupière avec couvercle pour le Cabaret Fledermaus [Cabaret de la chauve-souris],
argent et nickel
Soepterrine met deksel voor het Cabaret Fledermaus, zilver en nikkel
c. 1905
h. 18,5 cm / 7.2 in.
Private Collection / Privatkollektion / Collection privée / Privécollectie

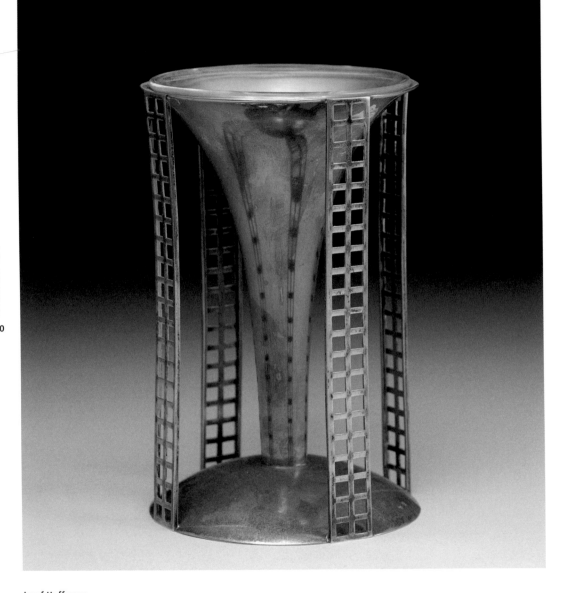

Josef Hoffmann
(Pirnitz 1870 - Wien 1956)
Conical vase, silver or silver-plated metal
Konische Vase, Silber oder versilbertes Metall
Vase conique, argent ou métal plaqué argent
Conische vaas, zilver of zilver verguld metaal
c. 1905

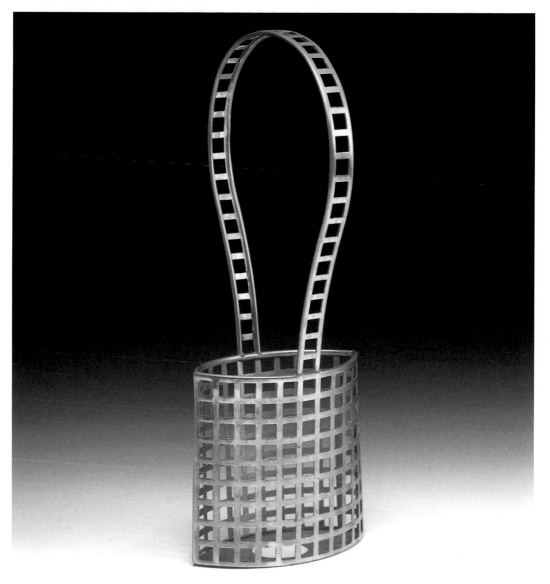

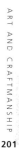

Josef Hoffmann
(Pirnitz 1870 - Wien 1956)
Elliptical vase with basket handle, machine perforated sterling silver
Ellipsenförmiges Gefäß mit schlingenförmigem Griff, versilbert mit Silber oder weißer Legierung, punziert
Vase elliptique avec anse en forme de noeud coulant, argenté avec argent ou alliage blanc, poinçonné
Elliptische vaas met lusvormige handgreep, verzilverd met zilvere of witte legering, gemerkt
c. 1906
Private Collection / Privatkollektion / Collection privée / Privécollectie

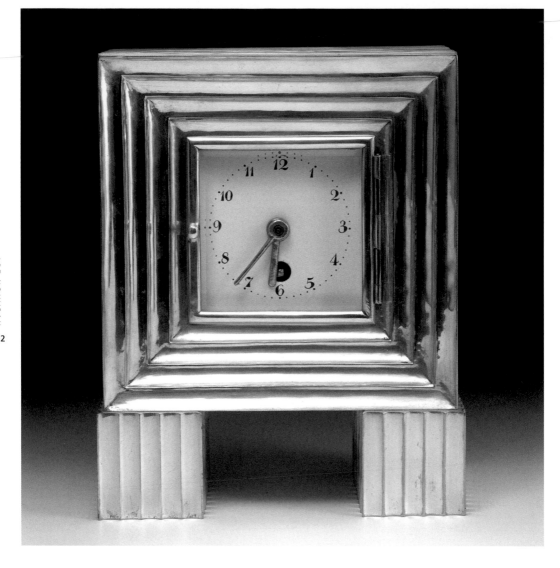

Josef Hoffmann
(Pirnitz 1870 - Wien 1956)
Clock, silver
Uhr, Silber
Pendule, argent
Klok, zilver
c. 1910
Private Collection / Privatkollektion / Collection privée /
Privécollectie**Wiener Werkstaette**

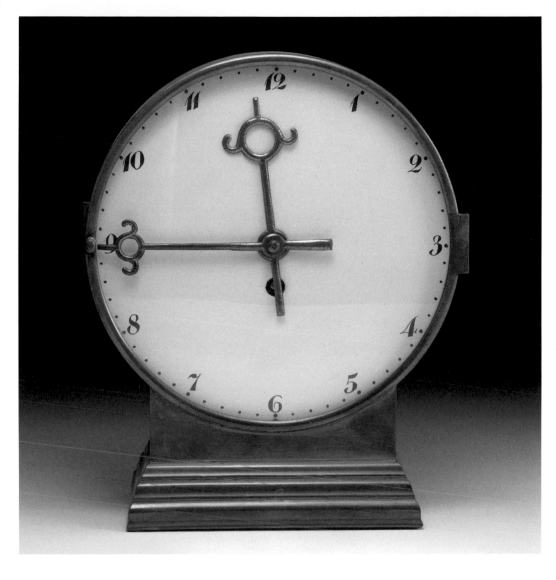

Josef Hoffmann
(Pirnitz 1870 - Wien 1956)
Round clock, brass
Uhr mit rundem Uhrenkasten, Messing
Montre à boîtier rond, laiton
Klok met ronde wijzerplaat, messing
Private Collection / Privatkollektion / Collection privée / Privécollectie

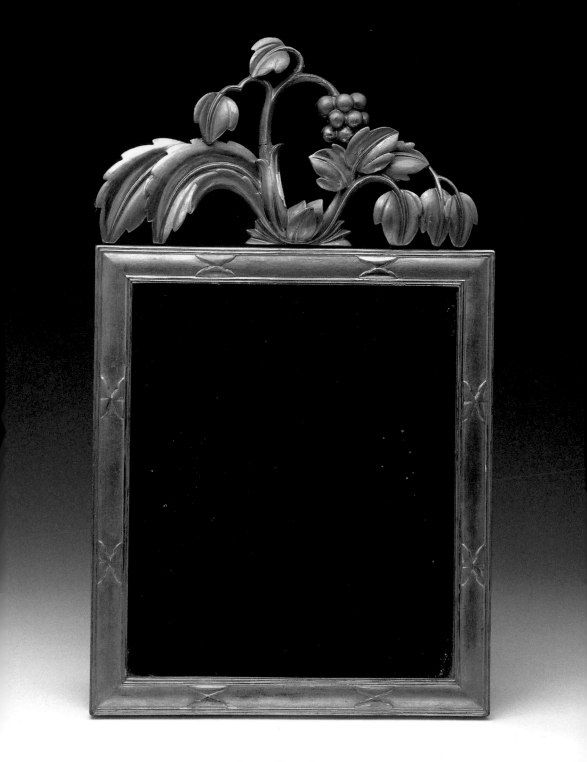

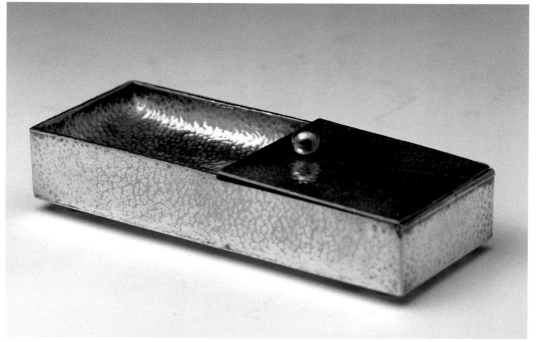

■ The Wiener Werkstätte, a famous Vienese company founded in 1903 by the architect Josef Hoffmann, aimed to produce crafted pieces accessibile to a wide public, satisfying both funtional and aesthetic requirements.
■ Die berühmte Wiener Werkstätte wurde 1903 ebendort vom Architekten Josef Hoffmann gegründet und befürwortete eine für das breite Publikum erschwingliche Produktion, die unter Beibehaltung ihrer kunsthandwerklichen Eigenarten Funktionalität und Ästhetik verbinden sollte.
■ La Wiener Werkstätte, célèbre entreprise viennoise fondée en 1903 par l'architecte Josef Hoffmann, se proposait de réaliser une production accessible à un vaste public et unissant esthétique et fonctionnalité, tout en gardant un caractère artisanal.
■ De Wiener Werkstätte, beroemde Weense onderneming, in 1903 opgericht door de architect Joseph Hoffmann, legde zich toe op het verwezenlijken van een voor een groot publiek toegankelijke productie, die functionaliteit verbond met schoonheid, met behoud van een ambachtskarakter.

Wiener Werkstätte
Small box with ash tray, alpaca and silver
Dose mit Aschenbecher, Alpaka und Silber
Petite boîte avec cendrier, maillechort et argent
Doosje met asbak, alpaca en zilver
c. 1903-1904
Private Collection / Privatkollektion / Collection privée / Privécollectie

◀ **Dagobert Peche**
(Sankt Michael im Lungau 1887 - Wien 1923)
Mirror with top ornament, gold-plated linden wood
Spiegel mit Ornament, oben, Linde geschnitzt, goldplattiert
Miroir avec ornement dans la partie haute, bois de tilleul sculpté plaqué or
Spiegel met ornament bovenop, verguld ingekerfd lindehout
1922
Private Collection / Privatkollektion / Collection privée / Privécollectie

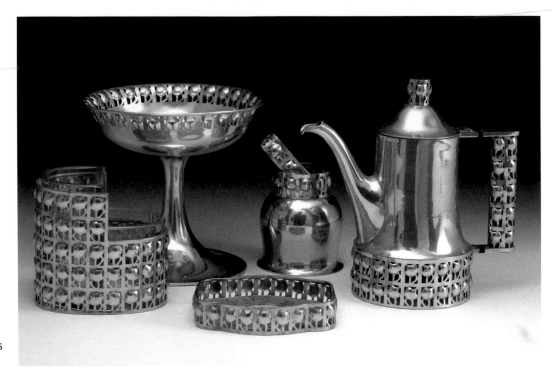

Wiener Werkstätte
Five piece set: jug, sugar-bowl, fruit dish, vase and tray, silver and silverplate
Fünfteiliges Tischset: Kanne, Zuckerdose, Obstschale, Blumenvase und kleines Tablett, Silber oder silberplattiertes Metall
Service de table de cinq pièces : verseuse, sucrier, compotier, vase et petit plateau, argent ou métal plaqué argent
5-delige Tafelset: kannetje, suikerpot, fruitschaal, bloemenvaas en dienblad, zilver of zilver verguld metaal
c. 1905
Private Collection / Privatkollektion / Collection privée / Privécollectie

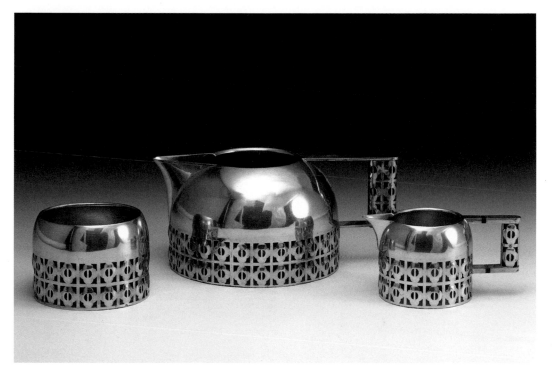

Wiener Werkstätte
Coffee set: coffee pot, milk jug, sugar bowl, silver and silverplate
Dreiteiliges Kaffeeset: Kaffeekanne, Milchkännchen, Zuckerdose, Silber oder silberplattiertes Metall
Service à café de trois pièces : cafetière, pot à lait, sucrier, argent ou métal plaqué argent
3-delige Koffieset: koffiepot, melkkannetje, suikerpot, zilver of zilver verguld metaal
c. 1905
Private Collection / Privatkollektion / Collection privée / Privécollectie

▶ **Charles Rennie Mackintosh**
(Glasgow 1868 - London 1928)
Fish cutlery silver nickel
Fischbesteck, Nickel versilbert
Couverts à poisson, nickel argenté
Visbestek, verzilverd nikkel
c. 1900
23,5 x 6,1 cm / 22,9 x 2,8 cm
9.2 x 2.4 in. / 9 x 1.1 in.
Museum of Modern Art, New York

▶ **Charles Rennie Mackintosh**
(Glasgow 1868 - London 1928)
Fabric, cotton with cylindrical print
Stoff, Baumwolle, Zylinderdruck
Tissu d'ameublement, cretonne imprimée au cylindre
Textiel, op cilinder bedrukt katoen
c. 1922
88,5 x 78,4 cm / 34.8 x 30.8 in.
Victoria and Albert Museum, London

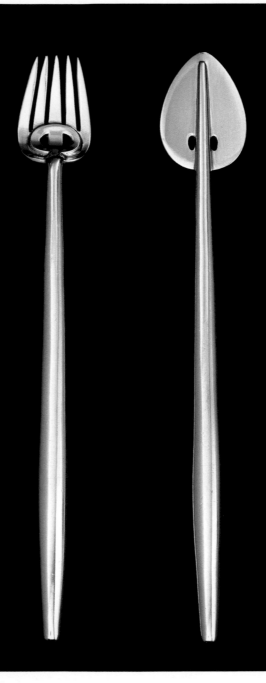

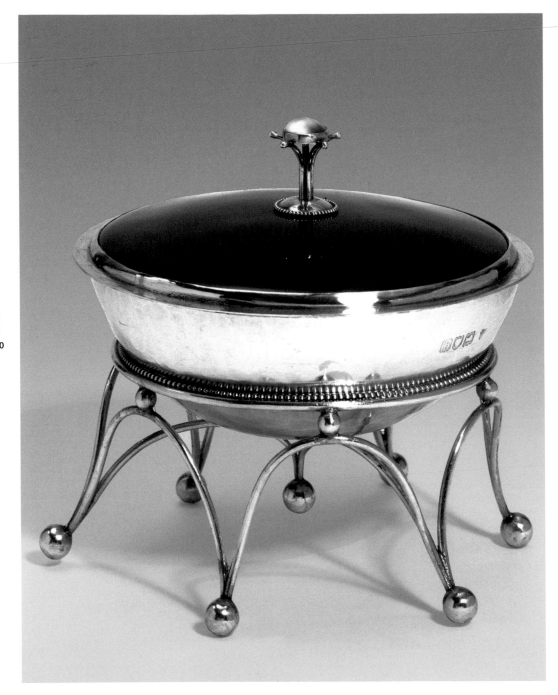

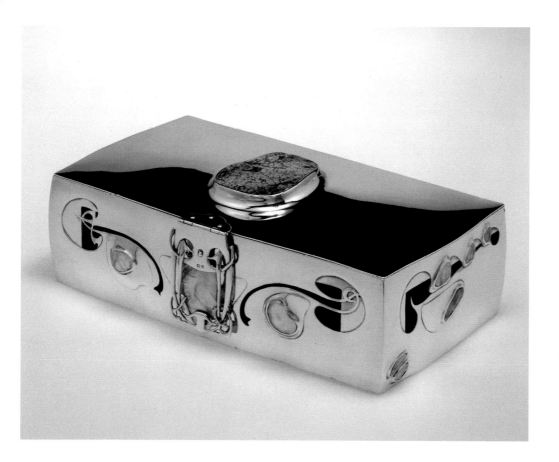

Archibald Knox
(Cronkbourne 1864 - Braddan 1933)
Jewelbox, silver, mother of pearl, turquoise, enamel
Schmuckdose, Silber, Perlmutt, Türkis, Email
Boîte à bijoux, argent, nacre, turquoise, émail
Juwelenkistje, zilver, parelmoer, turkoois, emaille
c. 1900
10,2 x 29,2 x 16,5 cm / 4 x 11.4 x 6.4 in.
Museum of Modern Art, New York

◀ **Charles Robert Ashbee**
(Isleworth 1863 - London 1942)
Bowl, silver, red enamel and semi-precious stones
Schüssel, Silber, rotes Email und Halbedelsteine
Bol à couvercle, argent, émail rouge et pierres semi-précieuses
Kom, zilver, rood emaille en halfedelstenen
1899-1900
h. 11,5 cm / 4.5 in.
Victoria and Albert Museum, London

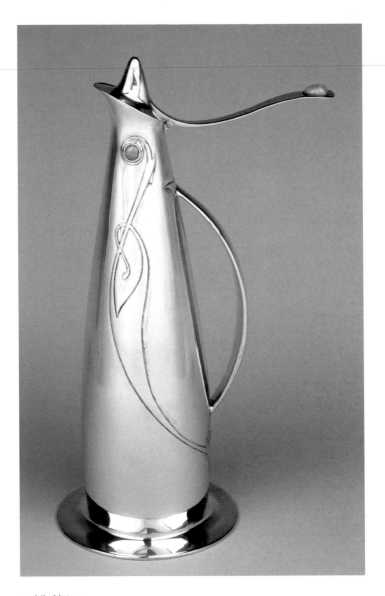

Archibald Knox
(Cronkbourne 1864 - Braddan 1933)
Jug, silver and chrysophrase
Krug, Silber, Chrysopras
Carafe à vin, argent, chrysoprase
Kan, zilver, chrysopraas
1900-1901
h. 29,2 cm / 11.4 in.
Metropolitan Museum of Art, New York

▶ **Charles Francis Annesley Voysey**
(Yorkshire 1857 - Winchester 1941)
Bedspread, silk
Bettbezug, seide
Couvre-lit, soie
Sprei, zijde
316 x 181,5 cm / 124.4 x 71.4 in.
Museum of Fine Arts, Boston

Liberty & Co.
Inkpot, pewter and copper enamel
Tintenfass, Hartzinn und emailliertes Kupfer
Encrier, étain argenté et cuivre émaillé
Inktpot, tin en geëmailleerd koper
1904
8,9 x 15,2 x 15,2 cm / 3.5 x 5.9 x 5.9 in.
Museum of Modern Art, New York

▶ **Manifattura Chini**
Jug with serpents, polychrome maiolica
Krug mit Schlangen, majolica, mehrfarbig
Pichet à décor de serpents, majolique polychrome
Bokaal met slangen, polycroom majolica
c. 1896-1898

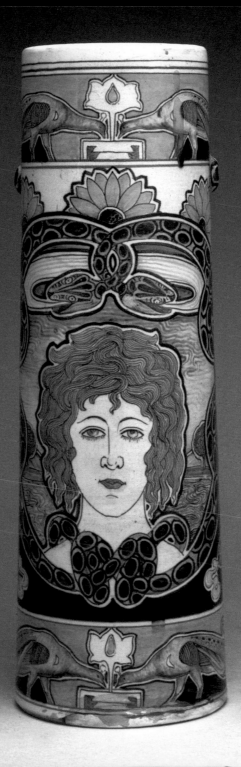

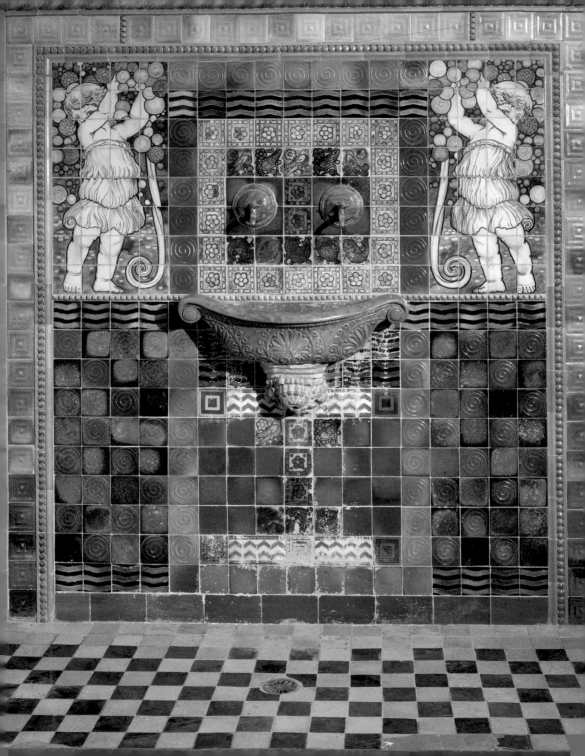

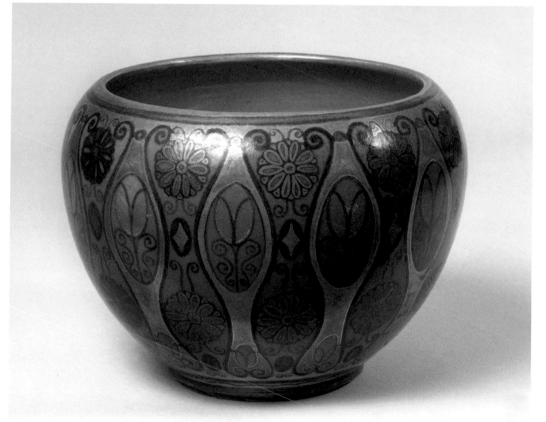

Manifattura Chini
Vase with floral motifs
Vase mit Blumenmotiven Keramikmuseum
Vase à motifs floraux
Vaas met bloemenmotief
Museo delle Ceramiche, Faenza

◀ **Galileo Chini**
(Firenze 1873 - Lido di Camaiore, Lucca 1956)
Maiolica decoration with putti and a pool, polychrome maiolica
Dekoration mit Putten und Wanne, majolica mehrfarbig
Décoration avec putti et vasque, majolique polychrome
Decoratie met putti en kuip, polychroom majolica
c. 1910
Stabilimento Termale Tamerici, Montecatini Terme (Pistoia)

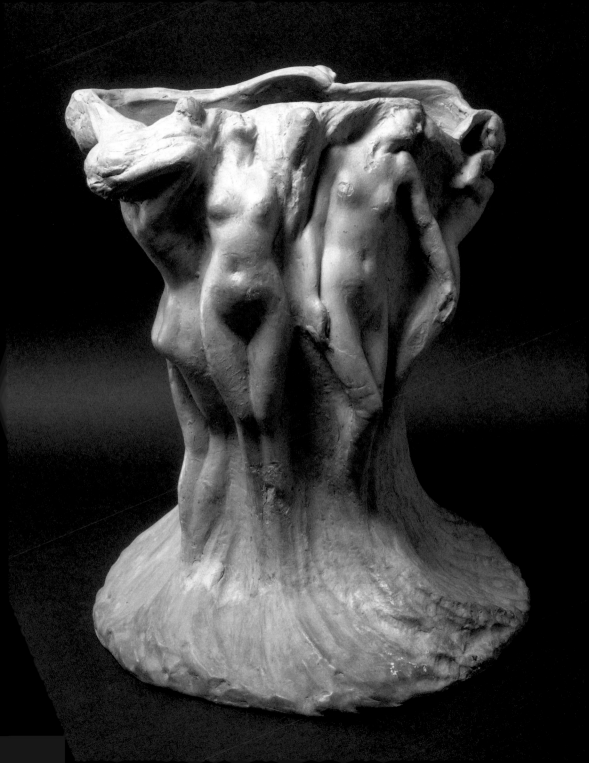

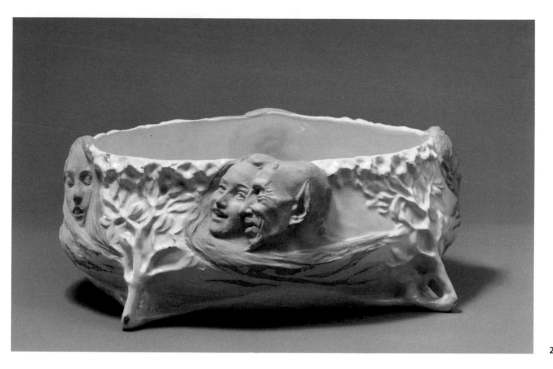

Domenico Baccarini
(Faenza 1882 - 1907)
Cache-pot with nymphs and fauns
Übertopf mit Nymphen und Faunen
Cache-pot à décor de nymphes et de faunes
Cache-pot met nimfen en faunen
1907
Museo delle Ceramiche, Faenza

◄ **Domenico Baccarini**
(Faenza 1882 - 1907)
Vase
Vaas
1904
Museo delle Ceramiche, Faenza

Basilio Cascella
(Pescara 1860 - Roma 1950)
Allegory of Maturity, polychrome ceramic
Allegorie der Reife, Keramik, mehrfarbig
Allégorie de la maturité, céramique polychrome
Allegorie van de volwassenheid, polychroom keramiek
1926
Stabilimento Termale Il Tettuccio, Montecatini Terme (Pistoia)

Basilio Cascella
(Pescara 1860 - Roma 1950)
Allegory of Beauty, polychrome ceramic
Allegorie der Schönheit, céramique polychrome
Allégorie de la beauté, keramik, mehrfarbig
Allegorie van de schoonheid, polychroom keramiek
1926
Stabilimento Termale Il Tettuccio, Montecatini Terme (Pistoia)

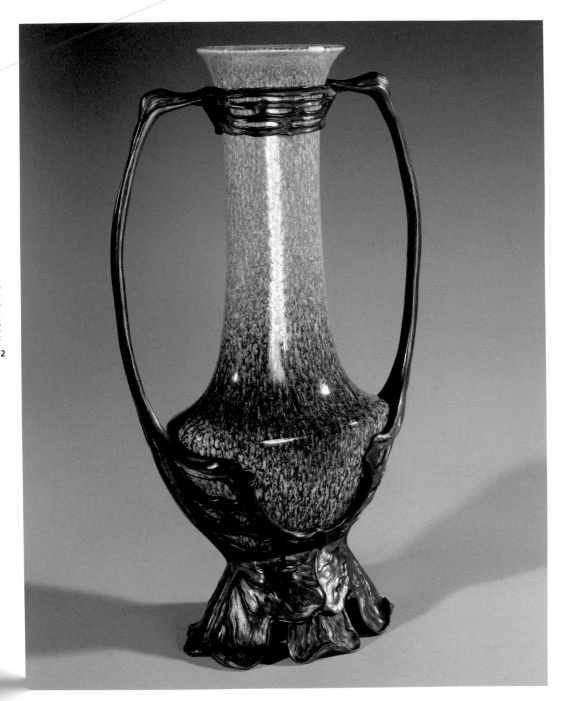

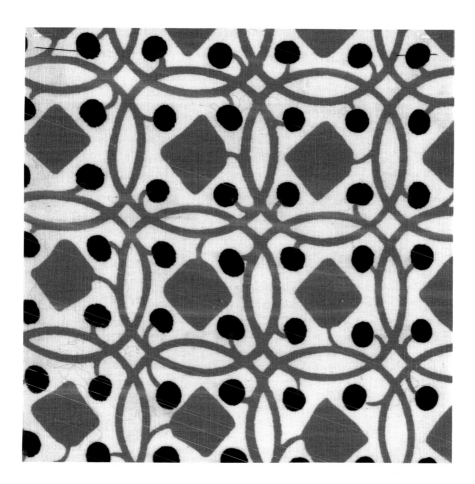

Richard Riemerschmid
(München 1868 - 1957)
Drapery Fabric, printed cotton
Textilfabrik, Baumwolldruck
Étoffe de tenture, coton imprimé
Drapery Fabric, bedrukt katoen
1908
17,4 x 17,4 cm / 6.8 x 6.8 in.
Museum of Modern Art, New York

◄ **Otto Eckmann e Otto Schultz**
(Hamburg 1865 - Badenweiler 1902)
Vase, porcelain and bronze
Vase, Porzellan und Bronze
Vase, porcelaine et bronze
Vaas, porselein en brons
1897-1900
51,7 x 29 x 16 cm / 20.3 x 11.4 x 6.2 in.
Musée d'Orsay, Paris

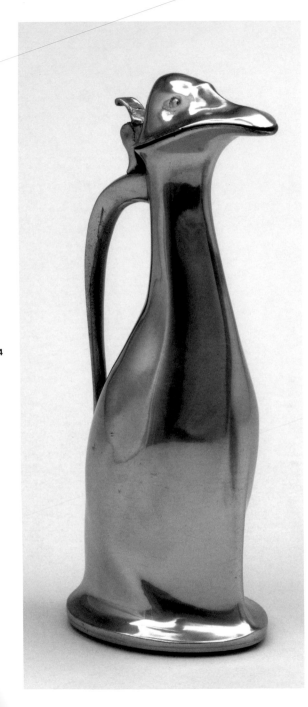

J.P. Kayser & Sohn
Caraffe, pewter
Karaffe, Hartzinn
Carafe, étain argenté
Karaf, tin
1900-1902
20,3 x 9,2 x 6,7 cm / 7.9 x 3.6 x 2.6 in.
Museum of Modern Art, New York

▶ **Emile Gallé**
(Nancy 1846 - 1904)
Vase decorated with lilies
Vase, mit Lilien verziert
Vase à décor de lis
Vaas gedecoreerd met lelies
1900
25,2 cm / 9.9 in.
Kunstgewerbemuseum, Staatliche Museen zu Berlin, Berlin

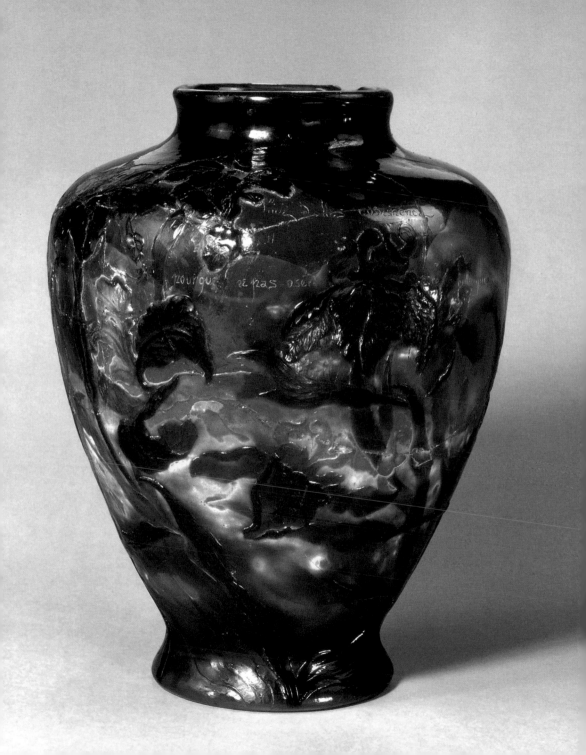

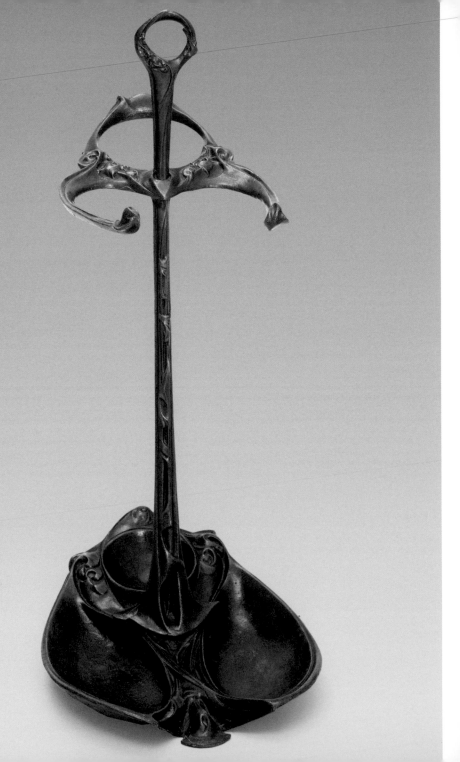

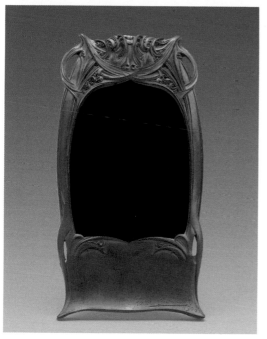

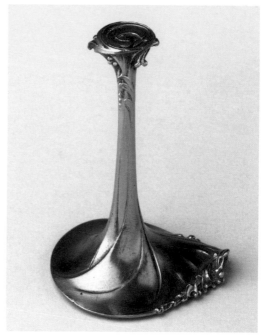

Hector Guimard
(Paris 1867 - New York 1942)
Frame, bronze
Bilderrahmen, Bronze
Cadre, bronze
Lijst, brons
1908
15,4 x 8,3 x 7,3 cm / 6 x 3.2 x 2.8 in.
Museum of Modern Art, New York

Hector Guimard
(Paris 1867 - New York 1942)
Seal, bronze
Siegel, Bronze
Cachet, bronze doré
Zegel, brons
1913
6,1 cm / 2.4 in.
Museum of Modern Art, New York

◀ **Hector Guimard**
(Paris 1867 - New York 1942)
Umbrella stand, iron
Schirmständer, Eisen
Porte-parapluies, fonte peinte
Parapluhouder, ijzer
1907
83,8 x 34,3 x 47 cm / 32.9 x 13.5 x 18.5 in.
Museum of Modern Art, New York

1861

❚ English painter and designer William Morris founded his decorative arts firm in England.

❚ Der Maler und Designer William Morris eröffnet in England das erste Geschäft, in dem Dekorationsgegenstände verkauft werden.

❚ Le peintre et styliste William Morris ouvre en Angleterre le premier négoce d'objets de décoration.

❚ De schilder en ontwerper William Morris opent in Engeland de eerste winkel voor decoratieve voorwerpen.

1870

❚ The book *The Technical Educator*, by Chistopher Dresser, launched one of Art Nouveau's key themes: plant motifs.

❚ Das Buch *The Technical Educator* von Chistopher Dresser schafft eines der bedeutendsten Themen der Art Nouveau Bewegung: die Pflanzenmotive.

❚ Le livre *The Technical Educator*, de Chistopher Dresser, invente l'un des thèmes les plus féconds de l'Art Nouveau : les motifs végétaux.

❚ Het boek *The Technical Educator*, van Christopher Dresser, creëert één van de meest vitale thema's van de Art Nouveau: de plantenmotieven.

1872

❚ The arts and crafts movement held an exhibition at Princeton University.

❚ An der Princeton University wird die Ausstellung "The arts and crafts movement" eröffnet.

❚ Ouverture de l'exposition « *The Arts and Crafts Movement* » à l'université de Princeton.

❚ The Arts and Crafts Movement Tentoonstelling vindt plaats in de Princeton University.

1879

❚ Foundation of Louis Comfort Tiffany Company Associated Artists, specialising in interior decoration.

❚ Es kommt zur Gründung der Louis Comfort Tiffany Company Associated Artists, die auf Inneneinrichtung spezialisiert ist.

❚ Fondation de la « *Louis Comfort Tiffany Company Associated Artists* », spécialisée dans le stylisme et les aménagements intérieurs.

❚ Oprichting van Louis Comfort Tiffany & Associated Artists, gespecialiseerd in de interieurvezoring.

1880

❚ French sculptor Auguste Rodin commissioned to cast a bronze door – known as the *Door of Hell* – for the new Musée des Arts Décoratifs in Paris.

❚ Der französische Bildhauer Auguste Rodin wird mit der Anfertigung einer Bronzetür, bekannt als *Das Höllentor*, für das neue Musée des Arts Décoratifs in Paris beauftragt.

❚ Le sculpteur Auguste Rodin reçoit la commande d'une porte de bronze monumentale pour le nouveau musée des Arts décoratifs de Paris : ce sera la *Porte de l'Enfer*.

❚ Er wordt een bronzen deur besteld bij de Franse beeldhouwer Auguste Rodin – bekend als de *Poort van de hel* – voor het nieuwe Museé des Arts Décoratifs van Parijs.

1882	■ English architect and designer Arthur Mackmurdo founded the Century Guild, an association of artists craftsmen and designers.	■ Der englische Architekt und Designer Arthur Mackmurdo gründet den Century Guild, einen Künstler, Handwerker- und Designerverein.	■ L'architecte et styliste anglais Arthur Mackmurdo fonde la « Century Guild », association d'artistes, à la fois stylistes et artisans.	■ De Engelse architect en designer Arthur Mackmurdo richt de Century Guild op, een vereniging voor ambachtskunstenaars en designers.
1883	■ Spanish architect Antoni Gaudí began work on the Sagrada Familia.	■ Der spanische Architekt Antoni Gaudí beginnt mit den Arbeiten an der Sagrada Familia.	■ L'architecte espagnol Antoni Gaudí lance les travaux du sanctuaire de la Sagrada Familia.	■ De Spaanse architect Antoni Gaudí begint aan de werken voor de Sagrada Familia.
1887	■ Czech artist Alphonse Mucha began working as an illustrator for the most fashionable magazines in Paris.	■ In Paris beginnt der Tschechoslowake Alphonse Mucha seine Tätigkeit als Illustrator bei den modernsten Zeitungen.	■ À Paris, le tchèque Alfons Mucha inaugure l'activité d'illustrateur dans les journaux et revues à la mode.	■ In Parijs begint de Tsjechoslowaakse Alphonse Mucha zijn werkzaamheden als illustrator bij de meest bekende bladen.
1888	■ William Morris, Arthur Mackmurdo, Walter Crane and Charles Roberts Ashbee founded Arts and Crafts Exhibition Society.	■ William Morris, Arthur Mackmurdo, Walter Crane und Charles Roberts Ashbee gründen die Arts and Crafts Exhibition Society.	■ William Morris, Arthur Mackmurdo, Walter Crane et Charles Roberts Ashbee fondent l'« Arts and Crafts Exhibition Society ».	■ William Morris, Arthur Mackmurdo, Walter Crane en Charles Roberts Ashbee richten de Arts and Crafts Exhibition Society op.
1889	■ French architect Hector Guimard began redesigning entrances to the metro stations in Paris.	■ Der französische Architekt Hector Guimard beginnt mit den Arbeiten für die Eingänge der Pariser Metrostationen.	■ L'architecte français Hector Guimard lance les travaux de décoration pour les entrées des stations de métro parisiennes.	■ De Franse architect Hector Guimard begint met het werken aan de ingangen van de metrostations in Parijs.
1891	■ Decorative arts were included in the Salon National des Beaux-Arts in France.	■ In Frankreich werden die dekorativen Künste zum Salon National des Beaux-Arts zugelassen.	■ En France, les arts décoratifs font leur entrée au Salon national des Beaux-Arts.	■ In Frankrijk worden de decoratieve kunsten toegelaten in de Salon National des Beaux-Arts.

1892

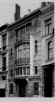

❚ Secession in Münich Baviera co-founded by German painter and sculptor Franz Von Stuck.

❚ Gründung der Sezession in München. Unter den Förderern ist der deutsche Maler und Bildhauer Franz Von Stuck.

❚ Fondation du mouvement de la « Sezession » à Münich. Au nombre de ses promoteurs figure le peintre et sculpteur allemand Franz von Stuck.

❚ De oprichting van de Secessie in München. Onder de vertegenwoordigers bevindt zich de Duitse schilder en beeldhouwer Franz Von Stuck.

1893

❚ First issue in England of *The Studio* magazine. Highly influential in Europe on design and furnishing. Belgian architect Victor Horta designed the first Art Nouveau building, the Hôtel Tassel in Bruxelles. Tiffany designed a chapel for the World's Colombian Exhibition in Chicago.

❚ In England wird die Zeitschrift *The Studio* gegründet, die Architekturmodelle, Tapisserie und Textilien in ganz Europa verbreitet. Der belgische Architekt Victor Horta errichtet mit dem Hôtel Tassel in Brüssel das erste Gebäude des Art Nouveau Stils. Tiffany errichtet die Kapelle für die Weltausstellung in Chicago.

❚ La revue *The Studio* est fondée en Angleterre : elle diffuse en Europe des projets et modèles d'architecture, de tapisseries et de tissus. À Bruxelles, l'architecte belge Victor Horta réalise l'hôtel Tassel, premier édifice de style Art Nouveau.

❚ In Engeland wordt het tijdschrift *The Studio*, dat in Europa modellen van architectuur, wandbekleding en weefsels verspreid, opgericht. De Belgische architect Victor Horta verwezenlijkt in Bruxelles het Hôtel Tassel, het eerste Art Nouveau gebouw. Tiffany verwezenlijkt de Kapel voor de Universele Tentoonstelling van Chicago.

1894

❚ The association *La Libre esthétique* founded in Bruxelles to promote innovative tendencies in painting and decorative arts through exhibitions and lectures. First edition of the *The Yellow Book*, under the art direction or English engraver Aubrey Beardsley.

❚ In Brüssel wird der Verein *La Libre esthétique* gegründet, der die innovativen Tendenzen in der Malerei und in der dekorativen Kunst durch Ausstellungen und Konferenzen vertritt und fördert. *The Yellow Book* wird herausgegeben, mit dem englischen Graveur Aubrey Beardsley als Kunstdirektor.

❚ Fondation à Bruxelles de l'association « La Libre Esthétique », qui s'efforce de défendre et de promouvoir, par des expositions et des conférences, les tendances novatrices dans la peinture et les arts décoratifs français. Sortie de *The Yellow Book* dont le graveur anglais Aubrey Beardsley est le directeur artistique.

❚ In Bruxelles wordt de vereniging *La Libre Esthétique* opgericht, met als doel het verdedigen en bevorderen, middels tentoonstellingen en conferenties, van de vernieuwende tendens in de schilderkunst en in de decoratieve kunsten. *The Yellow Book*, waarvan de Engelse etser Aubrey Beardsley art director is, wordt uitgegeven.

1895

❚ Siegfried Bing opens the Maison de l'Art Nouveau on the rue de Provence in Paris displaying works by Henry Van de Velde, Karl Koepping, Louis Comfort Tiffany, René Lalique, etc.

❚ Siegfried Bing eröffnet in Paris in der Rue de Provence "La Maison de l'Art Nouveau", das zu einem späteren Zeitpunkt die Kreationen von Henry Van de Velde, Karl Koepping, Louis Comfort Tiffany, René Lalique etc. auf der ganzen Welt bekannt macht.

❚ Siegfried Bing ouvre à Paris, rue de Provence, la « Maison de l'Art Nouveau », pour faire connaître les créations de Karl Köpping, Henry Van de Velde, Louis Comfort Tiffany, René Lalique et autres.

❚ Siegfried Bing opent in de Rue de Provence, in Parijs, het Maison de l'Art Nouveau, dat de creaties van Henry van de Velde, Karl Koepping, Louis Comfort Tiffany, René Lalique, enz. zal introduceren.

1896

■ German painter and engraver Otto Eckmann publishes the *Jugend* magazine, from which the Jugendstil movement takes its name, in Munich. First exhibition devoted to Norwegian painter Edvard Munch in Siegfried Bing's Maison de L'Art Nouveau gallery in Paris.

■ Der deutsche Graveur und Maler Otto Eckmann gründet in München die Zeitschrift *Jugend*, von der die Jugendstil-Bewegung ihren Namen erhält. Erste Ausstellung des norwegischen Malers Edvard Munch in der Pariser Galerie L'Art Nouveau von Siegfried Bing.

■ Otto Eckmann, peintre et graveur allemand, fonde à Munich la revue *Jugend* [« Jeunesse »] qui donnera son nom au mouvement du *Jugendstil*. Première exposition personnelle du peintre norvégien Edvard Munch, dans la galerie parisenne de Siegfried Bing, « L'Art Nouveau ».

■ Otto Eckmann, Duitse schilder en etser, richt in München het blad *Jugend* op, waar de naam van de Jugendstilbeweging van zal worden afgeleid. Eerste voorkomen van de Noorse Edvard Munch in de Parijse galerie L'Art Nouveau van Siegfried Bing.

1897

■ Birth of Viennese Secession and the movement's magazine *Ver Sacrum*.

■ In Wien entsteht die Sezessionsbewegung, dessen Presseorgan die Zeitschrift «Ver Sacrum» ist.

■ Naissance à Vienne du mouvement de la Sécession viennoise dont l'organe est la revue *Ver Sacrum*.

■ Totstandkoming van de Secessie beweging in Wenen, wiens instrument het blad «Ver Sacrum» is.

1897-1898

■ Joseph Maria Olbrich creates the Secession building in Vienna. Written above the entrance were the words "to every age its art and to art its freedom". The International Art Exhibition in Munich includes 'modern minor arts' for the first time. Also in Munich August Endell sets up his photographic studio, Elvira, one of the leading exponents of the Jugendstil.

■ Joseph Maria Olbrich errichtet in Wien die Sezession. Die Front trägt die folgende Aufschrift: „Jeder Epoche sein Stil, jedem Stil seine Freiheit". In München widmet die internationale Ausstellung zum ersten Mal einen Ausstellungsraum den dekorativen Künsten. Ebenfalls in München gründet August Endell das Fotoatelier Elvira, eine der wichtigsten Ausdrucksformen des Jugendstils.

■ Joseph Maria Olbrich érige à Vienne le « Palais de la Sécession ». Le fronton arbore les mots suivants : « À chaque époque son style, à chaque style sa liberté. » À Munich, l'Exposition internationale consacre pour la première fois un espace aux arts décoratifs. Toujours à Munich, August Endell crée l'atelier photographique « Elvira » – une des plus hautes expressions du *Jugendstil*.

■ Joseph Maria Olbrich sticht in Wenen het Secessionsgebouw. Op het fronton zijn de volgende woorden aangebracht "Elk tijdperk zijn stijl, elke stijl zijn vrijheid". In München wijdt de Internationale Tentoonstelling voor de eerste keer een ruimte aan de decoratieve kunsten. Nog steeds in München, creëert August Endell de fotostudio Elvira, één van de ultieme expressies van de Jugendstil.

1897-1899

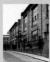

■ Charles Rennie Mackintosh builds the Glasgow School of Art.

■ Charles Rennie Mackintosh errichtet das Gebäude, in dem die Kunstschule Glasgow beherbergt ist.

■ Charles Rennie Mackintosh réalise l'édifice destiné à l'École d'Art de Glasgow.

■ Charles Rennie Mackintosh verwezenlijkt het gebouw dat de kunstschool van Glasgow huisvest.

1898

■ Following the birth of the Secession in Münich and Vienna the Berlin group is formed.

■ Nach der Münchner und der Wiener Sezession entsteht die Berliner Sezession.

■ Naissance de la « Sezession » de Berlin, après celles de Munich et de Vienne.

■ Na de Secessie van München en Wenen, deed deze zich ook in Berlijn voor.

1900

■ World Exhibition in Paris: Siegfried Bing's Art Nouveau pavilion displays work by Edouard Colonna, Georges de Feure and Eugène Gaillard.

■ Weltausstellung in Paris: In der Siegfried Bing gewidmeten Messehalle werden die Kunstwerke von Edouard Colonna, Georges de Feure und Eugène Gaillard ausgestellt.

■ Exposition universelle de Paris : dans le pavillon Art nouveau de Siegfried Bing sont exposées les créations d'Édouard Colonna, Georges de Feure et Eugène Gaillard.

■ Universele Tentoonstelling van Parijs: in het paviljoen gewijd aan Siegfried Bing zijn de creaties van Edouard Colonna, Georges de Feure en Eugène Gaillard tentoongesteld.

1901

■ L'Ecole de Nancy or the Alliance provinciale des Industries d'art organised by Emile Gallé, Louis Majorelle, Jean-Antonin Daum, EugèneVallin, Victor Prouvé.

■ Die Ecole de Nancy bzw. die "Alliance provinciale des Industries d'art" wird von Emile Gallé, Louis Majorelle, Jean-Antonin Daum, Eugène Vallin und Victor Prouvé gefördert.

■ L'École de Nancy, ou « Alliance provinciale des Industries d'Art », a pour promoteurs Émile Gallé, Louis Majorelle, Antonin Daum, Eugène Vallin et Victor Prouvé.

■ De Ecole de Nancy of de Alliance Provinciale des Industries d'Art wordt vertegenwoordigd door Emile Gallé, Louis Majorelle, Jean-Antonin Daum, Eugène Vallin en Victor Prouvé.

1902

■ Inclusion of decorative arts in Turin Exhibition signals Italian support of Art Nouveau.

■ In Turin kommt es mit der Ausstellung der dekorativen Künste zum italienischen Apogäum des Art Nouveau Stils.

■ À Turin, l'exposition des Arts décoratifs marque l'apogée italien de l'Art Nouveau.

■ In Turijn geeft de Tentoonstelling van de Decoratieve Kunsten het Italiaanse hoogtepunt aan van de Art Nouveau.

1903

■ In Vienna Architect Joseph Hoffmann and painter Koloman Moser found the Wiener Werkstätte, designed to promote collaboration between the arts and industry.

■ Der Architekt Joseph Hoffmann und der Maler Koloman Moser gründen in Österreich die Wiener Werkstätten, in denen die Verbindung zwischen Kunst und Industrie gefördert wird.

■ L'architecte Josef Hoffmann et le peintre Koloman Moser fondent en Autriche les Wiener Werkstätte, ateliers d'art et d'artisanat qui prônent le mariage entre l'art et l'industrie.

■ De architect Joseph Hoffman en de schilder Koloman Moser stichten in Oostenrijk de Wiener Werkstätte, een werkplaats die de samenkomst tussen kunst en industrie bevordert.

1904-1906

▌Antoni Gaudí designs the Casa Batlló in Barcellona.

▌Antoni Gaudí errichtet in Barcelona Casa Batlló.

▌Antoni Gaudí réalise à Barcelone la Casa Batlló.

▌Antoni Gaudí verwezenlijkt het Casa Batlló in Barcelona.

1907

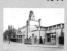

▌Peter Behrens becomes one of the first industrial designers as design director of the *Allgemeine Elektricitäts-Gessellschaft* (AEG).

▌Peter Behrens wird zum Direktor des Projektbüros der *Allgemeinen Elektricitäts-Gesellschaft* (Aeg) bestellt und wird somit einer der größten Industriedesigner der Geschichte.

▌Peter Behrens est nommé directeur du bureau d'études de l'*Allgemeine Elektricitäts Gesellschaft (AEG)*, devenant du même coup l'un des premiers stylistes industriels [*industrial designers*] de l'histoire.

▌Peter Behrens wordt aangesteld als directeur van de afdeling vormgeving van de *Allgemeine Elektricitäts-Gessellschaft* (AEG) en wordt zo één van de eerste industrial designers van de geschiedenis.

1911

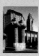

▌Joseph Hoffmann builds the Palais Stoclet in Bruxelles, the triumph of the geometrical Art Nouveau style over plant motifs.

▌Joseph Hoffmann errichtet in Brüssel den Stoclet-Palast, Triumph der geometrischen Art Nouveau über den Jugendstil Art Nouveau.

▌Josef Hoffmann construit à Bruxelles le Palais Stoclet, triomphe de l'Art nouveau « géométrique » sur l'Art Nouveau « floral ».

▌Joseph Hoffman richt het Stocletpaleis op in Bruxelles, zege van de geometrische Art Nouveau op de florale Art Nouveau.

1914

▌Saarinen completes the railway station in Helsinki.

▌Saarinen stellt den Bau des Bahnhofs Helsinki fertig.

▌Eero Saarinen achève la construction de la gare d'Helsinki.

▌Saarinen voltooit de bouw van het spoorwegstation van Helsinki.

1916

▌Frank Lloyd Wright begins the Imperial Hotel in Tokyo, with stylistic references to Art Nouveau.

▌Frank Lloyd Wright beginnt mit den Arbeiten am Hotel Imperiale in Tokio, das Stilreferenzen des Art Nouveau Stils aufweist.

▌Frank Lloyd Wright lance le chantier de l'«Imperial Hotel» de Tokyo, avec des références stylistiques à l'Art Nouveau.

▌Frank Lloyd Wright begint met het werken aan het Imperial Hotel van Tokio, waarin stylistische verwijzingen naar de Art Nouveau zijn aangebracht.

1925

▌International exhibition of Decorative Arts in Paris signals the end of Art Nouveau.

▌Die internationale Ausstellung der dekorativen Künste in Paris bezeichnet das Ende des Art Nouveau Stils.

▌L'exposition internationale des Arts décoratifs à Paris marque la fin de l'Art Nouveau.

▌De Internationale Tentoonstelling van de Decoratieve Kunsten van Parijs kondigt het einde van de Art Nouveau aan.

Glossary

Applied arts Aesthetics applied to objects of everyday use: the term is used in reference to functional pieces in metal, leather, wood, glass, ebony, and to arms and armour, musical instruments, furniture, clocks, and fabrics.

Arabesque Ornamental motif, Islamic in origin, composed of elegant, harmonious and geometrical arrangement of stylised vegetal forms, drawn, incised or in relief. From the sixteenth century the motif became widely diffused throughout Europe and from the late nineteenth to early twentieth century was an important element in Art Nouveau.

Art Nouveau Artistic movement popular from about 1890 to 1915 signalling a renewal in architecture and the decorative arts in Europe and the United States of America. The term art nouveau, used to describe the movement in France, was interpreted differently in other countries: in Italy it became *stile floreale* or *liberty*, in Britain the *modern style*, in Spain *modernisme*, in Belgium the *coup de fouet* or *Velde stile*, in Germany *Jugendstil*, and in Austria *Sezessionsstil* . It was a spirited reaction to the nineteenth-century academic art and a rejection of past styles in favour of all things modern. The movement was in sympathy with industrial production and shared the principles of the English Arts and Crafts movement founded to give aesthetic value to mass produced objects, to combine beauty with function. The movement is characterised by the use of naturalistic motifs (plant and animal) , with those derived from Japanese art, and by a preference for wavy and fluid lines and cold, transparent colours.The movement's most evident innovations were in architecture, interior design and the applied arts. Leading exponents were Victor Horta and Henry van de Velde (Belgium), Hector Guimard (France), August Endell (Germany), Gustav Klimt (Austria) and Antoni Gaudí (Spain).

Arts and Crafts Movement founded in England in the second half of the nineteenth century to foster a return to craftsmanship in order to improve living conditions for workers and the aesthetic quality and design of everyday objects. The movement drew on the Utopian socialist theories of John Ruskin and included the painter William Morris among its celebrated practitioners.

Atelier Elvira The photographic studio in Munich created by August Endell in 1897-1898. The decoration was manifestly Jugendstil with very expressive oriental motifs. Considered an example of degenerate art, the studio was destroyed by the Nazis.

Enamel Vitreous substance used to decorate ceramics, glass and metal surfaces. Two widely used techniques are *cloisonné*, in which the enamel is poured into areas enclosed by wire raised above the metal surface and *champlevé* when the enamel is poured into areas scraped out of the metal surface.

Graphics Art Nouveau is often considered the foundation of modern graphics. Experimentation with printing, the insertion of floral decoration on the page, inventive lettering and asymmetrical pagination reflect the impact made by the first imported Japanese prints. The innovative art nouveau work remains an important point of reference to contemporary graphic designers.

Industrial design The term suggests an attempt to incorporate artistic and aesthetic values into mass production. The question of the relationship between art and industry was first raised in England in the mid nineteenth century and had a profound influence on Art Nouveau. The idea was developed further especially in Germany by the architect Walter Gropius and by the artists of the Bauhaus.

Jugend Magazine founded by Georg Hirth in Munich in 1896 to introduce every aspect of artistic innovation and overthrow traditional approaches through discussion and illustrations. 'Jugend' (youth) lent its name to Jugendstil , the term used to describe the German interpretation of Art Nouveau.

Liberty Liberty takes its name from the London department store established by Arthur Lasenby Liberty specialising in the sale of objects, fabric and furnishings of floral design. In Italy the Liberty style drew inspiration from art nouveau models which were widely disseminated after the Modern Decorative Art Exhibition held in Turin in 1902.

Linearism A term indicating the predominant use of linear decorative elements in art, crafts and architecture. The unrestrained and dynamic use of line is an essential feature of Art Nouveau, well expressed in the French description 'coup de fouet', or whiplash style.

Phytomorphism Plant motifs used as architectural and decorative elements. Ornamentation interpreted with sinuous lines to evoke the natural structure of leaves, trees and flowers. The Liberty style was one of the best expressions of the multiple variations of

phytomorphism in architecture and the applied arts, fostering the 'stile floreale' or floral style.

Posters Large images, on paper or canvas, publicising a product or event. Posters, whether of paintings, photograph, lithographs and other prints were usually designed to catch the public eye with a slogan and linear image. Following the earliest black and white productions in the eighteenth century lithography enabled the creation of coloured posters. These became highly fashionable with the Liberty taste of the late nineteenth century.

Revival Term indicates a return to a previous style. Over the centuries there have been frequent revivals in the history of art and Art Nouveau made symbolic reference to a variety of previous styles.

Secession Term describing a series of movements and groups of artists in opposition to academic art from the second half of the nineteenth to the beginning of the twentieth century. Most prevalent in Germany and Austria, above all in Munich, Berlin and Vienna. The secessionists, in sympathy with the art nouveau movement, considered art a mission, a means of educating the people and defeating ignorance.

Stained glass Segments of glass usually of different colours, joined together by strips of lead and inserted into a metal frame. Widespread in the gothic period, coloured stained glass was later used to create a variety of decorative effects on lamps, doors, and windows, produced and made popular by Art Nouveau.

Tiffany & Co. Company founded in New York in 1837 by Charles Lewis Tiffany and John B. Young. Initially they dealt in a wide variety of merchandise but later became world renowned for the sale of precious objects and jewellery.

Ver Sacrum Viennese magazine, published between 1898 and 1903, to disseminate the experimental ideas of the Secession. Contributors to the 120 issues, covering every aspect of artistic culture, included avant-garde artists and writers such as Gustav Klimt, Joseph Maria Olbrich, Otto Wagner, Josef Hoffmann, Koloman Moser, Rainer Maria Rilke and Maurice Maeterlinck.

Wiener Werksätten The Wiener Werksätten (Viennese workshops) were founded in 1903 by the architect Josef Hoffmann, with Koloman Moser and H.O. Czeschka. Inspired by the Arts and Crafts movement, the Werksätten had widespread influence throughout Europe, spreading the Jugendstil and innovative concepts of design.

Wrought iron Iron worked by craftsmen in the creation of daily objects from gates to a variety of rivets and fittings. Used throughout Europe from the eleventh century it fell out of favour during the Neoclassical period to be taken up again at the end of the nineteenth century by the Art and Crafts movement and by Art Nouveau.

Glossar

Angewandte Kunst Serienmäßig hergestellte Gebrauchsgegenstände, bei deren Anfertigung auch der ästhetische Aspekt berücksichtigt wird. Der Begriff umfasst Möbel, Uhren, Textilien, Metallgegenstände, Leder, Holz, Glas, Keramik, Ebenholz, Waffen und Musikinstrumente.

Arabeske Ornament, wahrscheinlich arabischer Herkunft, mit einer eleganten und harmonischen Verflechtung geometrischer Linien bzw. aus Blatt- und Rankenwerk stilisierter Pflanzen, das als Relief oder Graffiti entworfen bzw. angefertigt wird. Dieses vor allem von den Arabern verwendete Ornament breitete sich von Beginn des 16. Jahrhunderts an in allen europäischen Ländern aus und wurde zwischen Ende des 19. und Beginn des 20. Jahrhunderts zu einem bedeutenden Ornament des Art Nouveau Stils.

Art Nouveau Diese Kunstbewegung entwickelt sich ca. zwischen 1890 und 1915 und führt zu einer Neugestaltung der Architektur und der dekorativen Künste in ganz Europa und in den Vereinigten Staaten. Die Definition Art Nouveau, die die gleichnamige Bewegung in Frankreich bezeichnet, ist auch unter anderen Namen bekannt: In Italien spricht man von *Stile floreale* oder von *Liberty*, in Großbritannien wird diese Bewegung als *Modern Style* bezeichnet, in Spanien als *Modernismo*, in Belgien als *Coup de fouet*- oder *Velde-Stil*, in Deutschland spricht man von *Jugendstil*, in Österreich von *Sezessionsstil*. Derzeit bevorzugt man für die Bezeichnung dieses Phänomens den Begriff *Modernismo*, der als geeigneter angesehen wird, um das Essentielle dieser Erscheinung hervorzuheben. Die Art Nouveau Bewegung ist eine polemische Reaktion auf den Akademismus des 19. Jahrhunderts. Ihre Merkmale sind das Zurücklassen der Stile der Vergangenheit und die Inspiration an allem Modernen. Die Künstler teilen die Prinzipien der englischen Bewegung Arts & Crafts und akzeptieren die Industrieanfertigung. Sie erklären sich dazu bereit, in der Serienproduktion erzeugten Gegenständen eine ästhetische Würde zu verleihen und dabei das Schöne mit dem Nützlichen zu verbinden. Die Merkmale dieser Bewegung sind naturalistische Themen (Blumen und Tiere), Motive aus der japanischen Kunst, gekrümmte, gewellte und verschlungene Formen sowie kalte und transparente Farben. Die spektakulärsten Innovationen der Art Nouveau betreffen insbesondere die Architektur, den Einrichtungsbereich und die angewandten Künste. Zu den berühmtesten Vertretern dieser Bewegung zählen Victor Horta und Henry van de Velde (Belgien), Hector Guimard (Frankreich), August Endell (Deutschland), Gustav Klimt (Österreich) und Antoni Gaudí (Spanien).

Arts & Crafts Diese Bewegung entwickelt sich in der zweiten Hälfte des 19. Jahrhunderts in England und fordert die Rückkehr zum Handwerk, um sowohl die Lebensbedingungen der Arbeiter als auch die ästhetische Qualität der alltäglichen Gebrauchsgegenstände zu verbessern. Als theoretischer Bezug dieser Bewegung gilt der utopische Sozialismus von John Ruskin. Zu seinen wichtigsten Vertretern zählt der Maler William Morris.

Atelier Elvira Name des von August Endell von 1897-1898 gegründeten Münchner Fotoateliers. Die Dekoration erfolgte zur Gänze im Jugendstil mit sehr ausdrucksstarken Ornamenten im „Peitschenhieb-Stil". Das Atelier wurde von Nazis als Beispiel der Entartung der Kunst zerstört.

Emaillack Glasiger Lack, der für die Verzierung von Keramik, Glas und Metalloberflächen verwendet wird. Der Begriff bezeichnet auch eine Maltechnik, bei der Glaspasten auf Metall aufgetragen werden. Die Lackierverfahren sind die *Cloisonné*-Technik, bei der die Glaspasten in leicht aus der Metallfläche ausgehobene Felder geklebt werden, und die *Champlevé*-Technik, bei der die Glaspasten direkt in ausgehobene Felder auf der Platte eingefüllt werden.

Glasgemälde Komposition aus meist verschiedenfarbigen Glasstücken, die durch Bleilegierungen miteinander verbunden und in Metallgerüste eingefügt sind. Die Buntglasgemälde, die in der Gotik sehr stark verbreitet waren, leben in Form von Dekorationsversuchen zahlreicher verschiedener Techniken und Objekte der Art Nouveau Bewegung, wie Lampen, Tore oder Fenster, wieder neu auf.

Grafik In den Grafiktexten wird die Art Nouveau-Bewegung oft als Ausgangspunkt für die zeitgenössische Grafik betrachtet. Dank der Druckexperimente, der Verwendung von Blumendekorationen auf Papier, der Erfindungen im Lettering und der Asymmetrie des Layouts als Ergebnis der Einflüsse durch die ersten, in den Westen importierten japanischen Drucke kann diese Kunstrichtung als wichtiger Bezugspunkt für die zeitgenössischen Grafikdesigner angesehen werden.

Industrial Design Ein englischer Ausdruck, der wörtlich übersetzt für „Industriedesign" steht und den Versuch beschreibt, die industrielle Serienproduktion mit der Suche nach Kunst und Ästhetik in Einklang zu bringen. Die Frage des Zusammenhangs zwischen Kunst und Industrie, die man sich in England zum ersten Mal in der Mitte des 19. Jahrhunderts stellt, beeinflusst die Art Nouveau Bewegung sehr stark und wird später vor allem in Deutschland vom Architekten Walter Gropius und vom Unternehmen Bauhaus

vorangetrieben.

Liberty Der Begriff Liberty stammt vom Namen der Londoner Geschäfte von Arthur Lasenby Liberty, die sich auf den Verkauf von Gegenständen, Stoffen und Einrichtungsgegenständen im Blumenstil spezialisieren. In Italien identifiziert sich Liberty mit einer Geschmacksrichtung, die sich in erster Linie an den Modellen der Art Nouveau Bewegung inspiriert und die sich seit der Ausstellung der Modernen Dekorativen Künste 1902 in Turin schnell verbreitete.

Linearismus Dieser Begriff bezeichnet das Vorherrschen des linearen Bestandteils des handwerklichen Kunstobjekts bzw. der architektonischen Dekoration. Die Modulation mit geraden Linien, die sich frei und dynamisch bewegt, stellt eine bedeutende Folge der Art Nouveau Bewegung dar und findet eine seiner berühmten Ausprägungen in der französischen Redewendung 'style coup de fouet' bzw. „Peitschenhieb-Stil".

Phytomorphismus Begriff, der für Formen floraler Herkunft verwendet wird, die in architektonischen Strukturen und in Dekorelementen vorhanden sind, deren Entwicklung sich geschmeidig verläuft und somit natürliche Strukturen wie Blätter, Bäume oder Blumen in Erinnerung ruft. Der Stile Liberty war einer der Bewegungen, in denen der Phytomorphismus sowohl in der höheren als auch in der angewandten Kunst in unterschiedlichen Formen am besten zum Ausdruck kam. So kam es in dieser Bewegung zur Einleitung des so genannten „Stile Floreale".

Revival Englischer Begriff, der für Wiedergeburt steht und der das Neuaufleben eines Stils bezeichnet, der bereits in einer vergangenen Epoche verwendet wurde. Das Revival, das oft in der darstellenden Kultur der vergangenen Jahrhunderte vorkommt, wird in heterogenen Stilformen auch von der Art Nouveau Bewegung als Sinnbild und Symbol verwendet.

Schmiedeeisen Handwerklich verarbeitetes Schmiedeeisen für die Herstellung von verschiedenen Objektarten, von Werkzeug des täglichen Gebrauchs über Eisengitter bis hin zu verschiedenen Verzierungen. Nachdem dieses Material seit dem 11. Jahrhundert in verschiedenen europäischen Regionen verwendet wurde und später während des Neoklassizismus in Vergessenheit geraten war, lebte es Ende des 19. Jahrhunderts dank Bewegungen wie Arts & Crafts und Art Nouveau wieder neu auf.

Sezession Begriff, der eine Reihe von Bewegungen und Künstlergruppen aus der zweiten Hälfte des 19. und dem Beginn des 20. Jahrhunderts bezeichnet, die sich gegen die akademische Kunst auflehnen. Die Sezessionen setzen sich insbesondere in Österreich und in Deutschland durch, wobei die berühmtesten die Münchner, die Berliner und die Wiener Sezession sind. Die Sezessionen, die auf die Art Nouveau Bewegung zurückgehen, betrachten Kunst als Mission bzw. als Wert, der zur Bildung des Volkes und zum Sieg über Unwissen beiträgt.

Tiffany & Co. Diese im Jahr 1837 von Charles Lewis Tiffany und John B. Young in New York gegründete Bewegung vermarktete anfangs eine große Vielfalt von Artikeln und wurde später zu einem wichtigen internationalen Bezugspunkt für den Verkauf von Schmuck und Schmuckstücken.

Werbeplakat Großflächiges Bild, das auf Papier oder auf Leinwand erstellt wird und ein Produkt oder ein Ereignis ankündigt und in der Öffentlichkeit bekannt macht. Die Plakate, die in Form von Malerei, Lithographie, Fotografie oder Druck erstellt werden, bedienen sich üblicherweise eines Slogans und eines Bildes, die aufgrund ihrer Linearität ein breites Publikum ansprechen. Nach den ersten Modellen in Schwarz-Weiß aus dem 18. Jahrhundert wurden die Plakate dank der Lithographie-Technik in Farbe angefertigt und erfreuten sich in der Liberty-Kultur der zweiten Hälfte des 19. Jahrhunderts großer Beliebtheit.

Wiener Werkstätten Die Wiener Werkstätten wurden im Jahr 1903 vom Architekten Josef Hoffmann zusammen mit Koloman Moser und H.O. Czeschka gegründet. Diesem berühmten Wiener Betrieb, der mit der Welt des Designs in Verbindung stand und der sich an der Arts & Crafts Bewegung inspirierte, gelang es, in ganz Europa eine neue Geschmacksrichtung im Sinne des Jugendstils und der Moderne durchzusetzen.

Zeitschrift «Jugend» Name der Zeitschrift, die von Georg Hirth in München im Jahr 1896 mit der Absicht gegründet wurde, Innovationen aufzuzeigen und die traditionalistischen Tendenzen durch Diskussion und Darstellung aller neuen, als interessant geltenden Produktionen zu überwinden. Vom Titel „Jugend" stammt der Begriff Jugendstil, jene Kunstrichtung bezeichnet, die als deutsche Version der Art Nouveau Bewegung betrachtet wird.

Zeitschrift «Ver Sacrum» Titel der zwischen 1898 und 1903 herausgegeben Wiener Zeitschrift, die die Kultur und die Ideen der Sezession prägte. Die 120 veröffentlichten Broschüren, in denen alle Kunstrichtungen eine harmonische Verbindung finden, enthalten die Unterschriften von Künstlern und Literaten der Avantgarde der damaligen Zeit wie Gustav Klimt, Joseph Maria Olbrich, Otto Wagner, Josef Hoffmann, Koloman Moser sowie von den Literaten Rainer Maria Rilke und Maurice Maeterlinck.

Glossaire

Affiche publicitaire Image de grande taille, réalisée sur toile ou sur papier fort, qui annonce et vante un produit ou un événement. Les affiches, qu'elles soient peintures, lithographies, photographies ou gravures, arborent généralement un slogan et une image simples, destinés à intéresser et frapper un vaste public. Après les premiers exemples en noir et blanc du XVIIIe siècle, les affiches ont été traitées en couleurs grâce au procédé lithographique ; elles deviennent très à la mode dans la seconde moitié du XIXe siècle, dans la culture esthétique de l'Art Nouveau.

Arabesque Motif ornemental qui consiste en un entrelacs élégant et harmonieux de formes végétales ou de lignes géométriques, dessinées, incisées ou traitées en relief. Utilisée initialement dans l'art arabo-persan, l'arabesque se diffuse dans tous les pays européens à partir du XVIe siècle et devient, entre la fin du XIXe siècle et le début du XXe, un motif ornemental important de l'Art Nouveau.

Art Nouveau Mouvement artistique développé entre 1890 et 1915 environ, qui renouvelle l'architecture et les arts décoratifs dans toute l'Europe, ainsi qu'aux États-Unis. Ce mouvement, défini génériquement par son appellation française, est aussi connu sous d'autres noms dans les autres pays : on parle ainsi de modern style en Angleterre ; de « style coup de fouet » ou « style Van de Velde » en Belgique ; de *Jugendstil* en Allemagne et en Autriche ; de *Sezessionsstil* en Autriche ; de *stile floreale* ou *liberty* en Italie ; de modernismo en Espagne. On connaît aussi les sobriquets de « style nouille » et « style anguille » dans l'espace francophone. Le mouvement de l'Art Nouveau est en fait une réaction polémique à l'académisme du XIXe siècle, caractérisée par l'abandon des styles du passé pour s'inspirer de tout ce qui est moderne. Les artistes acceptent la production industrialisée et, partageant les idées du mouvement anglais des *Arts & Crafts*, ils se proposent d'accorder une dignité esthétique aux objets de la production en série, visant ainsi à joindre le beau et l'utile. Le mouvement se caractérise par la présence de sujets naturalistes (fleurs et animaux), de motifs dérivés de l'art japonais, de formes incurvées, ondulées et sinueuses, de coloris froids et transparents. Les innovations les plus importantes de l'Art Nouveau concernent surtout l'architecture, le mobilier et les arts appliqués. Les principaux représentants de ce mouvement sont Victor Horta et Henry Van de Velde pour la Belgique, Hector Guimard et Louis Majorelle pour la France, August Endell pour l'Allemagne, Gustav Klimt pour l'Autriche et Antoni Gaudí pour l'Espagne.

Arts & Crafts Mouvement artistique développé en Angleterre dans la seconde moitié du XIXe siècle. Il se proposait de revenir au travail artisanal pour améliorer aussi bien les conditions de vie des ouvriers et des artisans que la qualité esthétique des objets d'usage courant. La référence idéologique de ce mouvement était le socialisme utopique de John Ruskin. L'un de ses principaux représentants fut le peintre William Morris.

Arts appliqués Objets d'usage commun produits en série, mais dont la conception et la création prennent en compte l'aspect esthétique. Ce terme générique peut ainsi se référer à des meubles, des horloges, des tissus, des objets de métal, de bois, de verre ou de céramique, des armes et des instruments de musique.

Atelier « Elvira » Nom de l'atelier photographique créé par les féministes Anita Augspurg et Sophie Goudstikker, à Munich, en 1897-1898 ; l'extérieur du bâtiment fut déciré par August Endell. Le décor était totalement *Jugendstil*, avec des motifs ornementaux violemment expressifs. Occupé par les S.A. en 1933, l'atelier fut détruit par les autorités nazies en 1937, comme exemple d'art dégénéré.

Email Vernis vitreux utilisé pour décorer la céramique, le verre et les surfaces métalliques. Ce terme désigne aussi l'œuvre d'art obtenue par l'émaillage d'un support métallique. Les procédés d'émaillage sont le *cloisonné* : la poudre ou la pâte vitreuse est alors coulée dans des alvéoles définies par de petites cloisons en relief qui dessinent le motif à obtenir ; et le *champlevé*, dans lequel la poudre ou la pâte d'émail est déposée dans des alvéoles creusées directement dans la plaque métallique de support.

Fer forgé Fer travaillé artisanalement pour élaborer divers types d'objets, des ustensiles d'usage quotidien aux ferrures de grille en passant par les garnitures les plus variées. Matériau utilisé à partir du XIe siècle dans toutes les régions de l'Europe, puis tombé en désuétude à l'époque néoclassique, il fut remis à l'honneur par des mouvements artistiques comme l'*Arts & Crafts* et l'Art Nouveau.

Graphisme L'Art Nouveau est souvent considéré comme le point de départ du graphisme contemporain. Les expérimentations typographiques, l'utilisation de décors végétaux et floraux sur la page, les trouvailles du lettrage et l'asymétrie dans la mise en page – fruit de l'influence exercée par les premières estampes japonaises parvenues en Occident – font que cette tendance artistique peut effectivement être considérée comme une référence importante pour les stylistes et graphistes

contemporains.

Industrial design Expression anglo-saxonne que l'on pourrait traduire littéralement par « conception industrielle ». On l'emploie pour désigner la tentative de conjuguer les principes de la production industrielle en série et de la recherche artistique et esthétique. Le problème des rapports entre art et industrie se pose en Angleterre à partir du milieu du XIXᵉ siècle, influençant bientôt profondément les débuts de l'Art Nouveau. Il sera par la suite approfondi, surtout en Allemagne, par l'école du *Bauhaus*, avec l'architecte Walter Gropius.

Jugend (revue) Revue d'art fondée par Georg Hirth, à Munich, en 1896. Son propos était de signaler les innovations et de triompher des tendances traditionalistes, en présentant et en illustrant tous les genres de productions nouvelles considérés comme intéressants. Le titre *Jugend* [« Jeunesse »] a donné naissance au terme de *Jugendstil*, qui définit le courant artistique considéré comme la version allemande de l'Art Nouveau.

Liberty Le terme *Liberty* vient du nom des magasins londoniens d'Arthur Lasenby Liberty, spécialisés dans la vente des objets, étoffes et mobiliers dans le goût de l'Art Nouveau. En Italie, le « *style Liberty* » définit un courant essentiellement inspiré par les modèles de l'Art Nouveau, qui se diffuse rapidement à partir de l'Exposition des Arts décoratifs modernes organisée à Turin en 1902.

Linéarité Ce concept indique la prédominance de la composante linéaire dans un objet artistique artisanal ou surtout dans le décor architectural. La modulation linéaire, libre et dynamique dans son agogique, représente un apport essentiel de l'Art Nouveau et trouve une définition imagée dans l'expression française de « ligne » ou « style coup de fouet ».

Phytomorphisme Terme utilisé par référence aux formes d'inspiration végétale, employées dans les structures architecturales et l'art décoratif. Les éléments décoratifs prennent alors une allure souple et sinueuse évoquant les formes naturelles des plantes, des feuilles et des fleurs. L'Art Nouveau fut l'un des mouvements artistiques qui exprima le mieux le concept de phytomorphisme sous de multiples variantes, aussi bien dans les arts majeurs que dans les arts appliqués, illustrant ce que les Italiens appellent joliment le *stile floreale*.

Revival Terme anglais équivalant à « renaissance » et qui indique le retour à la mode d'un style déjà utilisé auparavant. Ponctuellement présent dans la culture figurative des siècles passés, le *revival* est aussi l'une des ressources de l'Art Nouveau comme

référence emblématique et symbolique – sous des formes stylistiques assez hétérogènes.

Sécession Ce terme allemand [*Sezession*] désigne, dans la seconde moitié du XIXᵉ siècle et le début du XXᵉ, toute une série de mouvements et de groupes artistiques en révolte contre l'art académique. Les plus connues sont – dans l'ordre chronologique – celles de Munich, de Vienne et de Berlin. Les « Sécessions » austro-allemandes, d'inspiration très proches de l'Art Nouveau, considèrent l'art comme une mission, douée d'une valeur transcendante qui permet d'éduquer le peuple et de triompher de l'ignorance.

Tiffany & Co. Firme fondée à New York en 1837 par Charles Lewis Tiffany et John B. Young. Elle commercialise d'abord une grande variété d'articles, avant de devenir une référence internationale de grand prestige dans la vente de bijoux.

Ver Sacrum (revue) Revue d'art viennoise publiée entre 1898 et 1903 pour promouvoir la culture et les idées expérimentales de la « Sécession » (voir ce terme). Dans les cent vingt numéros publiés – où tous les arts se mêlent harmonieusement – figurent les signatures de l'avant-garde artistique et littéraire de l'époque : Gustav Klimt, Joseph Maria Olbrich, Otto Wagner, Josef Hoffmann, Koloman Moser, pour les arts ; et pour les lettres, entre autres, Rainer Maria Rilke et Maurice Maeterlinck.

Vitrail Composition faite de morceaux de verre, généralement de couleurs diverses, maintenus par des ligatures de plomb et insérés dans une armature de métal. On s'en sert à partir de l'époque gothique pour clore des baies. Le procédé revient à la mode avec l'Art Nouveau, étendu à de nouvelles techniques et de Nouveaux objets : lampes, portes, fenêtres de toutes tailles, etc.

Wiener Werkstätten Les *Wiener Werkstätten* [Ateliers viennois] sont fondés en 1903 par l'architecte Josef Hoffmann, associé à l'artiste Koloman Moser et à l'industriel Fritz Wärndorfer. Cette firme, vite célèbre, est liée au monde du stylisme et s'inspire du mouvement anglais *Arts & Crafts*. Elle réussit à imposer en Europe un goût Nouveau, dans l'esprit moderniste du *Jugendstil* (voir Jugend).

Arabesk Versieringsmotief, waarschijnlijk van Arabische afkomst, bestaande uit een zowel sierlijke als harmonische verwikkeling van geometrische lijnen of gestileerde figuratieve vormen, ontworpen of uitgevoerd in reliëf of in graffito. Oorspronkelijk vooral toegepast door de Arabieren, breidde deze techniek zich vanaf de zestiende eeuw uit naar Europese landen, waar het, tussen eind negentiende en begin twintigste eeuw, een belangrijk versieringsmotief van de Art Nouveau werd.

Art Nouveau Artistieke beweging die zich ongeveer tussen 1890 en 1915 ontwikkelde en die de architectuur en de decoratieve kunsten in heel Europa en de Verenigde Staten vernieuwde. De benaming Art Nouveau, die de gelijknamige beweging in Frankrijk aanduidt, staat ook onder andere namen bekend: in Italië noemt men het *stile floreale* of *liberty*, in Engeland *modern style*, in Spanje *modernismo*, in België *Coup de fouet* of *Velde Stijl*, in Duitsland *Jugendstil* en in Oostenrijk *Sezessionsstil*. Tegenwoordig prefereert men *Modernisme* om dit fenomeen aan te duiden, daar deze benaming het meest geschikt wordt geacht om nadruk te leggen op de ware essentie. De Art Nouveau beweging is in feite een polemieke reactie op het negentiende-eeuwse academisme en wordt gekenmerkt door het verlaten van de oude stijlen, om zich vervolgens te laten inspireren door al datgene dat modern is. De kunstenaars accepteren de geïndustrialiseerde productie en, de principes van de Engelse beweging Arts and Crafts delend, leggen zich toe op het geven van esthetische waardigheid aan de voorwerpen van de serieproductie, met als doel het mooie met het nuttige te verenigen. De kenmerken van deze beweging zijn de aanwezigheid van naturalistische thema's (bloemen en dieren), motieven afgeleid van de Japanse kunst, golvende en kronkelende boogvormen en koude en transparante kleuren. De meest aanzienlijke innovaties van de Art Nouveau zijn vooral terug te vinden in de achitectuur, de inrichting en de toegepaste kunst. Victor Horta en Henry van de Velde (België), Hector Guimard (Frankrijk), August Endell (Duitsland), Gustav Klimt (Oostenrijk) en Antoni Gaudí (Spanje) worden gezien als de belangrijkste vertegenwoordigers van de beweging.

Arts and Crafts Beweging ontwikkelt in Engeland in de tweede helft van de negentiende eeuw, die zich toelegde op een terugkeer van de ambachten om zowel de levensomstandigheden van de arbeiders als de esthetische kwaliteit van de dagelijkse gebruiksvoorwerpen te verbeteren. De beweging had als theoretische verwijzing het Utopische Socialisme van John Ruskin. De schilder William Morris geldt als één van haar belangrijkste vertegenwoordigers.

Atelier Elvira Naam van het fotoatelier van München, verwezenlijkt door August Endell in 1897-1898. De decoratie was volledig in Jugendstilstijl met zeer expressieve ornamentele motieven in zweepslagstijl. Het atelier werd door de nazi's verwoest als een voorbeeld van ontaarde kunst.

Emaille Glasachtige laag, gebruikt voor het decoreren van keramieke, glazen en matalen oppervlaktes. De term duidt ook een verftype op metaal, uitgevoerd met glaspasta's, aan. De emailleringsprocessen zijn de *cloisonné*, waarbij de glaspasta's worden gegoten in licht uitstekende alveolen die op een metalen plaat bevestigd zijn en de *champlevé*, waarbij de glaspasta's de uitgeholde alveolen direct op de plaat vullen.

Glas-in-lood Compositie bestaande uit glazen elementen, over het algemeen in verschillende kleuren, gevat in lood en toegepast in metalen raamwerken. Vaak toegepast in het Gotische tijdperk, maakte het gekleurde glas-in-lood een succesvolle terugkeer met decoratieve doeleinden in talrijke typologiën van technieken en objecten - lampen, poorten, ramen – geproduceerd en verspreid door de Art Nouveau.

Grafische kunst In boeken over grafische kunst, wordt de Art Nouveau gezien als startpunt van de hedendaagse grafische kunst. De typografische experimenten, het gebruik van bloemdecoraties op de pagina, de inventies in lettering en de assymetrie van de opmaak, waren allemaal vrucht van de invloed uitgeoefend door de eerste Japanse prent die naar het Westen, werd geïmporteerd en ervoor gezorgd dat deze artistieke tendens beschouwd kan worden als een belangrijke referentie voor de hedendaagse graphic designers.

Industrial design Engelse uitdrukking die letterlijk kan worden vertaald als "industriële vormgeving". Het wordt gebruikt om de poging tot het samen laten komen van de serialiteit van de industriële productie met een artistieke en esthetische toepassing, aan te geven. De kwestie van de verhouding tussen kunst en industrie doet zich voor in Engeland vanaf de tweede helft van de negentiende eeuw, de Art Nouveau sterk beïnvloedend en ontwikkelt zich vervolgens vooral in Duitsland, met dank aan de architect Walter Gropius en het Bauhaus.

Liberty (Jugendstil) De term Liberty is afgeleid van de naam van de Londense Warenhuizen, gespecialiseerd in de verkoop van voorwerpen, stoffen en meubilair in Jugendstilstijl, van Arthur

Lasenby Liberty In Italië identificeert Liberty zich met een stroom van stijlen, voornamelijk geïnspireerd op de Tentoonstelling van de Moderne Decoratieve Kunst, in 1902 gehouden in Turijn.

Linearisme De term geeft de overheersing aan van de lineaire component in het ambachtelijke artistieke voorwerp of in de architectonische decoratie. De modulatie met lineair verband, die zich vrij en dynamisch beweegt, vertegenwoordigt een essentieel draagvlak van de Art Nouveau en vindt haar definitie terug in de bekende Franse uitdrukking 'style coup de fouet', ofwel zweepslagstijl.

Plantenmorfologie Term gebruikt als verwijzing naar vormen van floreale afkomst, aanwezig in architectonische structuren en decoratieve elementen. Deze elementen hadden een kronkelende loop, die terugverwees naar natuurlijke structuren als blaadjes, bomen en bloemen. De Liberty (Jugendstil) was één van de bewegingen, die als beste de verschillende varianten van de plantenmorfologie uitdrukte, zowel in de arti maggiori (hoogste ambachten) als in de toegepaste kunst, en wijdde de bekende stijl in als 'stile floreale'.

Reclamepamflet Afbeelding van groot formaat, uitgevoerd op papier of doek, die een product of een evenement aankondigt en adverteert. Er werd gewoonlijk gebruik gemaakt van een slogan en een zeer lineaire afbeelding op de pamfletten, uitgevoerd als schildering, lithografie, foto en prent, om een zeer groot publiek te bereiken. Na de eerste zwartwit exemplaren van de achtiende eeuw, werden de pamfletten uitgevoerd in kleur met behulp van de lithografie en werd het een ware trend in de Jugendstilcultuur van de negentiende eeuw.

Revival Engelse term die slaat voor wedergeboorte en die de terugkeer van een stijl, die al eerder in een vroeger tijdperk werd gebruikt, aangeeft. Vaak aanwezig in de figuratieve culturen van de verstreken eeuwen, wordt de revival toegepast in heterogene stylistische vormen, alsmede in de Art Nouveau als emblematische en symbolische terugverwijzing.

Secessie Term waarmee, in de tweede helft van de negentiende eeuw en aan het begin van de twintigste eeuw, een reeks van bewegingen en groepen van kunstenaars wordt aangegeven, die zich opwierpen tegen de academische kunst. De secessies vonden vooral plaats in Oostenrijk en Duitsland: tot de bekendste worden die van München, Berlijn en Wenen gerekend. De secessies die te herleiden zijn binnen de Art Nouveau, beschouwden de kunst als een missie, een waarde waarmee de mensen werden onderwezen en onwetendheid werd overwonnen.

Smeedijzer Ambachtelijk bewerkt ijzer voor het creëeren van verschillende soorten voorwerpen, van dagelijkse gebruiksvoorwerpen en traliehekken tot aan diverse versieringen. Gebruikt tot aan het einde van de éénentwintigste eeuw in verschillende delen van Europa, totdat het, na een periode van vergetelheid gedurende het neoclassicisme aan het einde van de negentiende eeuw, werd gerevalueerd door bewegingen als de Arts and Crafts en de Art Nouveau.

Tiffany & Co. Bedrijf opgericht in 1837 in New York door Charles Lewis Tiffany en John B. Young. In het begin commercialiseerde het een grote verscheidenheid aan artikelen, daarna werd het een internationale referentie van groot aanzien met de verkoop van juwelen en kostbaarheden.

Tijdschrift «Jugend» Naam van het tijdschrift opgericht door Georg Hirth in 1896 in München, met als doel de innovaties te vermelden en de conservatieve tendens te overwinnen, door alle nieuwe en als interessant beschouwde producties te bespreken en te illustreren. Van de titel 'Jugend' (jeugd) is de term Jugendstil, die de artistieke stroom, die als de Duitse versie van de Art Nouveau wordt beschouwd, afgeleid.

Tijdschrift «Ver Sacrum» Titel van het Weense tijdschrift, uitgebracht tussen 1898 en 1903, dat de cultuur en de ideëen van de Secessie verkondigde. In de 120 gepubliceerde uitgaves, waarin alle kunsten een harmonieuze samenhang vonden, zijn grote namen van de avant-gardistische kunstenaars en letterkundigen van dat moment te vinden, zoals de kunstenaars Gustav Klimt, Joseph Maria Olbrich, Otto Wagner, Josef Hoffmann, Koloman Moser en de letterkundigen Rainer Maria Rilke en Maurice Maeterlinck.

Toegepaste kunst Serieproductie van dagelijkse gebruiksvoorwerpen, waarbij, bij de creatie ervan, ook rekening wordt gehouden met het esthetische aspect: de term heeft betrekking op meubels, klokken, stoffen, muziekinstrumenten, wapens en metalen, leren, houten, glazen, keramieke en ebbenhouten voorwerpen.

Wiener Werkstätten De Wiener Werkstätten (Weense werkplaatsen) werden in 1903 opgericht door de architect Josef Hoffmann met Koloman Moser en H.O. Czeschka. Het ging om een beroemd Weens bedrijf verbonden aan de wereld van design en geïnspireerd door de Arts and Crafts, die erin slaagde om in heel Europa een nieuwe stijl, in de geest van de Jugendstil en het Modernisme, in te voeren.

Biographies
Biografien
Biografieën

Aubrey Beardsley
Brighton 1872 - Menton 1898

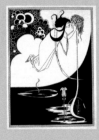

1893 Illustrated *La morte d'Arthur* by Thomas Malory. Contributions to *The Studio* / Illustriert er *Der Tod Arthurs* von T. Malory Mitarbeit an der Zeitschrift *The Studio* / Illustre *Le Morte d'Arthur* de T. Malory et collabore à la revue *The Studio* / Illustreert *De dood van Arthur* van T.Malory Werkt mee aan het tijdschrift *The Studio*

1894 Illustrated *Salomé* by Oscar Wilde / Illustriert er *Salomé* von Oscar Wilde / Illustre *Salomé* d'Oscar Wilde / Illustreert de *Salomé* van Oscar Wilde

1894-1895 Worked on *The yellow book* / Mitarbeit an der Zeitschrift *The Yellow Book* / Collabore à la revue *The Yellow Book* / Werkt mee aan het tijdschrift *The yellow book*

1896 Co-founded with A. Symons *The Savoy* magazine; illustrated *Lysistrata* by Aristophanes / Gründet er mit A. Symons die Zeitschrift *The Savoy* und illustriert die *Lysistrata* von Aristophanes / Fonde avec A. Symons *The Savoy Magazine* ; illustre de dessins érotiques *Lysistrata* d'Aristophane / Richt samen met A. Symons het tijdschrift *The Savoy* op; illustreert *Lisistrata* van Aristophanes

1898 Died of tuberculosis / Stirbt er an Tuberkulose / Meurt de tuberculose / Overlijdt aan Tuberculose

Galileo Chini
Firenze 1873 - Lido di Camaiore, Lucca 1956

1897 Firenze: Founded the Arte della Ceramica / Gründet er die Gesellschaft *Arte della ceramica* / Fonde la société florentine Art de la céramique / Richt de Fabriek 'Arte della Ceramica' op

1902-1914 Oversaw the decoration of the rooms at the Venice Biennale / Arbeitet er an der Dekoration der Biennale-Säle in Venedig / Est chargé des éléments décoratifs des salons à la Biennale de Venise / Verzorgt de decoraties van de salons op de Biënnale van Venetië

1906 Established the kilns at San Lorenzo / Gründet er die Manufaktur *Fornaci San Lorenzo* / Fonde Le Fornaci (le four) de San Lorenzo / Sticht de Fornaci (Ovens) van San Lorenzo

1908-1911 Roma: Chair in Decoration department at the Regia Accademia di Belle Arti / Lehrstuhl für den Dekorationslehrgang an der Regia Accademia di Belle Arti / Titulaire de la chaire de décoration à l'Académie royale des beaux-arts / Bekleedt de leerstoel voor de Decoratieve Kunst aan de Regia Accademia di Belle Arti

1911-1913 Bangkok: Decorated the Royal Palace / Dekoriert er den Königspalast / Décore la salle du trône du palais royal / Decoreert het Koninklijk Paleis

August Endell
Berlin 1871 - 1925

1896 Hermann Obrist introduced him to Art Nouveau / Führt ihn Hermann Obrist in die Art Nouveau ein / Autodidacte, il est initié à l'Art Nouveau par Hermann Obrist / Hermann Obrist introduceert hem in de wereld van de Art Nouveau

1896-1897 Built the photographic studio Elvira, destroyed in 1944 / Errichtet er das Fotoatelier Elvira, das 1944 zerstört wird / Décore la façade de l'Atelier de photo Elvira, détruit en 1944 /

Bouwt de fotostudio Elvira, verwoest in 1944

1901 Berlin: Buntes Theater (now destroyed) / Buntes Theater (heute zerstört) / Buntes Theater (disparu) / Buntes Theater (nu verwoest)

1905-1906 Decorated the rooms of the Hackeschen Höfe, known as Naumann'sche Festsäle / Dekoriert er die Säle der Hackeschen Höfe, die namhaften Naumann'sche Festsäle / Décore les salles des Hackshen Höfe, dites Naumann'sche Festsäle / Decoreert de zalen van de Hackeschen Höfe, Naumann's Festsäle genoemd

1908 Published *The Beauty of the Large City* / Gibt er das Buch *Die Schönheit der großen Stadt* heraus / Publie l'ouvrage *La Beauté dans la grande ville* / Publiceert het boek *De Schoonheid van de Grote Stad*

1912-1913 Built the Mariendorf trotting racetrack / Baut er in Mariendorf die Trabrennbahn / Construit l'hippodrome de Mariendorf / Bouwt het Hippodroom van Mariendorf

1918-1925 Breslau: Director of State Academy of Art / Leitet er die Staatliche Akademie für Kunst und Kunstgewerbe / Directeur de l'Académie d'État pour l'Art (aujourd'hui Wroclaw) / Directeur van de Staatsacademie voor de Kunst

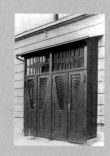

Antoni Gaudí
Reus 1852 - Barcelona 1926

1878 Diploma from the Escola Tècnica Superior d'Arquitectura in Barcelona; in Paris met Catalan industrialist Eusebi Guell i Bacigalupi, his main patron / Diplom an der Architektur Hochschule in Barcelona, in Paris begegnet er dem katalanischen Industriellen Eusebi Güell i Bacigalupi, seinem bedeutendsten Mäzen / Diplôme de l'École supérieure d'architecture de Barcelone ; rencontre à Paris l'industriel catalan Eusebi Güell i Bacigalupi, son mécène principal / Diploma behaald aan de Hogeschool voor Architectuur van Barcelona; ontmoet in Parijs de Catalaanse industrieel Eusebi Güell i Bacigalupi, zijn belangrijkste mecenas

1878-1880 Casa Vicens, Barcelona

1884 Barcelona: Director of building of the Sagrada Familia: left incomplete on his death / Wird ihm die Bauleitung der Sagrada Familia anvertraut, an der er bis zu seinem Tod arbeitet, ohne sie zu beenden / Obtient la direction des travaux de la Sagrada Familia. Il y travaille jusqu'à sa mort, la laissant inachevée / Krijgt de leiding over de werkzaamheden in opdracht van de Sagrada Familia, waaraan hij tot aan zijn dood werkt en het onvoltooid achterlaat

1885-1889 Güell palace / Palau Güell / Palais Güell / Palau Güell

1889-1893 Episcopal palace / Bischofspalast / Palais épiscopal / Bisschoppelijk Paleis

1889-1894 College of Santa Teresa del Gesù / Col.legi de les Teresianes / Collège de Sainte-Thérèse-de-Jésus / Colegio Teresiano (College van de Theresianen)

1900-1914 Parc Güell, Barcelona

1904-1906 Casa Batlló, Barcelona

1904-1914 Palma de Mallorca: Restoration of Cathedral of Santa Maria / Restaurierung der Kathedrale Santa Maria / Restauration de la cathédrale Sainte-Marie / Restauratie van de Kathedraal van Santa Maria

1905-1907 Casa Mila (La Pedrera) Barcelona

1926 Died after being run over by a tram / Wird er von einer Straßenbahn erfasst und stirbt / Meurt après avoir été renversé par un tramway / Overlijdt door een tramongeluk

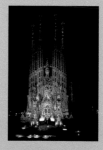

Hector Guimard

Paris 1867 - New York 1942

1895 Travelled in Great Britain and Belgium, where he met Victor Horta / Begibt er sich nach Großbritannien und Belgien, wo er Victor Horta begegnet / Se rend en Grande-Bretagne et en Belgique où il rencontre Victor Horta / Gaat naar Groot-Britannië en naar België, waar hij Victor Horta ontmoet

1897-1898 Designed interior and exterior detail of Castel Béranger / Innen- und Außengestaltung des Castel Béranger / Élabore le projet des éléments décoratifs intérieurs et extérieurs de l'immeuble du Castel Béranger (rue La-Fontaine, Paris, XVIe arr.) / Castel Béranger waarvan hij de interne en externe afwerking ontwerpt

1899 Paris: Won the Compagnie du Métro competition for design of metro entrances in Paris / Wettbewerb der Compagnie du Métro; ihm wird die Gestaltung der Eingänge der Pariser Metrostationen anvertraut / Remporte le concours de la Compagnie du Métro : il réalise les entrées du métropolitain / Wedstrijd van de Compagnie du Métro voor de ingangen van de metrostations: de verwezenlijking ervan wordt hem toevertouwd

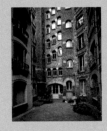

1902 Concert halls Humbert de Romans, now destroyed / Konzertsaal Humbert de Romans, heute zerstört / Salle de concerts Humbert-de-Romans (Paris), détruite en 1905 / Concertzaal Humbert de Romans, nu verwoest

1913 Synagogue de la rue Pavée, dans le Marais (IVe arr.)

1929 Received the Legion d'Honneur / Auszeichnung durch die Legion d'Honneur / Décoré de la Légion d'honneur / Wordt onderscheiden met de Légion d'Honneur

Josef Hoffmann

Pirnitz 1870 - Wien 1956

1897 Hoffmann, Olbrich and other architects found the Viennese Secession. Contributed to *Ver Sacrum* / Gründet er mit Olbrich und anderen Architekten die Sezession. Mitarbeit an der Zeitschrift *Ver Sacrum* / Participe avec Olbrich et d'autres architectes à la création de la Sécession. Collabore à la revue *Ver Sacrum* / Neemt met Olbrich en andere architecten deel aan de oprichting van de Secession Werkt mee aan het tijdschrift *Ver Sacrum*

1898 Entrance to the Secession Building / Atrium des Gebäudes der Sezession / Vestibule du Palais de la Sécession / Hal voor het Secessionsgebouw, Wien

1900 His furniture displayed at the Paris Exhibition / Stellt er seine Möbel auf der Pariser Weltausstellung aus / Expose ses meubles à l'Exposition de Paris / Exposeert zijn meubilair tijdens de Wereldtentoonstelling van Parijs

1901-1903 Entrance to Moser house / Atrium im Haus Moser / Vestibule de la maison Moser / Hal van het Huis Moser, Wien

1902 Entrance to Koller house / Atrium im Haus Koller / Vestibule de la maison Koller / Hal van het Huis Koller, Wien

1903 Founded the Wiener Werstätten with Moser and Czeschka / Gründet er mit Moser und Czeschka die Wiener Werkstätte / Fonde avec Koloman Moser et Carl Otto Czeschka les *Wiener Werstätte* (les ateliers viennois) / Richt met Moser en Czeschka de Wiener Werkstätten op

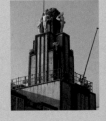

1905-1911 Palais Stoclet, Bruxelles

1909-1911 Designed the Ast Residence / Entwirft er Haus Ast / Projet de la Kunsthaus / Ontwerpt het Huis Ast, Wien

1913-1914 Austrian pavilion for the Werkbund exhibition / Österreichischer Pavillon der Werkbund-Ausstellung / Pavillon de l'Autriche à l'Exposition du Werkbund / Oostenrijks Paviljoen op de tentoonstelling van de Deutsche Werkbund, Köln

1924-1925 Designed the Villa Knips / Entwirft er Villa Knips / Projet de la villa Knips / Ontwerpt Villa Knips, Wien

1925 Popular housing in Strömstrasse and Mottlstrasse / Gemeindebauten in der Strömstraße und in der Mottl-Straße / Maisons populaires dans la Strömstrasse / Volkswoningen in Strömstrasse en Mottlstrasse, Wien

1934 Austrian pavilion at the Venice Biennale / Österreichischer Pavillon der Biennale di Venedig / Pavillon de l'Autriche à la Biennale de Venise / Oostenrijks Paviljoen op de Biënnale van Venetië

Victor Horta
Ghent 1861 - Bruxelles 1947

1878 Studied in Paris / Geht er nach Paris studieren / Études à Paris / Gaat studeren in Parijs

1881-1884 Bruxelles: Completed his studies at the Academy of Fine Arts / Schließt er die Studien an der Académie des Beaux-Arts / Achève ses études à l'Académie des Beaux-Arts / Studeert af aan de Academie van Schone Kunsten

1885 Took control in Alphonse Balat's architectural studio / Übernimmt er die Leitung des Architekturbüros A. Balat / Prend la direction de l'agence de l'architecte A. Balat / Neemt het atelier van de architect A. Balat over

1892-1893 Hôtel Tassel, Bruxelles

1898 Maison Horta, Bruxelles

1903-1906 Bruxelles: Designed the Magasins Waucquez department store in rue des Sables / Entwirft er das Kaufhaus Waucquez in der rue des Sables / Projet des magasins Waucquez, rue des Sables / Ontwerpt de Waucquez Warenhuizen, in de rue des Sables

1906-1924 Bruxelles: Built the Bruggemann Hospital / Erbaut er das Brugman-Hospital / Réalise l'hôpital Brugman / Verwezenlijkt het Bruggemanziekenhuis

1922-1928 Designed the Palais des Beaux-Arts / Entwirft er das Palais des Beaux-Arts / Projet du Palais des Beaux-Arts / Ontwerpt het Museum voor Schone Kunsten

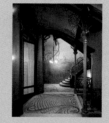

Fernand Khnopff
Grembergen-lez-Termonde 1858 - Bruxelles 1921

1877 Paris: Frequented the Lefèvre studio and the Académie Julian / Frequentiert das Atelier von Lefèvre und die Académie Julian / Il fréquente l'atelier de Lefèvre et l'Académie Julian / Bezoekt vaak het atelier van Lefèvre en de Académie Julian

1883 *Listening to Schumann* / *Schumanns Werken zuhörend* / *En écoutant du Schumann* / *Luisterend naar muziek van Schumann* (Musées Royaux des Beaux-Arts, Bruxelles)

1894 Contributed to *The Studio* / Mitarbeit an der Zeitschrift *The Studio* / Collabore à la revue *The Studio* / Werkt mee aan het tijdschrift *The Studio*

1896 *Medusa sleeping* / *Schlafende Medusa* / *Méduse endormie* / *Slapende Medusa* (Neuilly-sur-Seine, Collection Félix Labisse)

1904 *An abandoned city* / *Die Verlassene Stadt* / *Une ville abandonnée* / *Een verlaten stad* (Musées Royaux des Beaux-Arts, Bruxelles)

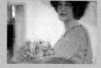

Gustav Klimt
Baumgarten, Wien 1862 - Wien 1918

1880 Decorated ceiling of the Karlsbad baths / Dekoriert er die Decke im Kurhaus von Karlsbad

/ Décore le plafond des thermes de Karlsbad / Decoreert het plafond in de thermen van Karlsbad /

1886 Wien: Decorated ceiling and stair lunette at the Burgtheater / Dekoriert er Decke und Lünette im Stiegenhaus des Burgtheaters / Décore le plafond et les lunettes de l'escalier du Burgtheater / Decoreert het plafond en de halfronde raampjes van het trappenhuis van het Burgtheater

1893 Wien: Decorated main hall at the University / Dekorationen der Aula Magna in der Universität / Décore le grand amphithéâtre de l'Université / Decoraties voor de grote aula van de Universiteit

1897 Co-founder of Viennese Secession / Ist er einer der Gründer der Wiener Sezession / Fait partie des membres fondateurs de la Sécession viennoise / Behoort tot de oprichters van de Weense Secessie

1902 *Beethoven frieze* / *Beethoven-Fries* / *La Frise Beethoven* / *Beethovenfries*

1905 *The three ages of woman* / *Die drei Lebensalter* / *Les Trois Âges de la femme* / *De drie levensfasen van de vrouw* (Galleria Nazionale d'Arte Moderna, Roma)

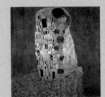

1905-1909 Bruxelles: Frieze for the Stoclet Palace: *Hope* and *The embrace* / Fries im Palais Stoclet: *Die Erwartung* und *Die Erfüllung* / La frise du palais Stoclet : *L'Attente* et *Le Baiser* / Fries van het Stocletpaleis: *De verwachting* en *De omhelzing* (Österreichisches Museum für Angewandte Kunst, Wien)

1906 *Portrait of Adele Bloch-Bauer* / *Adele Bloch-Bauer* / *Portrait d'Adèle Bloch-Bauer* / *Portret van Adèle Bloch-Bauer I* (Österreichische Galerie, Wien)

1907-1908 *The kiss* / *Der Kuss* / *Le Baiser* / *De kus* (Österreichische Galerie, Wien)

1912 Retouched *Death and Life*, substituting background gold with an intense blue: end of the gold period and new attention to colour / Überarbeitet er *Tod und Leben* und ersetzt im Hintergrund das Gold mit einem intensiven Blau: Überwindung der goldenen Periode und neues Augenmerk auf die Farben / Retouche *La Mort et la Vie*, en remplaçant l'or du fond par du bleu intense. Fin de la période dorée. S'intéresse à la couleur / Werkt *Dood en Leven* bij, Vienna, private collection, door het goud van de achtergrond te vervangen door diepblauw: laat de gouden periode achter zich en richt zijn aandacht op kleuren

1913 *The Virgin* / *La Vierge* / *De Maagd* / *Die Jungfrau* (Naròdni Galerie, Prague)

1917 Wien, München: Honorary member Academy of Fine Arts / Wird er zum Ehrenmitglied der Akademie der Schönen Künste ernannt / Élu membre honoraire de l'Académie des Beaux-arts / Wordt benoemd tot erelid van de Academie van de Schone Kunsten

1917-1918 *The bride* / *Die Braut* / *La Mariée* / *De Bruid* (Private Collection / Privatkollektion / Collection privée / Privécollectie)

René Lalique

Ay 1860 - Paris 1945

1882 Opened his first goldsmith's workshop / Gründet er seine erste Goldschmiedewerkstatt / Ouvre son premier atelier d'orfèvrerie / Opent zijn eerste juwelierszaak met werkplaats

1890-1900 Worked with glass, also making glass jewellery / Interesse für Glas, mit dem er auch Schmuck gestaltet / S'intéresse au verre avec lequel il réalise aussi des bijoux / Interesse voor glas, waarmee hij ook sieraden verwezenlijkt

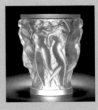

1898-1890 *Female Face* pendant / Halsschmuck mit dem Titel *Frauenprofil* / Pendant de cou intitulé *Profil de femme* / Hanger getiteld *Gezicht van Vrouw* (Musée Calouste Gulbenkian, Lisbonne)

1900-1901 *Owl bracelet* / *Armschmuck Eule* / *Bracelet Chouette* / *Armband Uil* (Musée Calouste Gulbenkian, Lisboa)

1925 Paris: Works displayed at the Exposition des Arts Décoratifs et Industriels Modernes / Stellt

er auf der Exposition des Arts Décoratifs et Industriels Modernes Kunstgewerbe Objekte aus / Expose des objets d'arts mineurs à l'Exposition des Arts décoratifs et industriels modernes / Exposeert arti minori (kleinere ambachten) voorwerpen op de Exposition des Arts Décoratifs et Industriels Modernes

Charles Rennie Mackintosh
Glasgow 1868 - London 1928

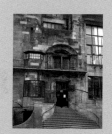

1884-1889 Apprentice to the architect John Hutchinson / Besucht er die Akademie und arbeitet im Architekturbüro John Hutchinson / Suit les cours du soir de l'école d'art de Glasgow et en apprentissage chez l'architecte John Hutchinson / Bezoekt vaak de academie en werkt in het atelier van de architect John Hutchinson

1890 Won Alexander Thomson Travelling Studentship / Erhält er ein Stipendium / Remporte la Alexander Thomson Travelling Studentship et part en Italie / Krijgt een studiebeurs

1894-1895 Furniture series for Guthrie & Wells / Möbelserie für Guthrie & Wells / Séries de meubles pour Guthrie et Wells / Meubelserie voor Guthrie & Wells

1895 London: The «Four» exhibit with the Arts and Crafts group / Mit der Gruppe «The Four» nimmt er an der Ausstellung Arts and Crafts teil / Participe avec le groupe des « Quatre », à l'exposition Arts & Crafts / Neemt met de groep van "Vier" deel aan de tentoonstelling van de Arts and Crafts

1896 Began work on the new Glasgow School of Art, completed in 1909 / Beginnt er die neue Kunsthochschule zu entwerfen, die 1909 fertig gestellt wird / Dessine le projet de la Glasgow School of Art, achevée en 1909 / Begint met het ontwerpen van de nieuwe kunstschool van Glasgow, afgerond in 1909

1899 Davidson House, Glasgow

1900-1902 Exhibited as part of the Glasgow School in Vienna, Dresden, Turin / Nimmt er mit der sogenannten Glasgow School an Ausstellungen in Wien, Dresden und Turin teil / Participe, avec l'Ecole de Glasgow, aux expositions de Vienne, Dresde, Moscou et Turin / Neemt, met de toenmalige school van Glasgow, deel aan de tentoonstellingen van Wenen, Dresden en Turijn

1901 Glasgow: Partner in the studio of Honeyman & Keppie Built Daily Record offices / Wird er Mitglied des Architekturbüros Honeyman & Keppie Daily Record Gebäude / Rejoint comme associé l'agence Honeyman et Keppie Bureaux du *Daily Record* / Wordt partner van het atelier Honeyman & Keppie Daily Record Kantoren

1902 Cranston House, Glasgow

1915 Moved to London with his wife Margaret MacDonald / Siedelt er mit seiner Frau Margaret nach London über/ S'installe à Londres avec sa femme Margaret / Verhuist naar Londen met zijn vrouw Margaret

1923 Settled in France, active as a watercolourist / Siedelt er nach Frankreich über und widmet sich der Malerei und dem Aquarel / S'installe dans le sud de la France où il se consacre à la peinture et à l'aquarelle / Verhuist naar Frankrijk waar hij zich wijdt aan schilderen en aquarelleren

Alphonse Mucha
Ivančice 1860 - Praha 1939

1879 Wien

1881 On his return to Moravia worked as a decorator and portraitist / Zurück in Mähren, betätigt er sich als Dekorateur und Portraitmaler / Retour en Moravie où il exerce une activité de décorateur et de portraitiste / Werkt als decorateur en portretschilder bij zijn terugkeer naar Moravië

1887 Studied at the Académie Julian and Academie Colarossi in Paris. Illustrations for magazines and posters / Siedelt er nach Paris über und setzt dort seine Studien an der Académie Julian und l'academie colarossi fort. Illustrationen für Zeitschriften und Werbeplakate / Installation à Paris où il poursuit ses études à l'Académie Julian et à l'Académie Colarossi. Réalise des illustrations pour des revues et des affiches publicitaires / Verhuist naar Parijs, waar hij zijn studie aan de Académie Julian en de Académie Colarossi vervolgt. Produceert illustraties voor tijdschriften en affiches

1894 Sarah Bernhardt offered him a 6 year contract / Schlägt ihm Sarah Bernhardt einen 6-jährigen Vertrag vor / Sarah Bernhardt l'engage pour six ans, il créera pour elle costumes et bijoux / Sarah Bernhardt biedt hem een contract van 6 jaar aan

1896 Printed the first panel of *The four seasons / Die vier Jahreszeiten*: Druck der ersten Tafel / Le premier panneau *Les Quatre Saisons* est imprimé / Het eerste paneel van *De vier seizoenen* wordt gedrukt

1897 Paris: One-man show with 448 works / Einzelausstellung mit 448 Werken / Organisation d'une exposition personnelle avec 448 œuvres / Stelt 448 eigen werken tentoon

1900 Interior of George Fouquet's jewellery shop / Arbeitet er am Innendesign des Schmuckgeschäfts George Fouquet / Décoration intérieure de la bijouterie Fouquet, rue Royale (Paris) / Werkt aan het ontwerp voor het interieur van de juwelierszaak van George Fouquet

1906-1910 In the United States of America / Lebt er in den Vereinigten Staaten Amerikas / Part aux États-Unis récolter des fonds pour son projet de *L'Epopée slave* / Woont in de Verenigde Staten

1910 Prague: Began working on *The Slav Epic* / Beginnt am Slawischen Epos zu arbeiten / Commence à travailler aux 20 toiles monumentales de *L'Epopée slave* / Begint met de werken over de Slavische Geschiedenis

1911 Completed decoration of the Prague townhall / Vollendet er die Dekorationen des Prager Rathauses / Achève la décoration de l'Hôtel de ville de Prague / Voltooit de decoraties voor het Stadhuis van Praag

1928 Completed *The Slav Epic* cycle / Vollendet er den Gemäldezyklus des Slawischen Epos / Termine le cycle de *L'Epopée slave* / Voltooit de serie van schilderijen over de Slavische Geschiedenis

1931 Prague: Stained glass window commissioned for the cathedral of St Vitus / Wird er mit einem Glasfenster für Veitsdom beauftragt / Commande d'un vitrail pour la cathédrale Saint-Guy / Hij krijgt opdracht voor een glasraam voor de Sint-Vituskathedraal

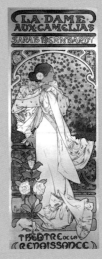

Edvard Munch
Løten 1863 - Ekely, Oslo 1944

1879 Abandoned his studies to enroll in a sculpture course / Bricht er die regulären Studien ab und besucht Lehrgänge für Bildhauerei / Abandonne ses études d'ingénieur pour suivre des cours de dessin / Verlaat school om sculptuurlessen te gaan volgen

1884 *Portrait of his sister Inger / Bildnis Schwester Inger / L'enfant malade / Portret van zus Inger* (Nasjonalgalleriet, Oslo)

1885 First trip to Paris: travels in the south of France and Italy / Erste Reise nach Paris, anschließend Aufenthalte in Südfrankreich und in Italien / Premier voyage à Paris, puis séjours dans le sud de la France et en Italie / Eerste Reis naar Parijs, verblijft daarna in het zuiden van Frankrijk en in Italië

1892 Controversial reaction to his works in the exhibition in Berlin marks birth of Berlin Secession / Ausstellung in Berlin, die einen Skandal auslöst, und Beginn der Berliner Sezession / Exposition à Berlin : scandale et point de départ de la Sécession berlinoise / Expositie in Berlijn, die eindigt in een schandaal en het einde van de Berlijnse Seccesie betekent.

The kiss / Der Kuss / Le Baiser / De kus (Munch-Museet Oslo)

1893 *The scream / Der Schrei / Le Cri / De Schreeuw* (Munch-Museet Oslo)

1893-1906 Trips to Germany / Mehrere Aufenthalte in Deutschland / Nombreux séjours en Allemagne / Verschillende bezoeken aan Duitsland

1893-1918 *The frieze of life / Lebensfries / La Frise de la vie / De fries van het leven* (Munch-Museet, Oslo)

1899 *Melancholy / Melancholie / Mélancolie / Melancholie* (Munch-Museet, Oslo)

1908 Nervous breakdown / Schweres Nervenleiden / Grave maladie nerveuse et alcoolisme / Ernstige Zenuwinzinking

1909-1916 Oslo: Sun frescoes for the University / Wanddekoration zum Thema Sonne für die Universität / Décoration murale sur le thème du soleil pour l'université / Muurschilderingen met onderwerp zon voor de Universiteit

1937 Beginning of Nazi persecutions: his work labeled "degenerate" / Lernt er die ersten Naziverfolgungen kennen, wobei seine Werke als "entartet" gelten / Après l'arrivée d'Hitler au pouvoir, les œuvres de Munch, considérées comme appartenant à « l'art dégénéré », sont retirées des musées / Maakt kennis met de eerste nazi vervolgingen en zijn werken krijgen een "degenererende" stempel

1940-1942 *Self portrait: Between clock and bed / Selbstportrait: Zwischen Uhr und Bett / Autoportrait. Entre l'horloge et le lit / Zelfportret tussen staande klok en bed* (Munch-Museet, Oslo)

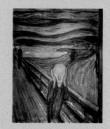

Joseph Maria Olbrich
Troppau 1867 - Düsseldorf 1908

1890-1893 Wien: Pupil of K. Von Hasenauer at the academy / Schüler Von K. Von Hasenauer an der Akademie / Elève de K. Von Hasenauer de l'Académie / Is leerling van K. Von Hasenauer op de Academie

1897 Co-founded Viennese Secession with Gustav Klimt, Josef Hoffmann and others / Mit Gustav Klimt, Josef Hoffmann und anderen gründet er die Wiener Sezession / Fonde, avec Gustav Klimt, Josef Hoffmann et d'autres, la Sécession viennoise / Richt samen met Gustav Klimt, Josef Hoffman en anderen de Weense Secessie op

1898 Wien: Secession Hall / Entwirft und baut er das Gebäude der Sezession / Projet et construction du Palais de la Sécession / Ontwerpt en bouwt het Secessionsgebouw

1898-1900 Series of projects for Wien including the Max Friedmann villa / Realisiert er eine Reihe von Projekten in Wien, darunter die Villa Max Friedmann / Réalise une série de projets à Vienne dont celui de la villa Max Friedmann / Voert een serie van projecten uit in Wenen, waaronder Villa Max Friedmann

1899 Summoned to Darmstadt by Grand Duke Ernst Ludwig of Hesse to establish a colony of artists / Wird er zum Großherzog Ernst Ludwig von Hessen nach Darmstadt gerufen, um eine Künstlerkolonie zu entwerfen / Appelé à Darmstadt par le grand-duc Ernest Ludovic de Hesse pour faire le projet d'une colonie d'artistes / Wordt door de Groothertog Ernst Lodewijk van Hessen ontboden naar Darmstadt om een kunstenaarskolonie te ontwerpen

1907 München: Among founders of the Deutsche Werkbund / Ist er einer der Gründer des Deutschen Werkbunds / Fait partie des fondateurs de la Deutsche Werkbund / Behoort tot de oprichters van de Deutsche Werkbund

1908 Moved to Düsseldorf : department store for Leonhard Tietz / Siedelt er nach Düsseldorf für den Bau des Warenhauses Tierz über / S'installe à Düsseldorf pour la construction des magasins Tierz / Verhuist naar Düsseldorf voor de bouw van het Warenhuis Tietz

Franz von Stuck

Tettenweiss 1863 - München 1928

1891 *Orpheus / Orphée* (Private collection / Privatkollektion / Collection privée / Privécollectie)

1892 Took part in the foundation of the Gegenverein zur Kunstlergenossensschaft, the first German Secession / Nimmt er an der Gründung des Gegenvereins zur Künstlergenossenschaft teil, der ersten deutschen Sezession / Participe à la première Sécession de Munich / Neemt deel aan de oprichting van de Gegenverein zur Kunstlergenossensschaft, eerste Duitse Secessie

1893 Ironical vein first apparent in *Salomé* / Greift eine ironische Ader um sich, unter anderem mit *Salomé* / S'engage dans une voie plus ironique avec, entre autres, *Salomé* / Hij slaat een meer ironische weg in, onder andere met *Salomé* (Städtische Galerie im Lenbachhaus, München)

The sin / Die Sünde / Le Péché / De Zonde (Neue Staatsgalerie, München)

1895 München: Began teaching Academy / Von nun an ist er Professor an der Akademie / Enseigne à l'Académie / Vanaf deze datum geeft hij les op de academie

1897 München: Built his own home, the Villa Stuck / Baut er seinen eigenen Wohnsitz, Villa Stuck / Construit sa résidence personnelle, la villa Stuck (transformée en musée) / Bouwt zijn eigen verblijf, Villa Stuck

1899 Three allegorical and visionary paintings at the Glaspalast / Stellt er erfolgreich drei Gemälde allegorischen und visionären Inhalts im Glaspalast aus / Expose avec succès trois tableaux aux sujets allégoriques et visionnaires à Glaspalaast / Exposeert met succes drie doeken met allegorische en visionaire onderwerpen in het Glaspalast

The guardian of paradise / Der Wächter des Paradieses / Le Gardien du paradis / De Paradijswachter (Private Collection / Privatkollektion / Collection privée / Privécollectie)

Homage to painting / Huldigung an die Malerei / Hommage à la peinture / Eerbetoon aan de schilderkunst (Piccadilly Gallery, London)

1926 *Judith and Holofernes / Judith und Holofernes / Judith et Holopherne / Judith en Holofernes* (Private Collection / Privatkollektion / Collection privée / Privécollectie)

Louis Comfort Tiffany

New York 1848 - 1933

1878 Paris: Glass and jewellery for the Maison Bing / Ist er und stellt für die Maison Bing Glas und Schmuck her / Travaille pour la maison Bing, où il fabrique verrerie et bijoux / Werkt hier voor Maison Bing en vervaardigt er glaswerken en juwelen

1892 Set up his own glass workshop. Predominant floral inspiration / Gründet er seine eigene Werkstatt, wo er häufig pflanzlich inspirierte Glasobjekte herstellt / Crée son propre atelier où il conçoit des objets en verre souvent d'inspiration florale / Richt zijn eigen werkplaats op, waar hij voorwerpen van glas, dikwijls geïnspireerd op bloemen, creëert

1893 Invention of favrile technique / Führt sein Unternehmen ein neues Verfahren mit dem Namen Favrile ein / Son entreprise invente une nouvelle technique, dite « Favrile » pour la réalisation de vases et de bols / Zijn bedrijf introduceert een nieuwe techniek, Favrile genaamd

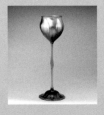

1900 Knight of the Legion of Honour / Erhält er den Rang eines Ritters der Ehrenlegion / Chevalier de la Légion d'honneur à Long Island / Ontvangt het ambt van Ridder van het Légion d'honneur

1904 Decorated his new house, Laurelton Hall, on Oyster Bay, Long Island / Dekoriert er sein neues Haus in Laurelton Hall, in der Oyster Bay auf Long Island / Décore sa nouvelle maison au Laurelton Hall, sur l'Oyster Bay au Long Island/ Decoreert zijn nieuwe huis in Laurelton Hall, aan de Oyster Bay in Long Island

Jan Toorop
Purworejo 1858 - Den Haag 1928

1869 Studied at academies in Amsterdam and Bruxelles / Lebt er in Holland, wo er an den Akademien in Amsterdam und Brüssel studiert / Études aux académies d'Amsterdam et de Bruxelles (1882-1886) / In Nederland studeert hij aan de Academie van Amsterdam en in België aan de Academie van Brussel

1880-1890 Humanitarian and social themes in his painting / Geht er in seinen Bildern soziale und humanitäre Themen an / Aborde en peinture des thèmes sociaux et humanitaires / Brengt sociale en humanitaire onderwerpen ter sprake in zijn schilderijen

1885-1893 Exhibits with symbolist group *Les XX* / Stellt er mit der Symbolistengruppe Les Vingt aus / Expose avec le groupe symboliste, *Les XX* / Exposeert met de symbolistische groep *Les XX*

1888 *After the strike* / *Nach dem Streik* / *Après la grève* / *Na de werkstaking* (Kröller-Müller Museum, Otterlo)

1892 *The young generation* / *Die junge Generation* / *La Jeune Génération* / *De jonge generatie* (Museum Boijmans-Van Beuningen, Rotterdam)

1894 Posters such as *Delftsche Slaolie* secure his role in advertising / Behauptet er sich mit Werken wie *Delftsche Slaolie* in der Werbegrafik / Avec des œuvres comme *Delftsche Slaolie*, il s'impose dans le graphisme publicitaire / Vestigt zich met werken als *Delftsche Slaolie* in de wereld van de grafische weergave

1905 Converted to Catholicism / Konvertiert er zum Katholizismus / Se convertit au catholicisme / Bekeert zich tot het Katholicisme

Henri de Toulouse-Lautrec
Albi 1864 - Malromé 1901

1872 1875 Paris

1877-1878 Fractured femurs / Bricht er sich die Oberschenkelknochen / Atteint d'une maladie osseuse, victime de fractures des fémurs, sa croissance s'arrête / Breekt zijn dijbenen

1882-1884 Frequented the studios of Léon Bonnat and Fernand Cormon: studied the Impressionists / Verkehrt er in den Ateliers von Léon Bonnat und Fernand Cormon, dann studiert er die Impressionisten / Fréquente les ateliers de Léon Bonnat et Fernand Cormon, puis étudie les impressionnistes / Bezoekt de ateliers van Léon Bonnat en Fernand Cormon, daarna bestudeert hij de impressionisten

1884 Montmartre: first exhibitions / Erste Ausstellungen / Premières expositions / Eerste tentoonstellingen

1888 *At the Fernando circus* / *Kunstreiten im Zirkus Fernando* / *Au cirque Fernand* / *In het Fernando circus* (The Art Institute, Chicago)

1892 *Aristide Bruant at the Ambassadeurs* / *Ambassadeurs: Aristide Bruant* / *Aristide Bruant aux Ambassadeurs* / *Aristide Bruant in de Ambassadeurs* (Musée Toulouse-Lautrec, Albi)

1892-1895 Paintings and drawings of the Paris brothels / Draagt veel schilderijen en ontwerpen op aan de bordelen van Parijs / Consacre de très nombreux tableaux et dessins aux maisons closes parisiennes / Widmet er viele Bilder und Zeichnungen den Pariser Freudenhäusern
Al Moulin Rouge / *In de Moulin Rouge* / *Au Moulin rouge* / *Im Moulin Rouge* (The Art Institute, Chicago)

1893 First important one-man show / Erste große Einzelausstellung / Première grande exposition personnelle / Eerste grote persoonlijke tentoonstelling

1894 *Al Salon di Rue des Moulins* / *Der Salon in der Rue des Moulins* / *Au Salon de la rue des Moulins* / *In de Salon in Rue des Moulins* (Musée Toulouse-Lautrec, Albi)

1896 *La toilette* / *Die Toilette* / *La Toilette* / *La toilette* (Musée d'Orsay, Paris)

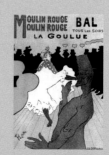

1897 Illness worsened by alchoholism / Verschlechtert sich sein psychischer Zustand auch wegen des Alkoholkonsums / Son état psychologique s'aggrave, en partie à cause de l'alcool / Zijn psychische gesteldheid verslechterd onder andere door alcoholmisbruik

Henri Van de Velde
Antwerpen 1863 - Zürich 1957

1882-1884 Frequented the Antwerpen Academy of Fine Arts / Besucht er die Akademie der Schönen Künste in Antwerpen / Fréquente l'académie des Beaux-Arts d'Anvers / Bezoekt de Academie voor Schone Kunsten van Antwerpen

1884-1885 Paris: Studied painting / Führt er seine Malereistudien / Poursuit ses études de peinture / Vervolgt de schilderstudie

1889 Bruxelles: Took part in the group *Les XX* / Nimmt er an der avantgardistischen Bewegung *Les XX* teil / Participe au mouvement d'avant-garde, *Les XX* / Neemt deel aan de avantgardistische beweging *Les XX*

1895 Wrote *Future Art* and *Observations toward a synthesis of art* / Schreibt er *Die zukünftige Kunst* und *Allgemeine Bemerkungen zu einer Synthese der Kunst* / Écrit *L'Art futur* et *Observations générales pour une synthèse des arts* / Schrijft *De kunst van de toekomst* en *Algemene observaties voor een synthese van de kunst*

1896 Bloemenwerf house at Uccle: first architectural project for which he also designed the furniture / Bloemenwerf Haus in Uccle, sein erstes architektonisches Werk, für das er auch die Ausstattung entwirft / Première œuvre architecturale, la maison Bloemenwerf à Uccle, dont il conçoit également le projet d'ameublement / Huis Bloemenwerf in Ukkel, zijn eerste architectuurwerk waarvan hij ook het meubilair ontwierp

1896-1897 Paris and Dresden: Exhibitions spread his fame throughout Europe / Verbreiten die Ausstellungen seinen Ruf in Europa / Ses expositions le rendent célèbre en Europe / De tentoonstellingen verspreiden zijn roem in Europa

1898 Set up his applied arts workshop / Gründet er seine Werkstatt für angewandte Kunst / Fonde son atelier d'arts appliqués / Richt zijn werkplaats voor Toegepaste Kunst op

1900 Restoration of Folkwang museum at Hagen in Germany / Neuer Innenausbau für das Museum Folkwang in Hagen, Deutschland / Réorganise le musée Folkwang à Hagen, en Allemagne / Reorganiseert het Folkwangmuseum in Hagen in Duitsland

1902 Summoned to Weimar by the Grand Duke of Saxony to direct the Kunstgewerbeschule Institute / Wird er vom Großherzog von Sachsen nach Weimar gerufen, um die Kunstgewerbeschule zu leiten / Appelé à Weimar par le grand-duc de Saxe pour diriger le Kunstgewerbeschule / Ontboden naar Weimar door de Groothertog van Saksen, om het Kunstgewerbeschule Institute te leiden

1930-1954 Designed the Kröller-Müller Museum in Otterlo / Entwirft er das Kröller-Müller Museum in Otterlo / Projets pour le musée Kröller-Müller à Otterlo (Pays-Bas) / Ontwerpt het Kröller-Müller Museum van Otterlo

Otto Wagner
Penzing, Wien 1841 - Wien 1918

1857 Wien: Studied at the Technische Hochule / Beginnt er seine Studien an der Technischen Hochschule / Débute ses études à la Technische Hochule / Start studie aan de Technische Hochschule

1861-1863 Enrolled at the architectural school of the Vienna Academy / Studiert er an der Architekturhochschule der Wiener Akademie / Étudie à l'école d'architecture de l'académie

de Vienne / Studeert architectuur aan de Academie van Wenen

1874-1883 Wien: Numerous buildings / Erbaut er zahlreiche Gebäude / Construit de nombreux édifices / Bouwt verschillende gebouwen

1890 Worked on enlargement of the city of Wien / Wird er mit der Stadterweiterung Wiens beauftragt / Est chargé du plan d'agrandissement de Vienne / Stond aan de leiding van het uitbreidingsplan van Wenen

1894-1899 Urban railway network for Wien / Bauten für die Wiener Stadtbahn / Constructions pour les stations du métro de Vienne / Bouw van het metrostation van Wenen

1898-1900 Majolikahaus, Wien

1899 Joined the Viennese Secession with his students Joseph Maria Olbrich and Josef Hoffmann / Schließt er sich mit seinen Schülern Joseph Maria Olbrich und Josef Hoffmann der Wiener Sezession an / Adhère à la Sécession viennoise, avec ses élèves, Joseph Maria Olbrich et Josef Hoffmann / Sluit zich samen met zijn leerlingen Joseph Maria Olbrich en Josef Hoffmann aan bij de Weense Secessie

1913 Villa Wagner, Hüttelbergstraße 28, Wien

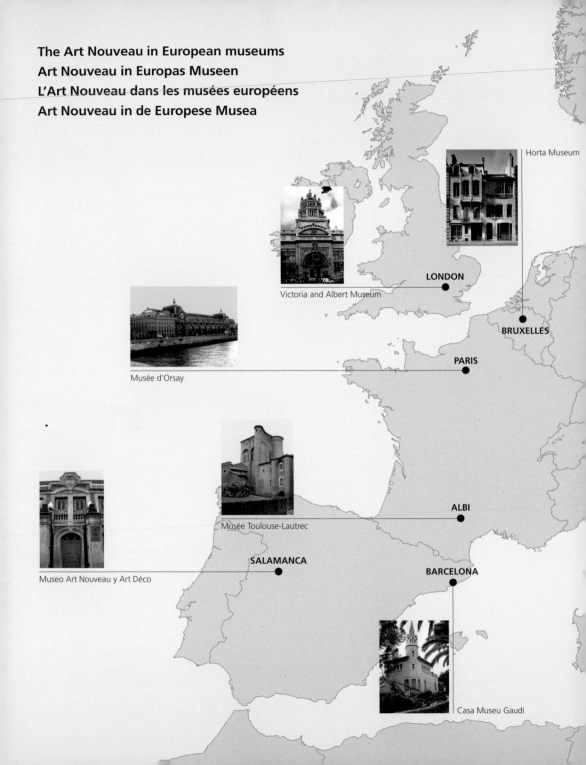

The Art Nouveau in European museums
Art Nouveau in Europas Museen
L'Art Nouveau dans les musées européens
Art Nouveau in de Europese Musea

Horta Museum

Victoria and Albert Museum

LONDON

BRUXELLES

Musée d'Orsay

PARIS

Musée Toulouse-Lautrec

ALBI

Museo Art Nouveau y Art Déco

SALAMANCA

BARCELONA

Casa Museu Gaudí

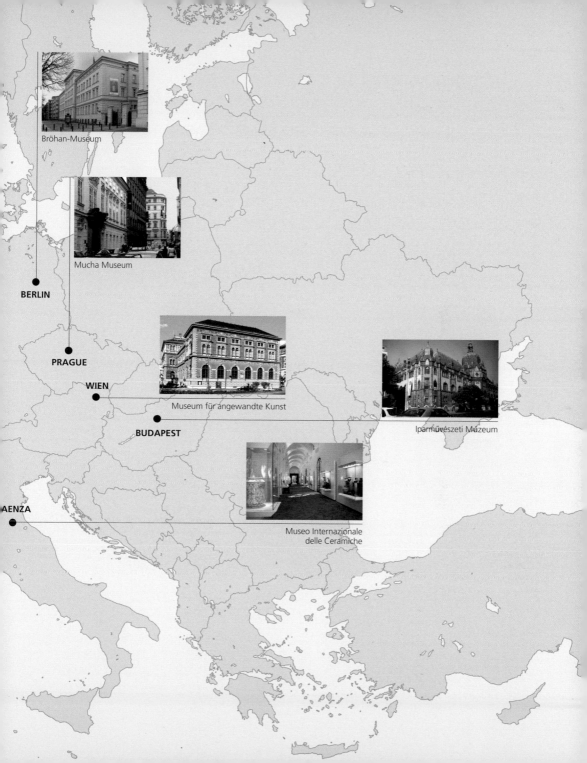

Bröhan-Museum

Mucha Museum

BERLIN

PRAGUE

WIEN

Museum für angewandte Kunst

Iparművészeti Múzeum

BUDAPEST

Museo Internazionale
delle Ceramiche

AENZA